PLYMOUTH **DISTRICT**
LIBRARY

Given by

Plymouth District Library

Staff and Board

in honor of

PATRICIA A. THOMAS,

Library Director,

1979-2013.

Travel
917.74 L

MS

Of Woods and Water

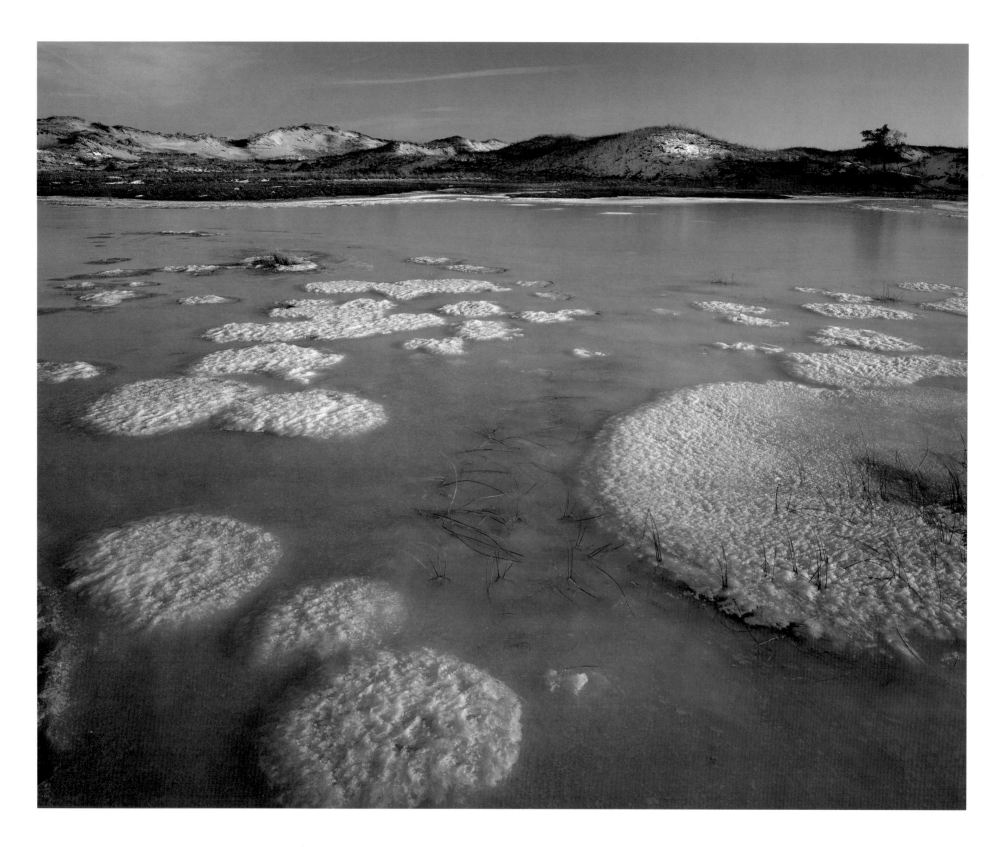

A portion of the frozen interdunal wetlands in the Ludington Dunes State Park [CJ]

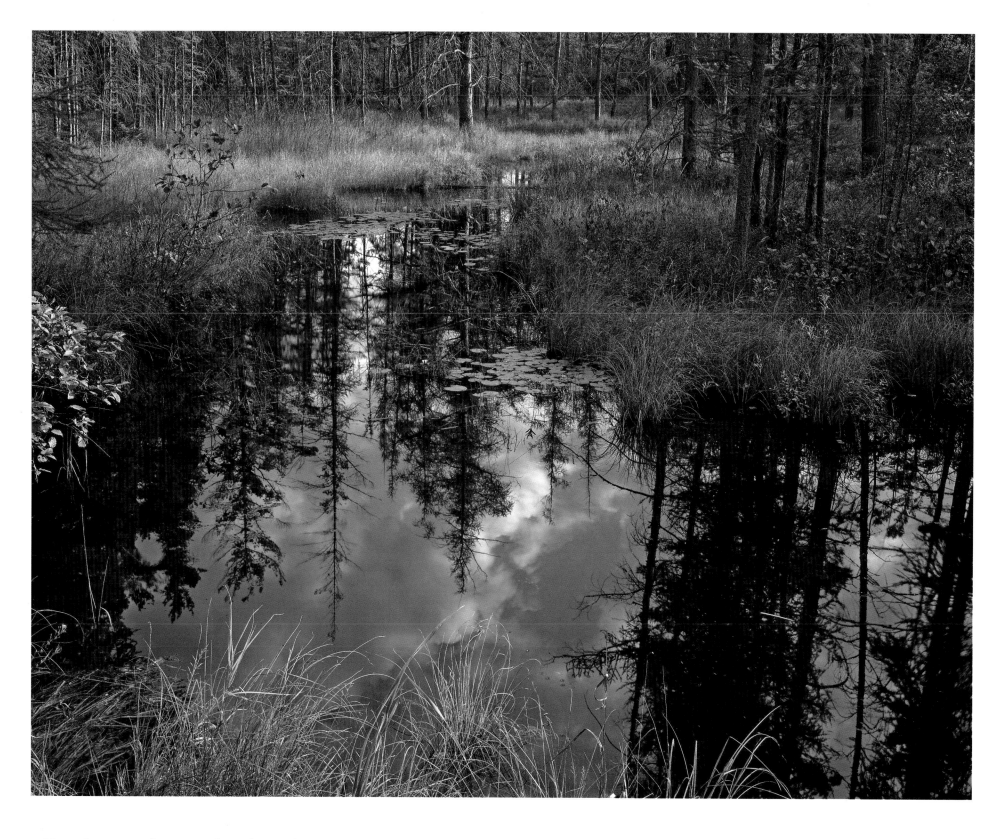

Near the town of Waters, the calm surface of an unnamed creek imitating the qualities of a mirror reflects a beautiful early fall afternoon. [RL]

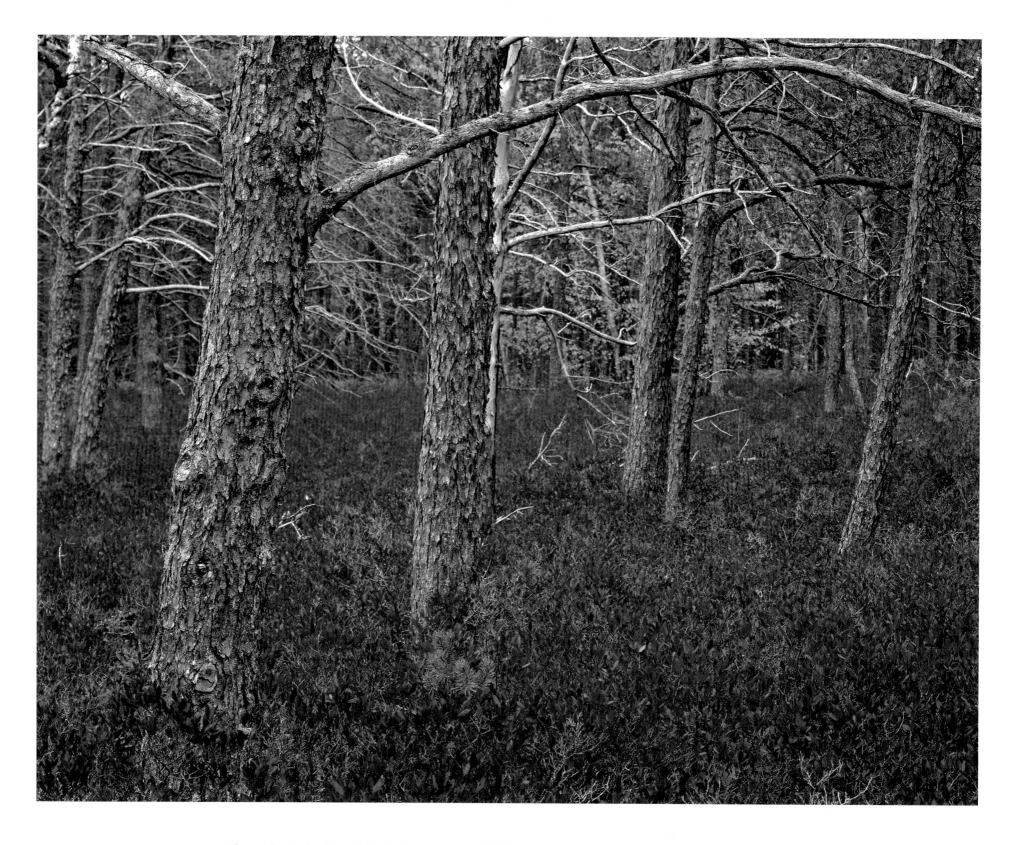

Along the Lakeshore North Country Trail above Miners Beach, low bush blueberry turns vibrant red in autumn, creating a striking contrast to the jack pine forest. [RL]

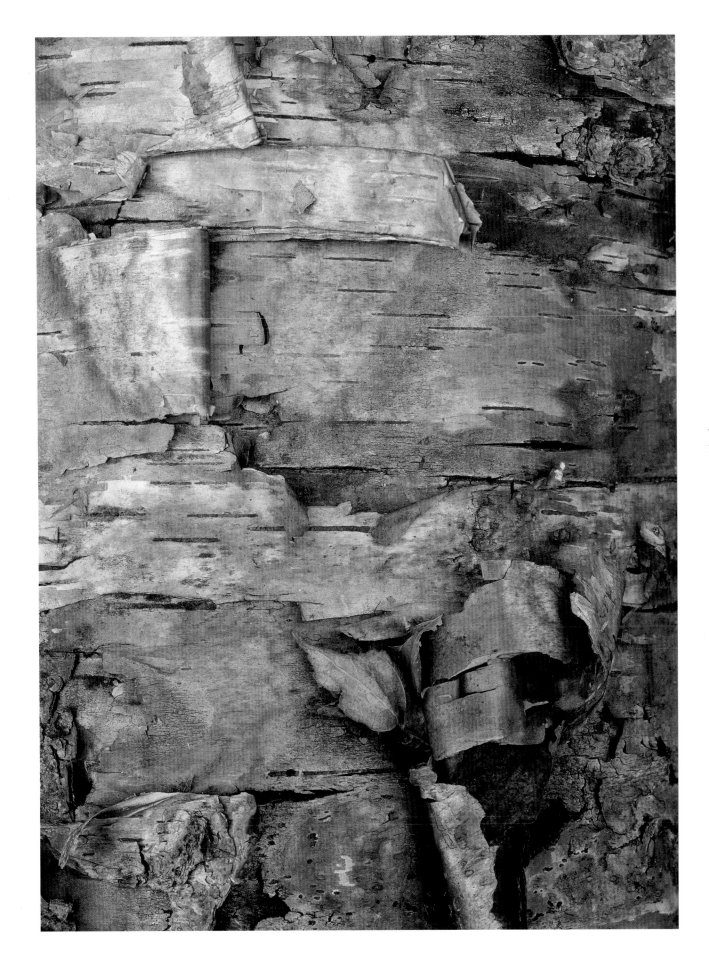

Peeling bark of a yellow birch tree reveals a range of soft colors and textures. [CJ]

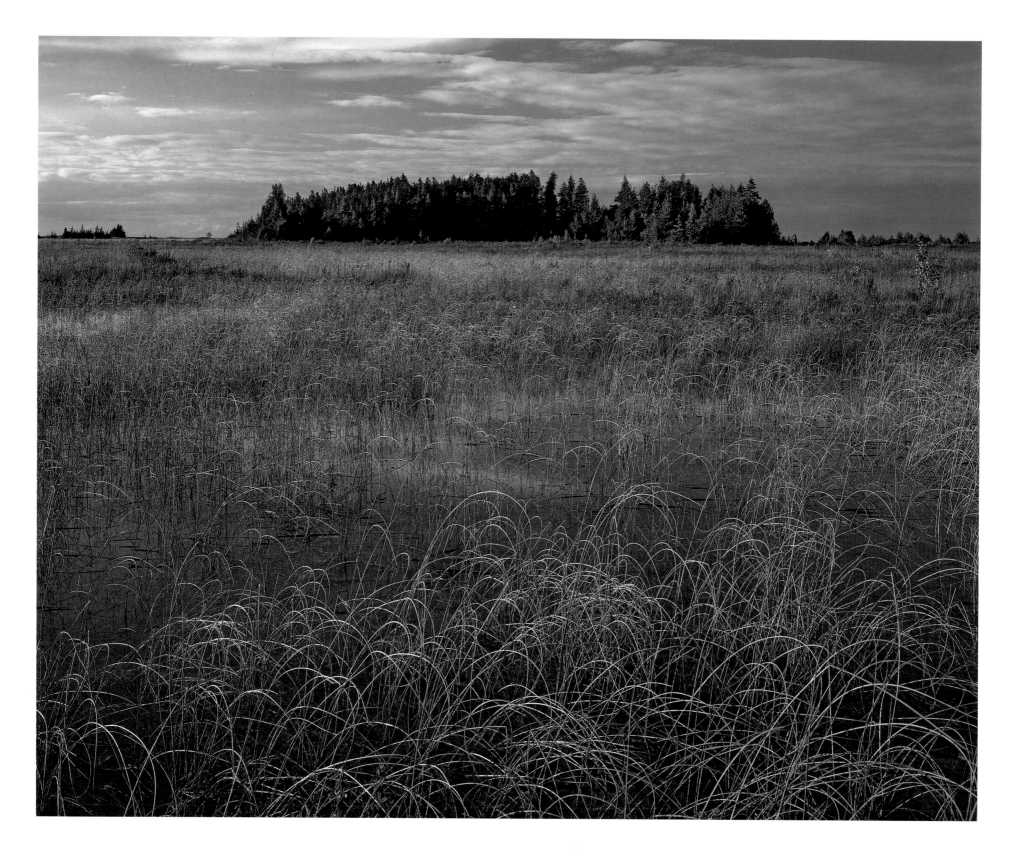

Sedges and grasses surround small stands of trees along the Waugoshance Point peninsula. [CJ]

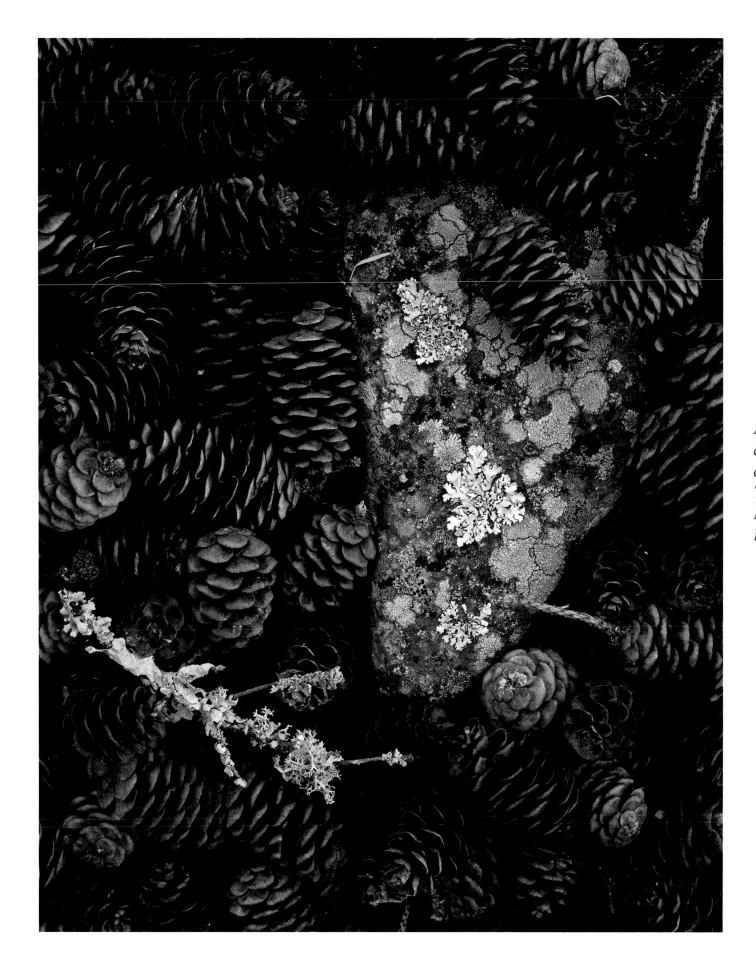

A lichen-encrusted rock offers a colorful contrast to the balsam cones it shares space with at The Nature Conservancy's Mary Macdonald Preserve at Horseshoe Harbor near Copper Harbor. [RL]

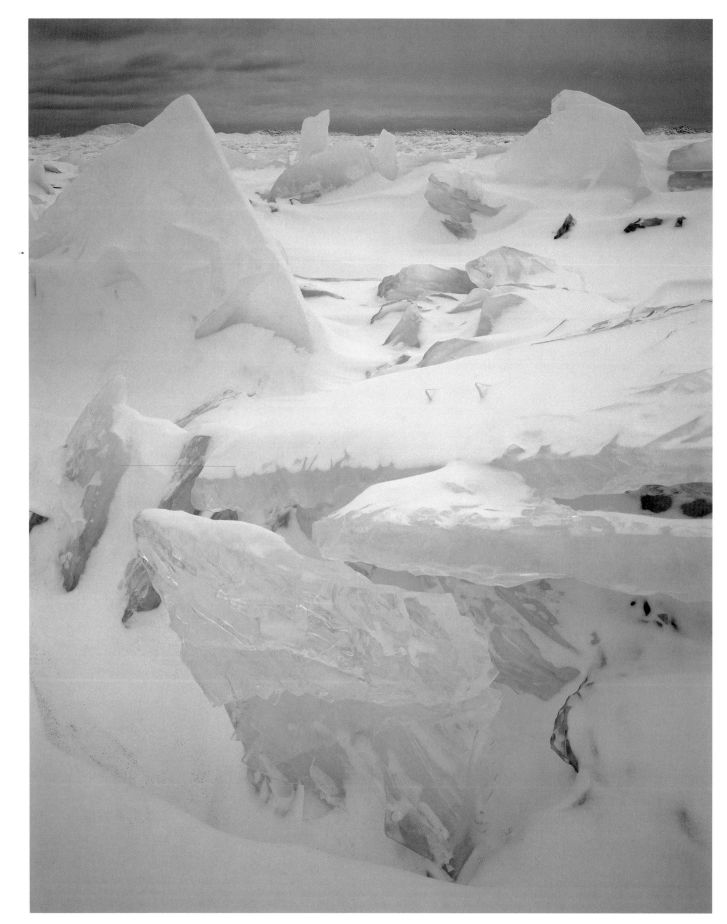

With a winter storm approaching, a foreboding sky and juxtaposed slabs of lake ice near the town of Gay on the Keweenaw Peninsula take on the look of an arctic landscape. [RL]

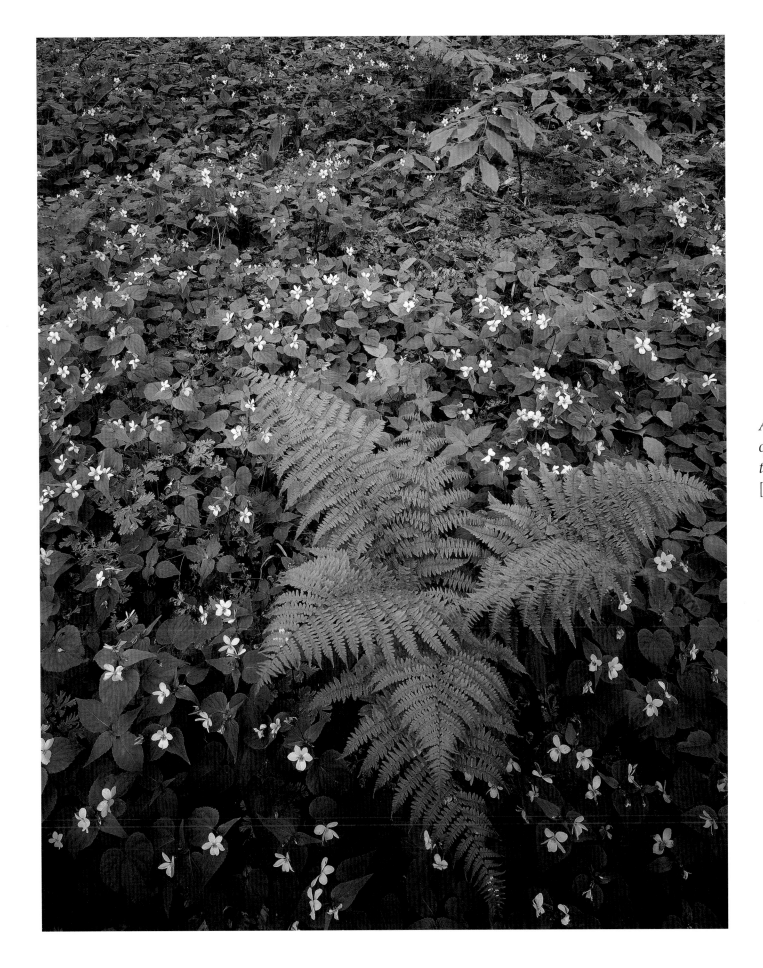

A large fern spreads above a bed of white violets along the wooded trail leading to the Empire Bluffs. [CJ]

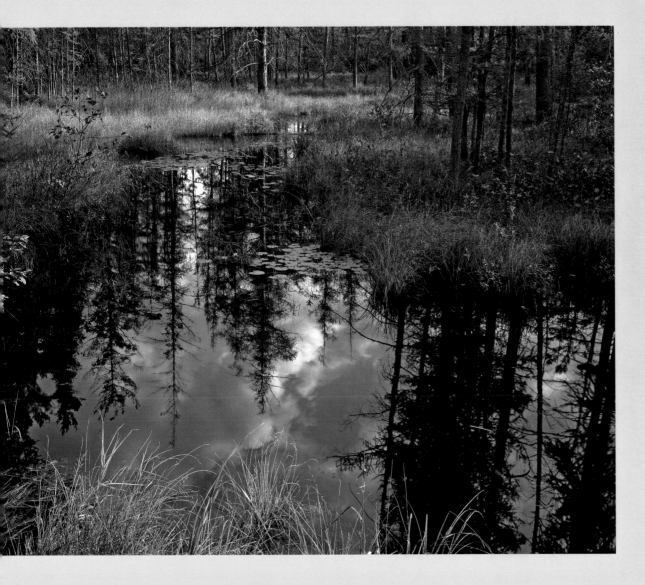

A Photographic Journey
across Michigan

Of Woods
and Water

Ron Leonetti and

Christopher Jordan

FOREWORD BY DAVE DEMPSEY

AN IMPRINT OF
INDIANA UNIVERSITY PRESS
BLOOMINGTON AND INDIANAPOLIS

This book is a publication of

Quarry Books

an imprint of

Indiana University Press

601 North Morton Street
Bloomington, IN 47404-3797 USA

http://iupress.indiana.edu

Telephone orders 800-842-6796
Fax orders 812-855-7931
Orders by e-mail iuporder@indiana.edu

MANUFACTURED IN CHINA

Library of Congress Cataloging-in-Publication Data

Leonetti, Ron, [date]
 Of woods and water : a photographic journey across Michigan / Ron Leonetti and Christopher Jordan ; foreword by Dave Dempsey.
 p. cm.
 ISBN 978-0-253-35276-7 (cloth : alk. paper) 1. Landscape photography—Michigan. 2. Natural areas—Michigan—Pictorial works. 3. Leonetti, Ron, [date] 4. Jordan, Christopher, [date] I. Jordan, Christopher, [date] II. Title.
 TR660.5.L465 2008
 779'.3609774—dc22
 2008014899

1 2 3 4 5 13 12 11 10 09 08

[ON PREVIOUS PAGE] *Near the town of Waters, the calm surface of an unnamed creek imitating the qualities of a mirror reflects a beautiful early fall afternoon.* [RL]

[ON PAGE 137] *Sleeping Mute Swan* [RL]

To my sons Jacob and Anthony: You two are my greatest accomplishments and I am most proud of who you have become. As you go through life, may you find the same peace and sanctuary in Nature as I have.

RL

To my children Iris and Solomon: This book is dedicated to you, with thanks for the inspiration, joy, and challenge you provide me every day. Your presence in my life has deepened my appreciation of these natural treasures. I love you beyond measure.

CJ

Contents

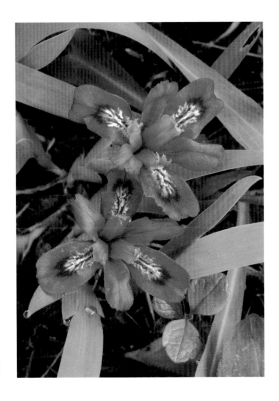

[RL]

Foreword

Capturing wild Michigan in photographs is a little like conveying the majesty of Mozart by humming a few bars. It's almost impossible, but if you're supremely talented, you just might pull it off.

After viewing the Michigan photographs of Ron Leonetti and Christopher Jordan that appear in this book, I know they are supremely talented.

Their acute eyes, feeling hearts, and professional skills have helped them accomplish something few if any have done before. They have grasped, without intruding upon, the spirit of the land and water of Michigan. They understand and love the character of a place like none other on earth, a place where I was born and which I will always cherish as dearly as my family.

What is the character of Michigan? You will understand in your own language only after studying and responding to the images and words in this book, but Ron and Christopher bring these adjectives to mind:

Tough and muscular. Like the men and women of the Motor City who put Americans on wheels, wild Michigan is powerful. Its Great Lakes waves sometimes thunder against the shore. Its towering forests sometimes roar in the wind. Tempered but not defeated by time, its cliffs, waterfalls, moraines, and alvar persist in beauty that is often craggy and stern.

Exquisite and fragile. Two of the state's natural icons illustrate this shading of Michigan's character. The Kirtland's warbler, a 6-inch-tall bird whose almost exclusive summer breeding ground for forty years has been the jack pine forests of northern Lower Michigan, at one time numbered only in the hundreds and is still vulnerable to extinction. The dwarf lake iris, a petite, subtly beautiful wildflower 90 percent of whose global population occurs close to Michigan's Great Lakes shorelines, is now the official state wildflower. It, too, faces an uncertain future—in its case due to climate change and continuing human development of its attractive habitat. The settlers of the 1800s surveyed mammoth forests and thought Michigan's natural wealth inexhaustible, only to liquidate the overwhelming majority of it in two generations. Today it is impossible to think of even the scenes of grandeur in this book as invulnerable to the hand of humankind.

Resilient. Throughout its more than 170-year history, Michigan has weathered catastrophe again and again but recovered. The year of its birth, 1837, was the year of a national economic panic that bankrupted the Michigan government. The Great Depression paralyzed the automobile industry. In the early 1980s the state's unemployment rate topped 17 percent. But each time its people awaited and contributed to new prosperity. Similarly, after the last glaciation ended approximately 10,000 years ago, the crust

of Michigan and adjacent areas, formerly depressed from the weight of the ice sheets, rebounded. Today Michigan's waters, renewed by more than a generation of strict pollution controls, are visibly healthier than they were, signaling that natural processes can heal if they are just given the chance to work.

Ron and Christopher have chronicled all of this, but they have done something more.

Each has found in these scenes of Michigan a representation of spirit—their own, and perhaps yours if you pass from page to page with open mind and heart.

A native of the state who grew up in metropolitan Detroit but attended college at far-off Northern Michigan University, Ron expresses in conversation as well as imagery his abounding love of the state. Ron's face relaxes into a grin as he remembers the wilds outside Marquette where he hiked, fished, and heeded Lake Superior's call. Time living in Indiana and Minnesota has only sharpened his love of his home state's natural beauty.

Ron's photographs quiver with that emotion, while his mastery of the camera steadies his hand and produces ravishing images of lush woodlands, shifting dunes, and reflective waters. It is clear that photographing Michigan has been to him far more than a job. It's been the culmination of all that he has lived.

Although he briefly inhabited the state, Christopher is a Hoosier who lives with family near Indianapolis. But it is clear in listening to him speak about his journey across the face of Michigan that he heard a music inaudible unless you pay close attention. He talks of a moment on the bluff edge of Pictured Rocks when a bald eagle soared offshore at eye level, seemingly within reach, but completely confident in its movements. And the photographic fruit of his hike

with Ron on Waugoshance Point testifies to his keen awareness of something almost concealed in that often lonely place, like so many others along the Great Lakes shoreline—a presence some might attribute to God.

A Michigan author, Bruce Catton, wrote of a nighttime lake crossing from Wisconsin:

> The Michigan shore seemed an unimaginable distance away and the dark sea ahead was what all adventurers have always seen when they pitted themselves against the great emptiness and its wonder and peril, and life itself is an enormous gamble played by people who are eager and frightened at the same time, with nothingness before and above and the chance of a dawn-swept landfall in the morning lying there, insubstantial and improbable beyond the night, as the possible reward.

Like Native American paddlers and voyageurs who traversed the great waters, Catton sensed something that night in the promise of an unseen place we now know as Michigan. At first only an idea related by the accounts of others, later a prospect trembling on the horizon after wearying travel, and finally a presence of soil underfoot and a vista of rock, sand, trees, fresh water, fish, and wildlife, Michigan was to the generations before us, and remains today, a bellwether of beauty and our collective capacity for valuing it. I hope you will agree that these photographs are evidence not just of a singular beauty, but of the need for undying human effort to protect it now and for all time.

In this book, two startlingly gifted photographers translate that intuition into indelible imagery. Prepare not only to be pleased, but to be moved—and challenged.

Dave Dempsey
March 31, 2008

Of Woods
and Water

Artists' Comments

I WAS BORN and grew up in what the Algonquian-speaking Ojibwa people called Meicigamma, which roughly translates as "the big water." Contemporarily known as the Great Lakes State, Michigan is where my deep respect and affection for the rich diversity and beauty of the Midwest's natural landscape has its roots. Over the last fourteen years I have lived in two other states, Indiana and Minnesota, both of which are beautiful and engaging in their own right. Michigan, though, maintains a very special spot in my heart and no matter where I am, it is the place that I will always refer to as home. Michigan is also where my journey as a photographer began.

It was while attending Northern Michigan University that the potential for marrying my experience as an outdoorsman with the art form of photography presented itself in an unusual way and place. I was working as the midnight disc jockey at the university radio station when I met Scot Stewart, who also worked there. We quickly became friends and found that we had a common interest albeit for different reasons.

Scot was an aspiring nature photographer who had gained notoriety with his work on timber wolf behavior. He was well traveled around the Upper Peninsula and certainly knew of places that were remote and breathtakingly beautiful. Some of these places also had streams, lakes, and beaver ponds that held the potential for rainbows, brookies, and bass. As for me, most of the places I had searched out for hunting and fishing were equally remote and beautiful with photographic promise.

And so it began. I enjoyed looking at his work all the while wishing I had better hand-to-eye coordination, but I could barely draw a straight line, so painting and sketching were out of the question. With my love of nature and art, photography would become my medium for expression. In 1980 I acquired my first "serious" 35mm camera. I began photographing what I knew best, wildlife. Scot and I would get together and do slideshows for each other and he acted as my technical mentor, helping me with everything from exposure to composition. Over the next ten years I would expose thousands of transparency slides and enjoy publication success.

Over time I noticed a greater percentage of my images being of flowers, close-up natural abstracts, and landscapes. It was then I got the idea to do a coffeetable book on my home state's natural beauty. When I compared my 35mm images to the landscapes I was looking at in the oversized photo books of the time, I knew that I needed to change formats. So I purchased my first large-format view camera, a Zone VI 4" × 5" wood field camera. I was now one big step closer to making my vision a reality.

I traveled over both peninsulas of the state looking for and capturing Michigan's rich diversity of natural habitats. I mean, there was so much out there to shoot. First, there are more than 32,000 miles of

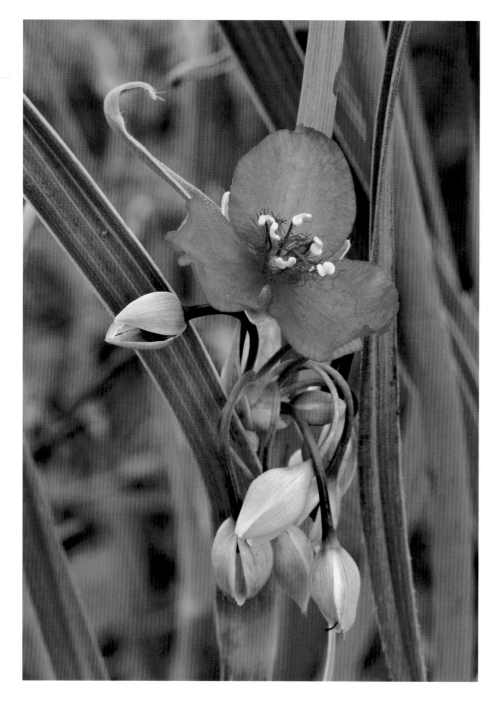

Spiderwort—Newaygo Prairie [RL]

forest, sand dunes, waterfalls, prairies, oak savannas, and wetlands—plus the ability to watch the sun literally rise and set over water on both sides of the state—and I truly believed that there was no better place in the world to revel in and commune with nature.

Then came a proverbial curve ball from out of left field. In my day job I got a promotion and I was transferred to Indiana in 1994. The Michigan book got shelved and I completely stopped photographing for the next six years. Through that entire time and in the back of my mind thoughts of my home state in all of its natural beauty and the peace I got from being in it remained strong. To make a long story short, I did get back into landscape photography and shot my first book on Indiana with Christopher Jordan, which was quickly followed by a second on the nature preserves of the Indiana chapter of The Nature Conservancy.

So here we are. Occasionally you hear people make the comment that something they did was a labor of love. This book project at no time was labor for me. All the thousands of miles of car travel to and from Minneapolis and all the miles I drove crisscrossing the state were like one long sentimental journey. Hiking and camping in places that I had not been to in more than twenty years not only flooded my mind with wonderful memories but also left me smiling so long and hard that my face hurt.

The Michigan state motto is "Si Quaeris Peninsulam Amoenam Circuspice"—If you seek a pleasant peninsula look around you. From expansive beds of American lotus along the back water bays of Lake Erie to the expansive view from the Lake of the Clouds Overlook in the Porcupine Mountains Wilderness State Park, from the sandy beaches at the Sleeping Bear Dunes National Lakeshore to the rocky cliffs on Lake Superior at Pictured Rocks National Lakeshore and from sunrise on Lake Huron to sunset on Lake Michigan, you will experience incredibly pleasant peninsulas (both of them).

I hope that these images prompt pleasant memories of your own experiences in Michigan's natural bounty. More so, I hope that these images will strike a chord within you to take ownership in the preservation of the state's rich yet fragile and all too often threatened natural diversity for the generations to come. It is true that I no longer live in Michigan. What I will tell you and what these images will bear out is that I am proud of my Michigan heritage and, by the virtue of all its natural splendor, Michigan lives in me and always will.

RL

freshwater shoreline, the most in the world. I know that Minnesota is referred to as the land of 10,000 lakes, but there are more than 11,000 inland lakes and 36,000 miles of streams combined on Michigan's peninsulas. Add to that extensive stretches of hardwood and conifer

SPEAKING as a nature/landscape photographer, it's only fair to mention right up front that I believe Michigan is an embarrassment—an embarrassment of riches that it has been my pleasure to get to know at least a little during the months and years that I've been working on this project. I was not particularly familiar with the state prior to my first photographic trip to the Pictured Rocks National Lakeshore in the fall of 2001. Since that time I've visited parks and preserves large and small, fallen even deeper in love with the Great Lakes, and found a number of areas for future photographic explorations.

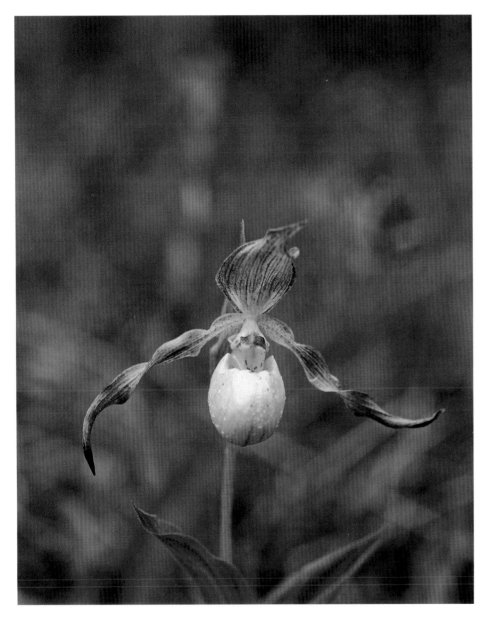

Yellow lady slipper orchid—Carl A. Gerstacker Nature Preserve
[CJ]

Considering the wealth of locations and richness of the various ecosystems, it seems almost indecently hasty to assemble a book of Michigan landscape photographs where the majority of the work was completed in a roughly 2 to 2½–year timeframe. On the other hand, that wealth and richness is such that you could work a lifetime and not exhaust the possibilities for interesting and unique photographs. Given millions of acres of forest, thousands of miles of shoreline, the largest freshwater dune complex in the world, and even more thousands of miles of inland waterways (not to mention prairies, savannahs, and a huge variety of wetlands), Michigan has a spectacular array of natural locations to visit and appreciate.

Perhaps more personally satisfying, I've come away from this project with a collection of experiences that I treasure. Some of those experiences were quiet and introspective, including one or two discussed in more detail in the essays found sprinkled throughout the book. Some were much louder and more dramatic. I'm reminded of the first morning I awoke after camping at the Twelve Mile Beach campground on my first Pictured Rocks visit. I went to sleep that night lulled by the quiet sounds of a relatively benign Lake Superior. I awoke to a thundering roar and rain blowing across the lake. Seemingly in an instant, the weather had transformed Lake Superior from a gentle giant to a howling beast that commanded respect, admiration, and perhaps a little uneasiness if you got too close. It was a dramatic and lasting lesson in the power of the Great Lakes, a lesson I continue to explore and appreciate. The range of moods seemed complete when, four days later, I photographed a wetlands elsewhere in the UP and took 2- and 3-minute exposures of tall grasses and fragile ferns without a breath of wind to disturb the stillness.

Ultimately, it is these experiences and lasting impressions of the locations shown here that led to one of the main goals behind this book. I hope that you the reader will appreciate the photographs as reflections of the many moods and faces of nature. In turn, if even one photograph here touches you in some way I ask that you use that as motivation to support the organizations that protect, nurture, and sustain these natural areas. Without the parks, preserves, recreation areas, forests, and lakeshores that you see in the pages to follow, the experiences that I and countless others have had in those areas will eventually be gone. History, I fear, would judge that as the greatest embarrassment of all.

CJ

Locations Visited

Allegan State Game Area
Au Sable State Forest
Au Train River
Bay City Recreation Area
Bete Grise Nature Preserve
Bond Falls
Burr Plant Preserve
Bush Bay Overlook
Carl A. Gerstacker Nature Preserve
Copper Country State Forest
Copper Harbor
Dowagiac Woods Nature Sanctuary
Duck Lake State Park
Fayette State Park
Garden Peninsula
Grand Mere State Park
Grass Bay Preserve
Hartwick Pines State Park
Holland State Park
Isaacson Bay
Island Lake Recreation Area

Jasper Woods Nature Preserve
Kensington Metro Park
Keweenaw Peninsula
Lake Erie Marsh
Lake Superior Scenic Shoreline Drive
Lake Superior State Forest
Lakeville Swamp Nature Sanctuary
Leelanau State Park
Little Presque Isle
Little Wolf Lake
Ludington Dunes State Park
Mackinac State Forest
Mary Macdonald Preserve at Horseshoe Harbor
Millecoquin River
Misery Bay Preserve
Nan Weston Nature Preserve
Newaygo Prairie
P. H. Hoeft State Park
Pictured Rocks National Lakeshore
Pigeon River Country State Forest
Porcupine Mountains Wilderness State Park

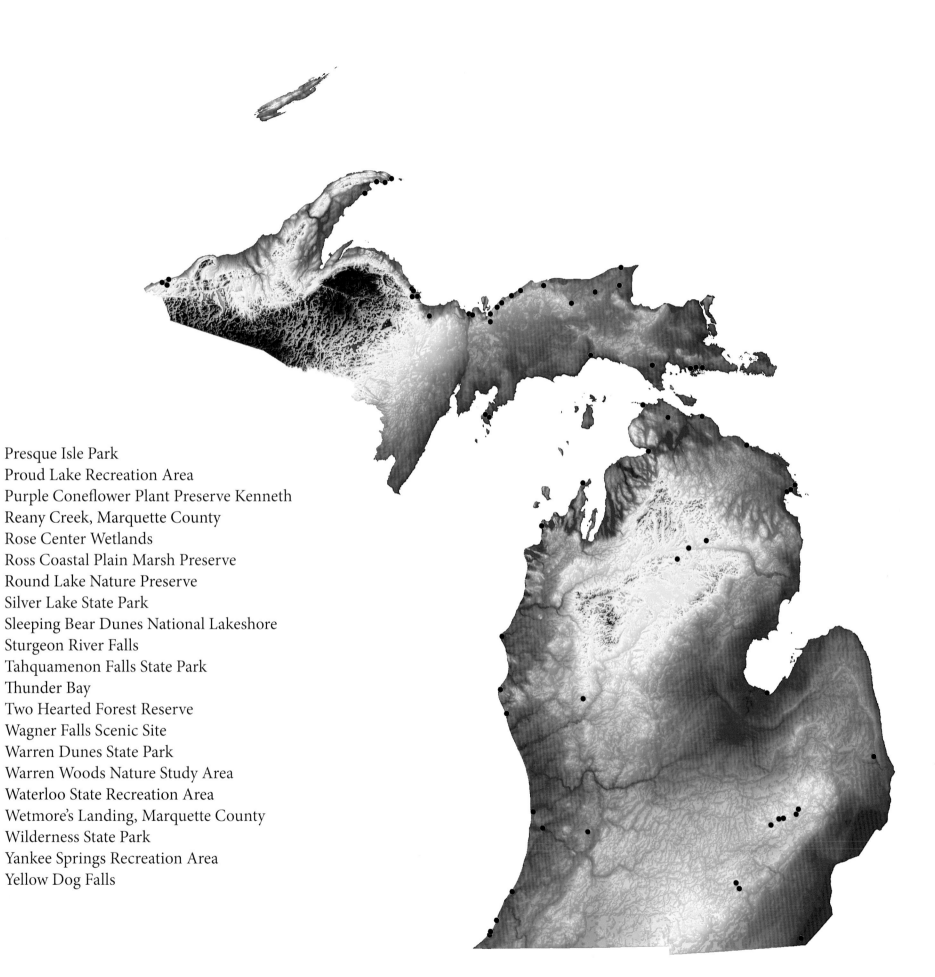

Presque Isle Park
Proud Lake Recreation Area
Purple Coneflower Plant Preserve Kenneth
Reany Creek, Marquette County
Rose Center Wetlands
Ross Coastal Plain Marsh Preserve
Round Lake Nature Preserve
Silver Lake State Park
Sleeping Bear Dunes National Lakeshore
Sturgeon River Falls
Tahquamenon Falls State Park
Thunder Bay
Two Hearted Forest Reserve
Wagner Falls Scenic Site
Warren Dunes State Park
Warren Woods Nature Study Area
Waterloo State Recreation Area
Wetmore's Landing, Marquette County
Wilderness State Park
Yankee Springs Recreation Area
Yellow Dog Falls

The Journey

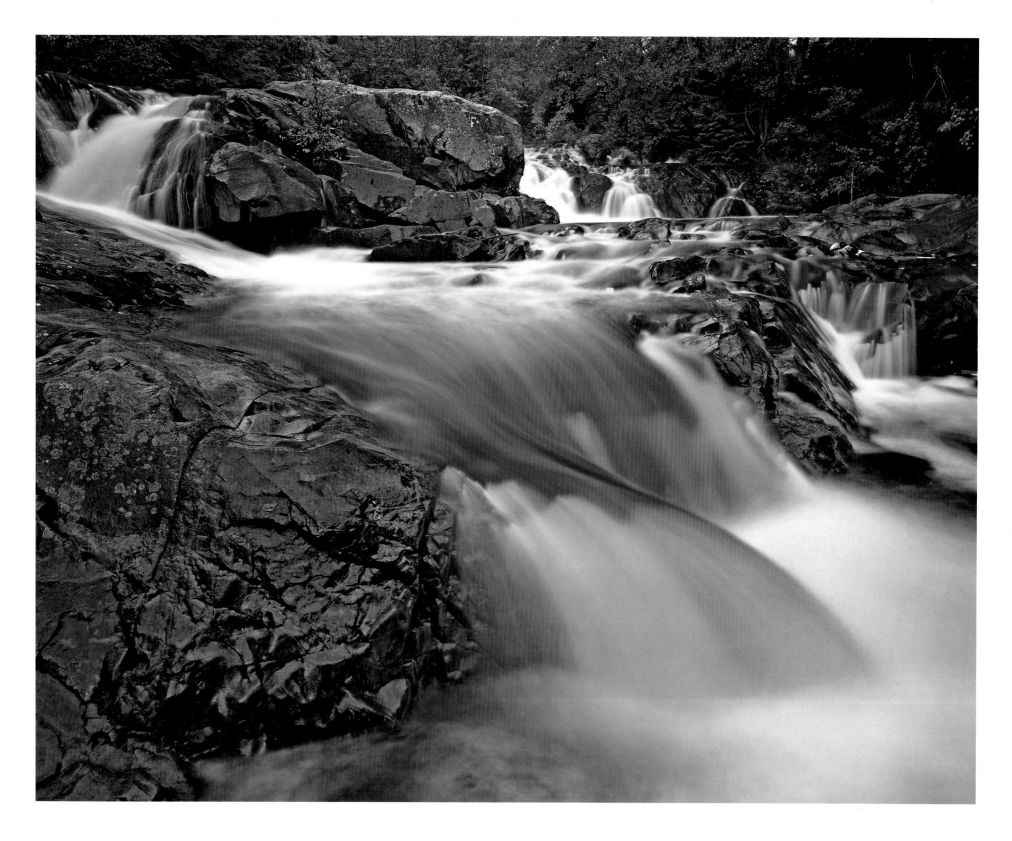

The Yellow Dog River runs for 51 miles through some of the most pristine wilderness area in north central Marquette County. The rivershed is currently part of a mining controversy that could significantly impact the natural state of this area and its inhabitants. [RL]

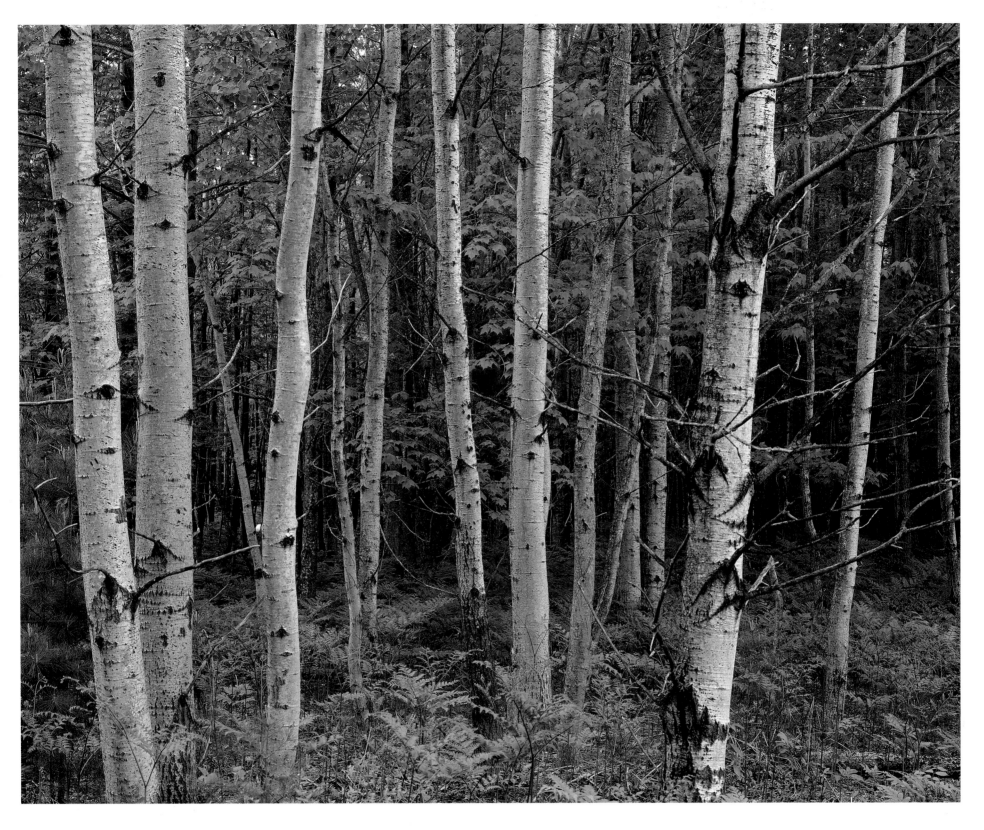

A small stand of aspen forms a row of white trunks against the surrounding forest, in the backwoods near Otter Lake. [CJ]

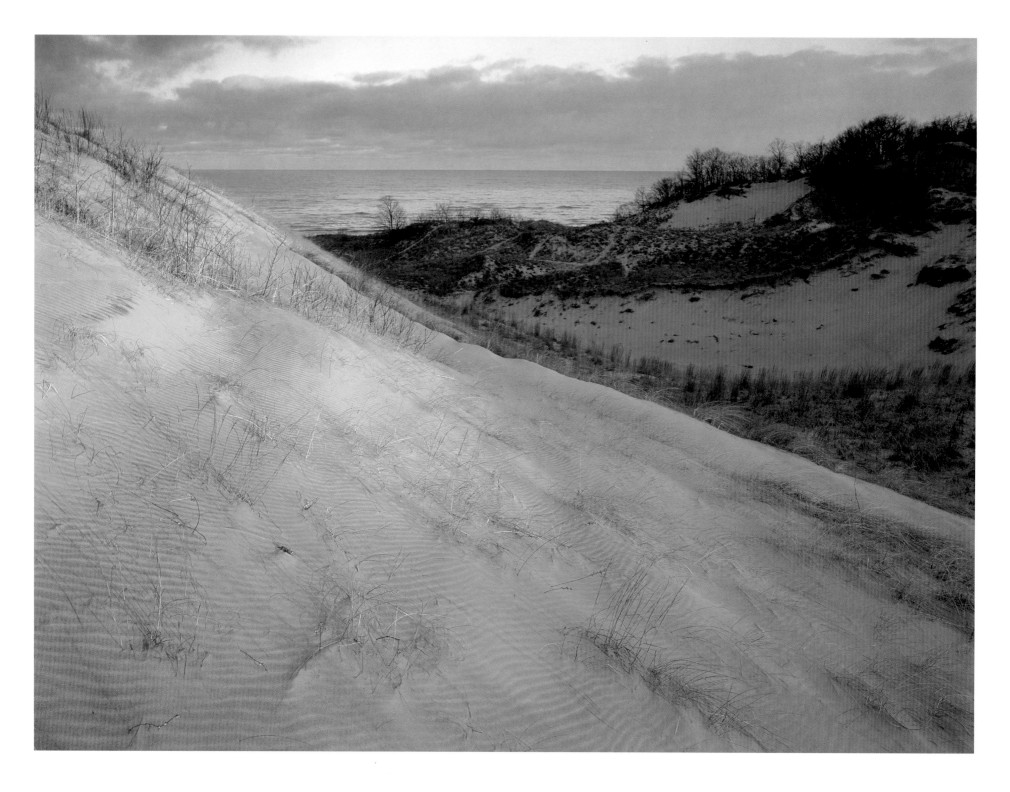

First light on windblown dunes and golden grasses overlooking Lake Michigan, part of the largest freshwater dune system in the world [CJ]

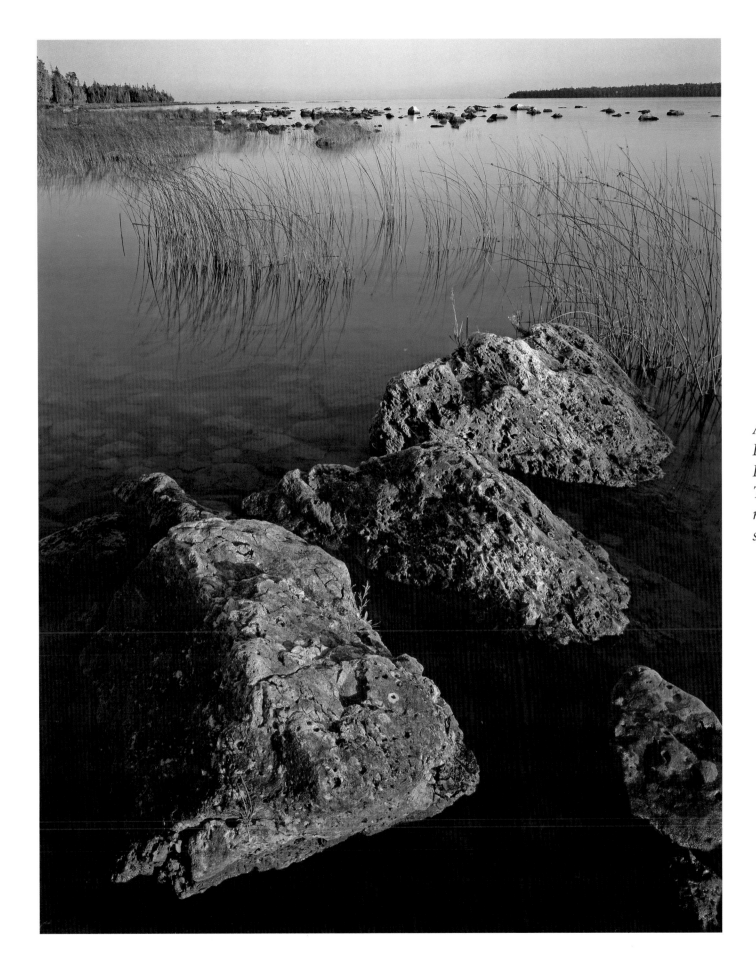

A late afternoon view of Bush Bay on the northern shore of Lake Huron east of Cedarville. The scattered limestone boulders make great cover for game fish like smallmouth bass. [RL]

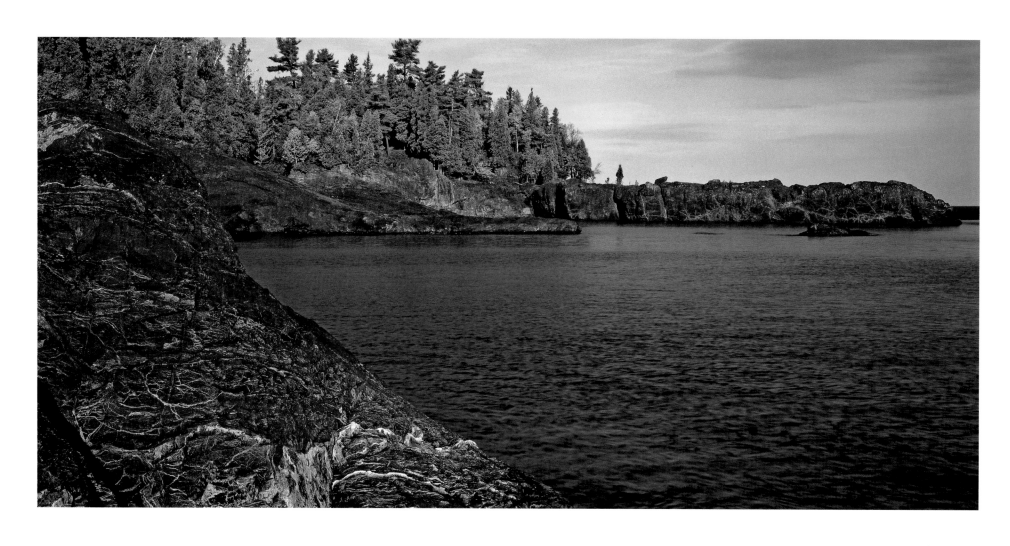

Presque Isle has more than 2 miles of jagged undeveloped Lake Superior shoreline.
Deer and peregrin falcons are found among the peninsula's residents. [RL]

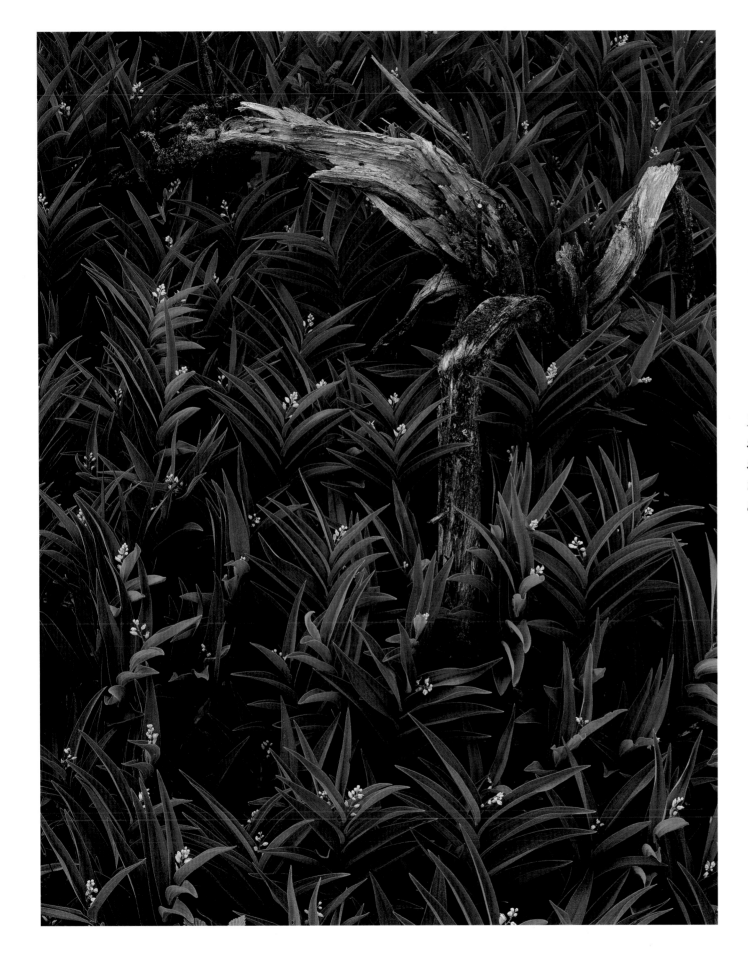

False Solomon's seal grows in springtime profusion around a small stump, one of many flowers that bloom in abundance within the Sleeping Bear Dunes. [CJ]

The Curtains are well known to ice climbers in the Munising area. This extensive stretch of ice-coated cliffs is located in the Pictured Rocks National Lakeshore near Sand Point.
[RL]

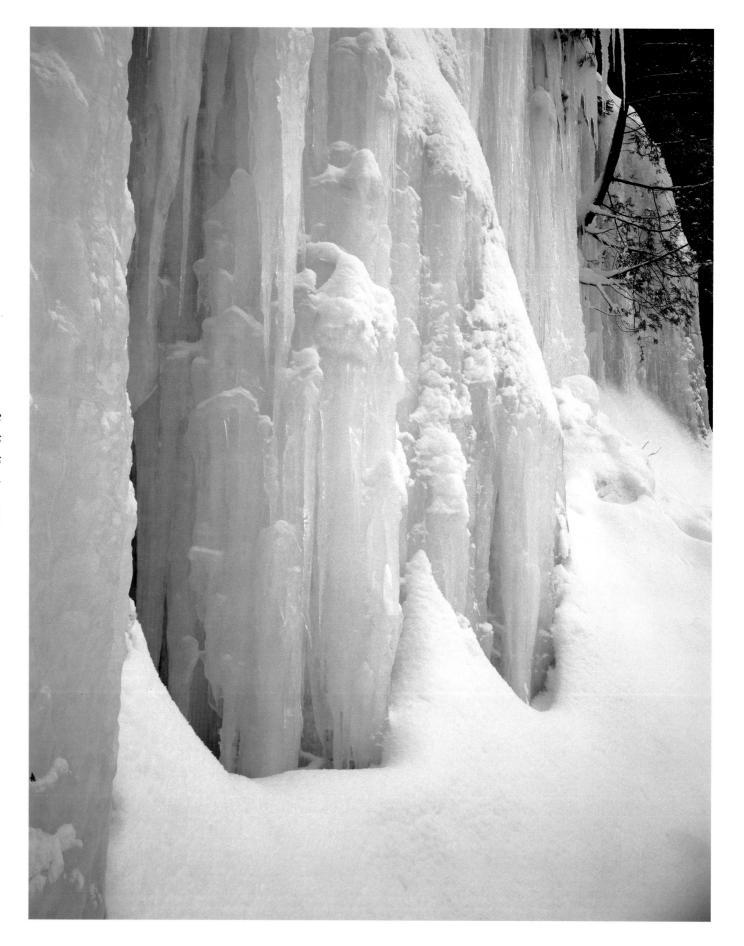

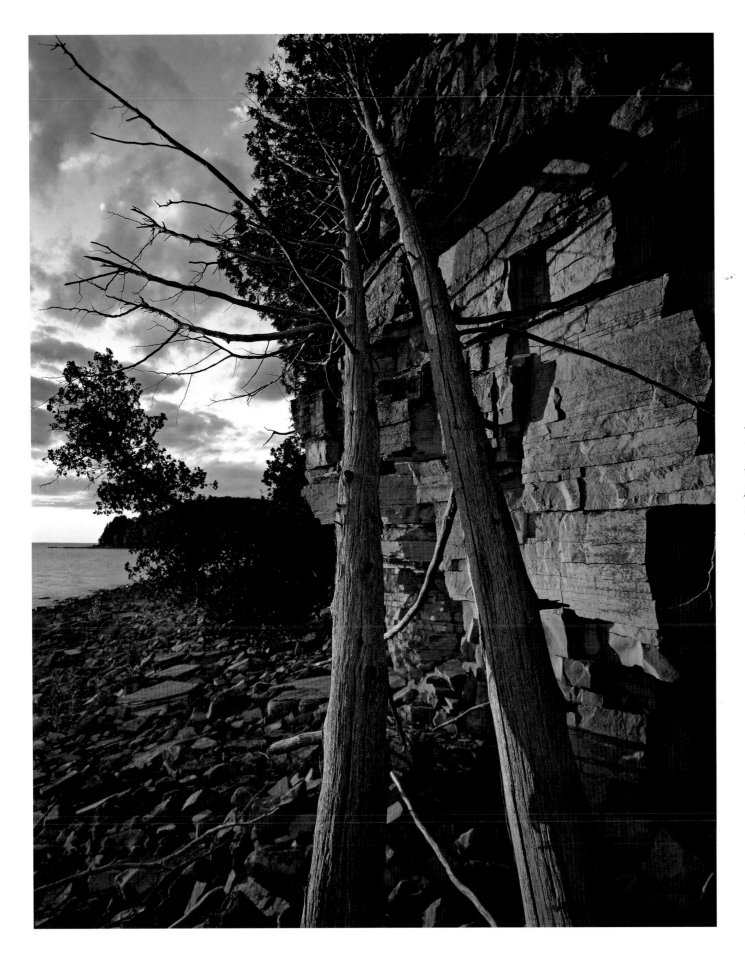

As the sun makes its way to the western horizon, bleached cedar skeletons and limestone outcroppings take on the warm glow of the day's last light near Fayette State Park. [RL]

A young birch tree clings precariously to the rocky bank of the swift-moving Sturgeon River. [RL]

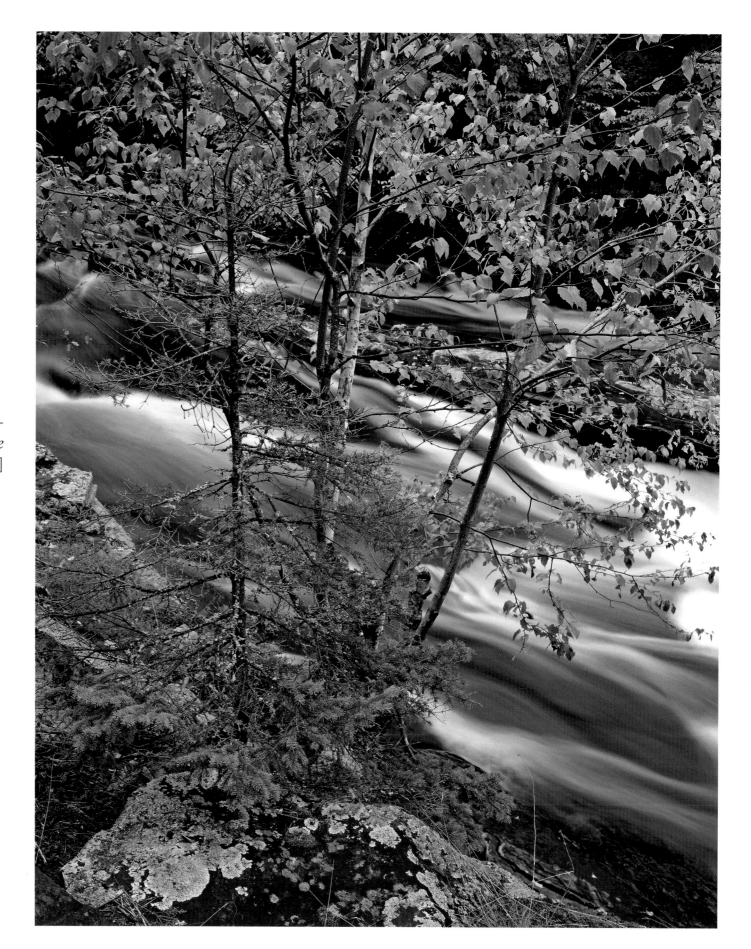

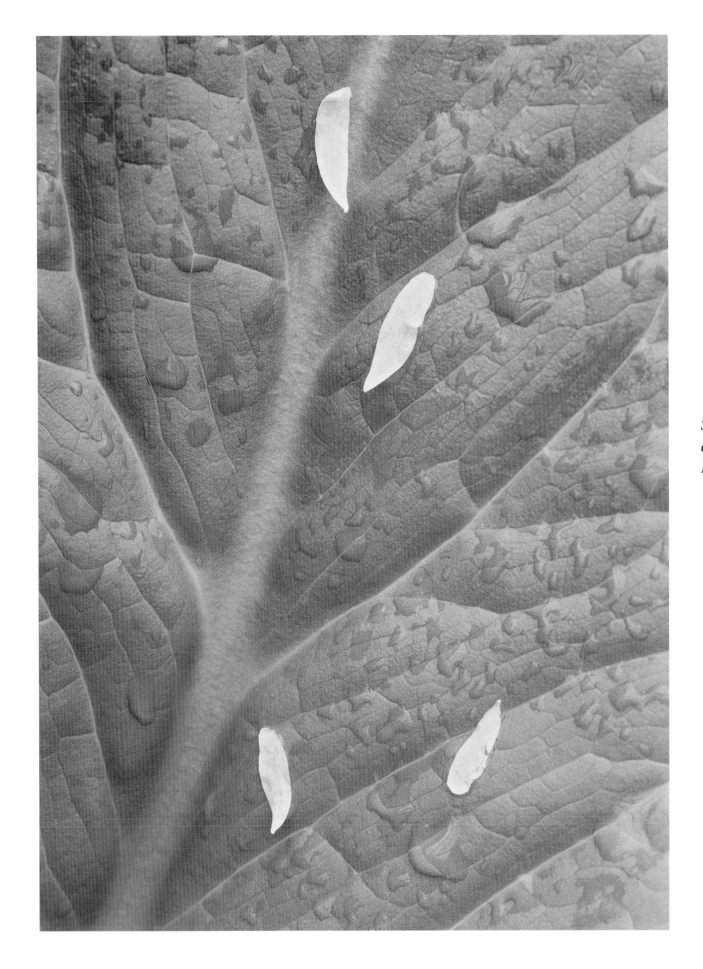

Serviceberry petals decorate a large skunk cabbage leaf in a wetlands portion of the Proud Lake Recreation Area. [CJ]

Being Prepared for Good Luck

You hear professional photographers talk about the preparation and discipline that goes into capturing powerful images of the natural landscape. There are a proverbial ton of things you must study, prepare for, and know, in order to consistently produce great images. On the other hand, *luck* doesn't always get the credit it deserves. Case in point.

For several years I lived near Kensington Metro Park and did a considerable amount of shooting there. The park abounds with wildlife and maintains a nice variety of natural communities affording photographers ample opportunities throughout the year. I regularly drove through the park on my way home from work in the city and commonly carried photo equipment in the car.

Late one afternoon in early March I am driving through the park. The surface of Kent Lake is glass-like and heavy fog is limiting viewing distance to only a few hundred yards. I had driven past this particular spot literally hundreds of times but on this day it had such a surreal look to it that I turned around and drove, then walked, toward it. Conditions were such that I could not tell where the sky ended and the lake began off in the distance. After standing there for a few moments with my mouth open in awe, I ran to the car and grabbed my gear. I had composed and exposed one sheet of 4" × 5" film when, from out of nowhere, a soft, almost undetectable breeze rose and blew away enough of the fog to make the distant islands and lake's edge visible. The incredible scene was gone.

At that moment, I was disappointed with how little time I had to work this composition. When I got the film processed my good luck presented itself on a single sheet of film. I have traveled past this spot many times since this experience, never seeing anything close to what I witnessed that day. When people see this image they remark how fortunate I was to have been there at that moment. I always reply, "Sometimes you're good and sometimes just good and lucky."

RL

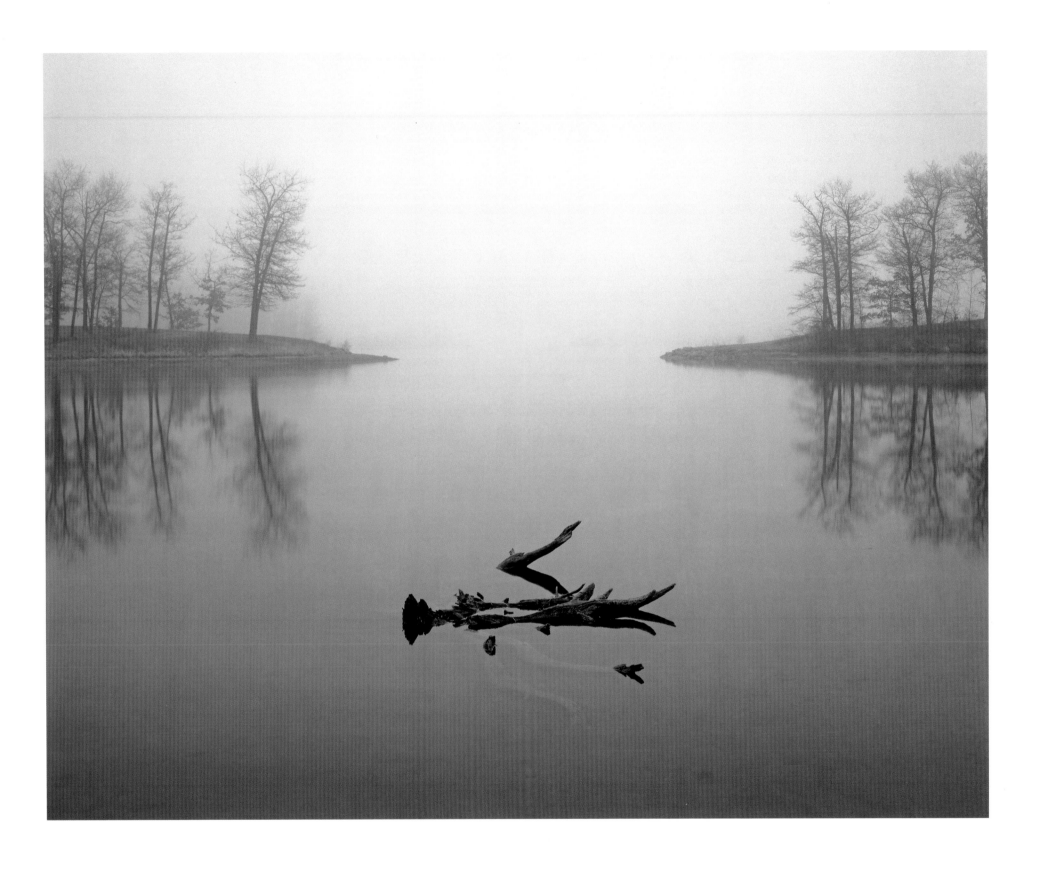

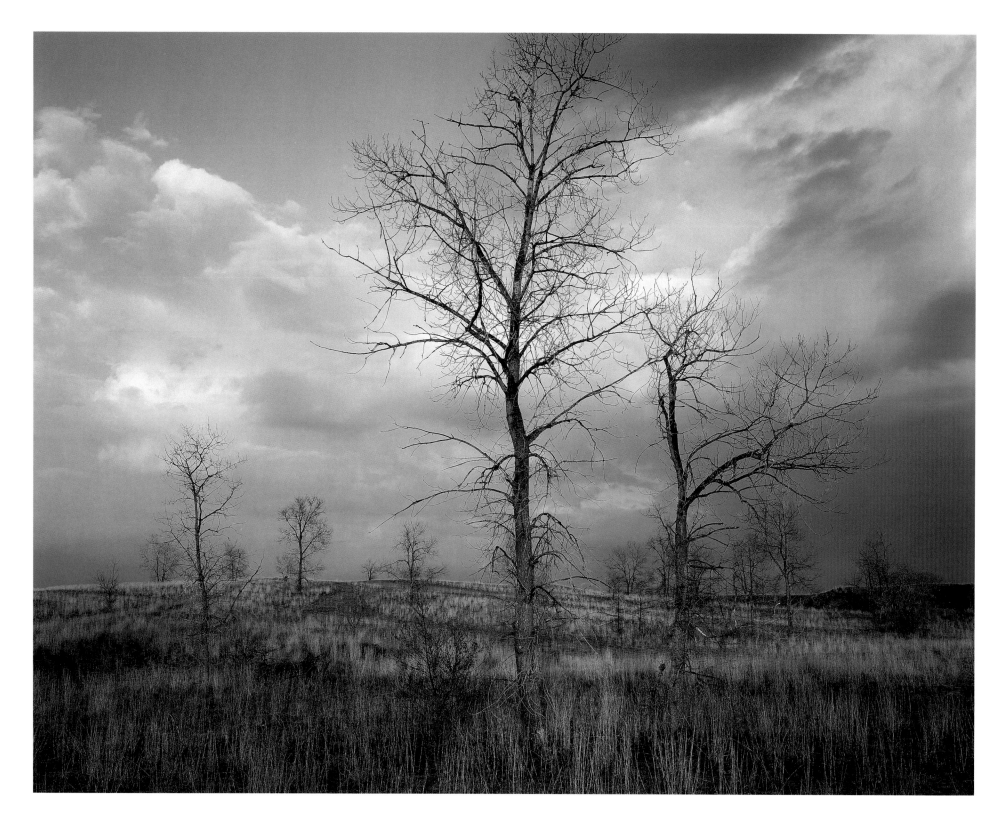

Oak trees and grasses glow in the late-day light following a rain storm within the Island Lake Recreation Area. [CJ]

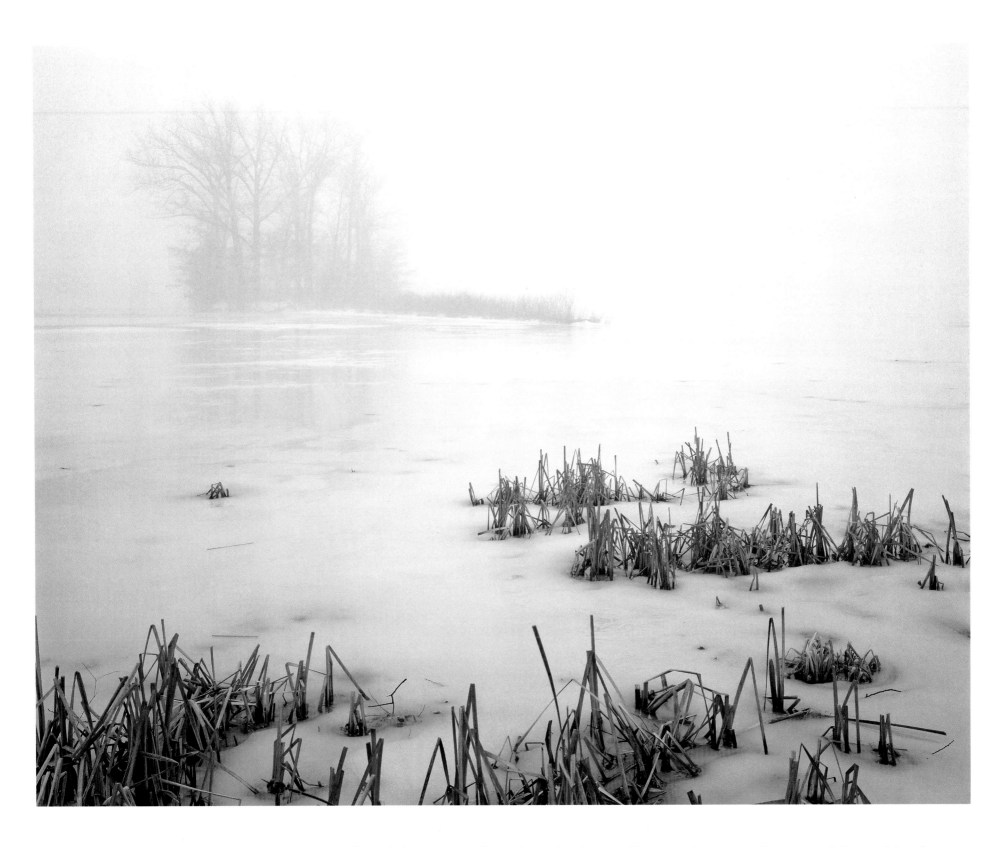

As winter loses its grip, lake ice begins to melt and the vague outline of an island on Wildwing Lake materializes out of the resulting fog. In recent years this island has become a heron rookery. [RL]

Tiny maple trees carpet the forest floor with a pattern of leaves on the Leelanau Peninsula. [CJ]

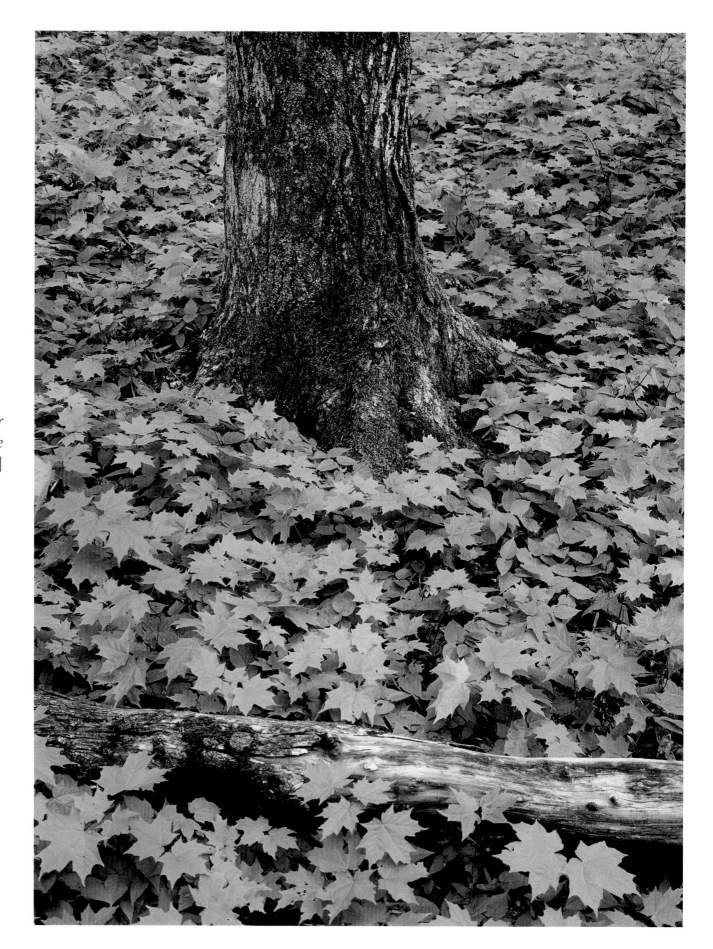

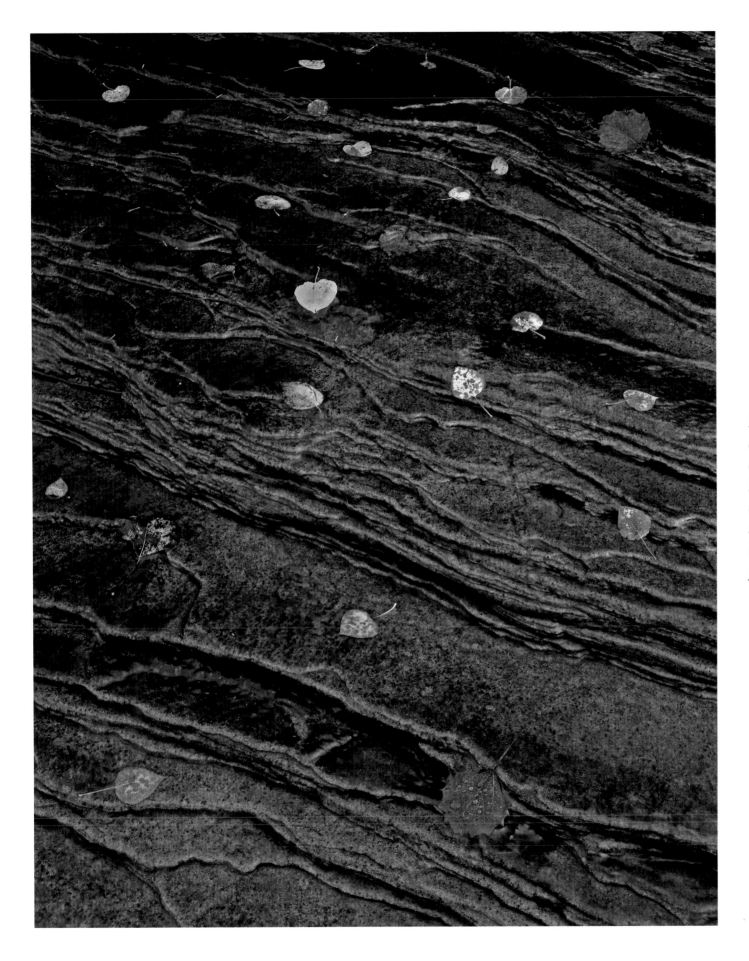

Fallen leaves rest on exposed Pre-cambrian sandstone at the east end of Miners Beach, Pictured Rocks National Lakeshore. There are three different formations of sandstone here with the oldest being more than 500 million years old. [RL]

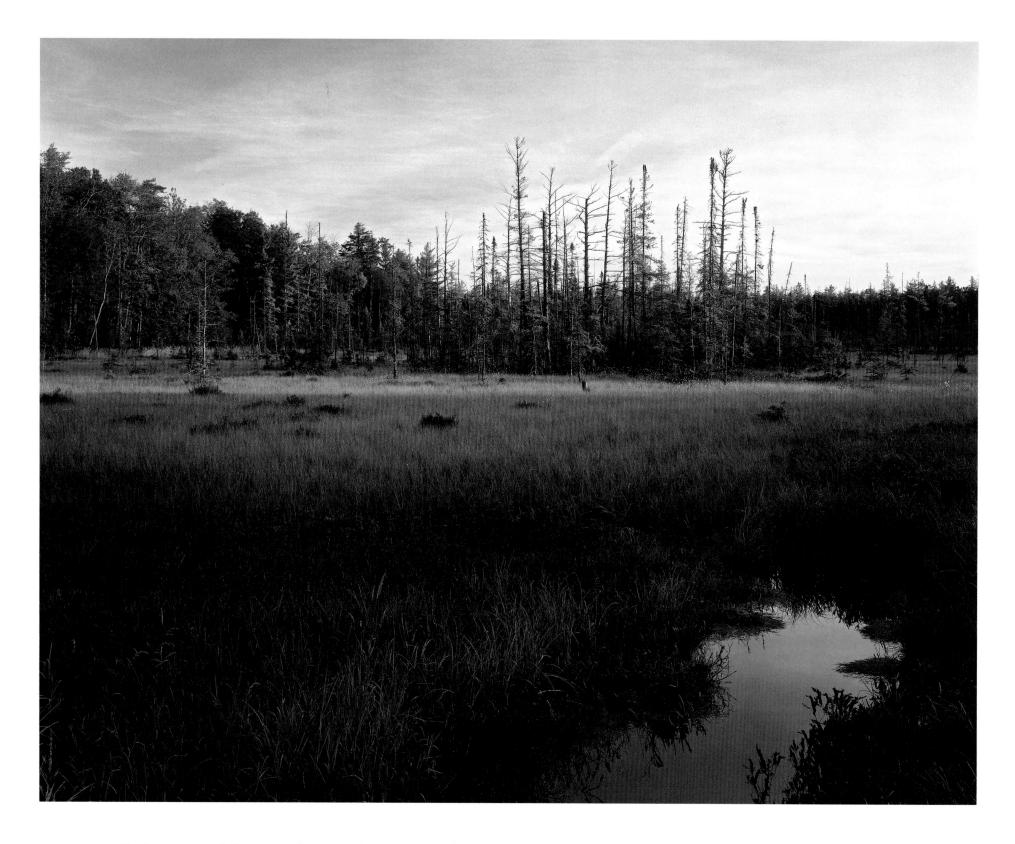

Early morning lights a small group of trees in one of the many wetland areas in the UP's Lake Superior State Forest. [CJ]

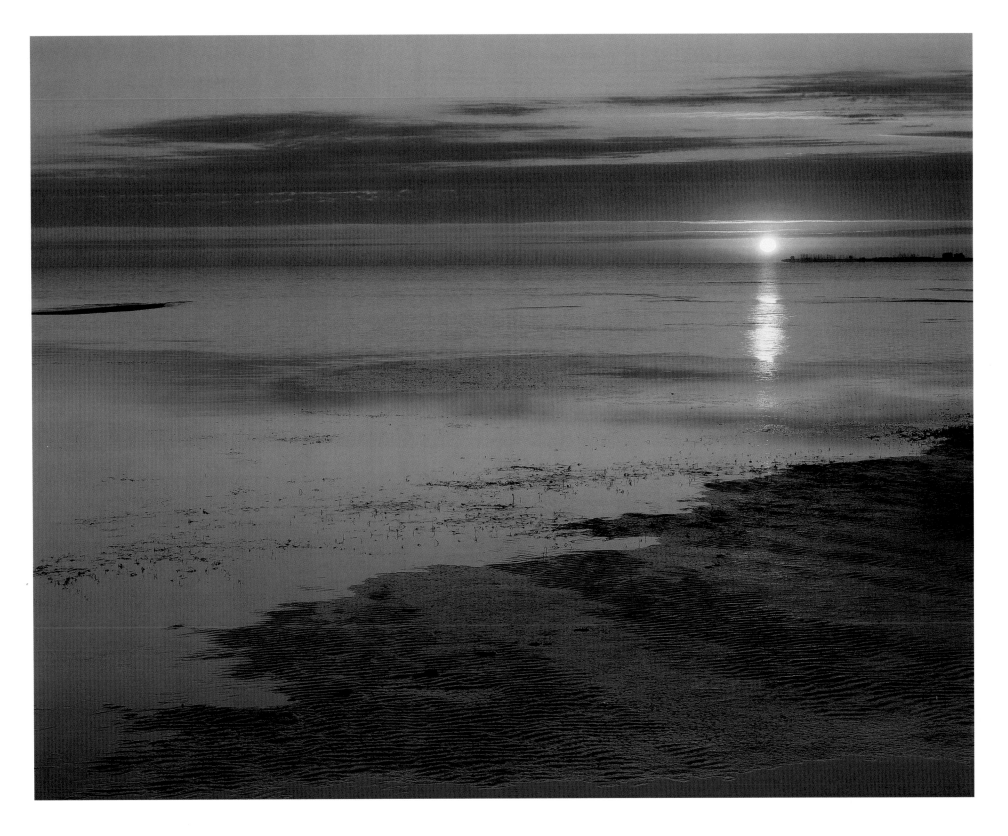

Early morning color lights up the sand ripples along the shore of Saginaw Bay. [CJ]

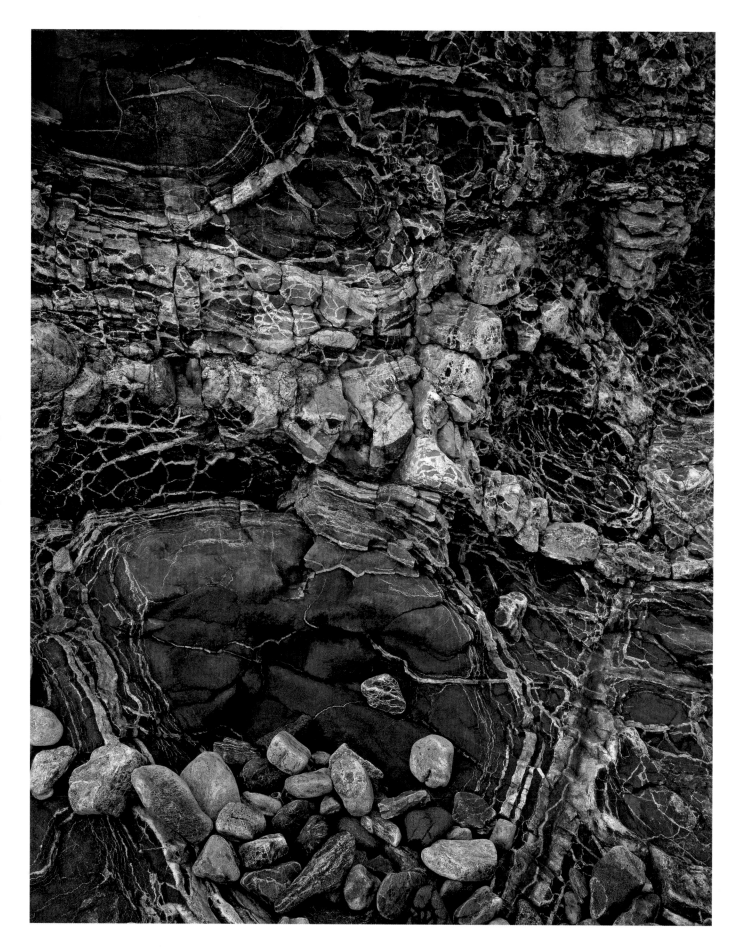

Baseball-size rocks gather on the colorful and veined shoreline at Presque Isle Park in Marquette. This 323-acre city park displays some of the oldest exposed rock formations in the world. [RL]

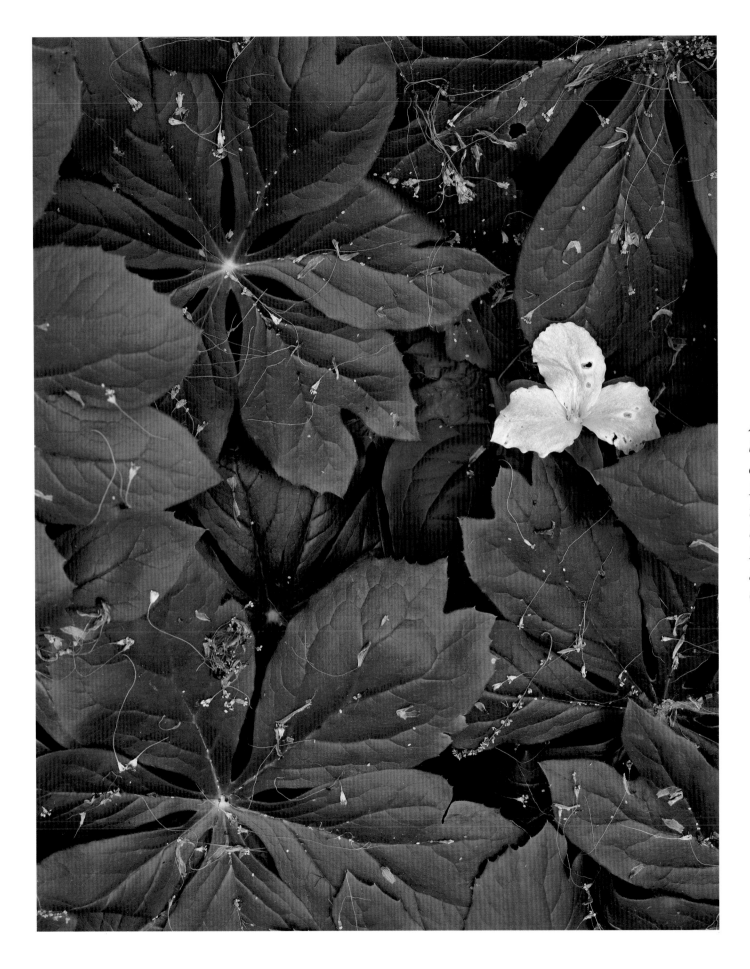

A single large-flowered trillium breaks through the leafy canopy created by a bed of mayapple. Both plants are widely distributed throughout the state with these being in The Nature Conservancy's Nan Weston Nature Preserve at Sharon Hollow in Washtenaw County. [RL]

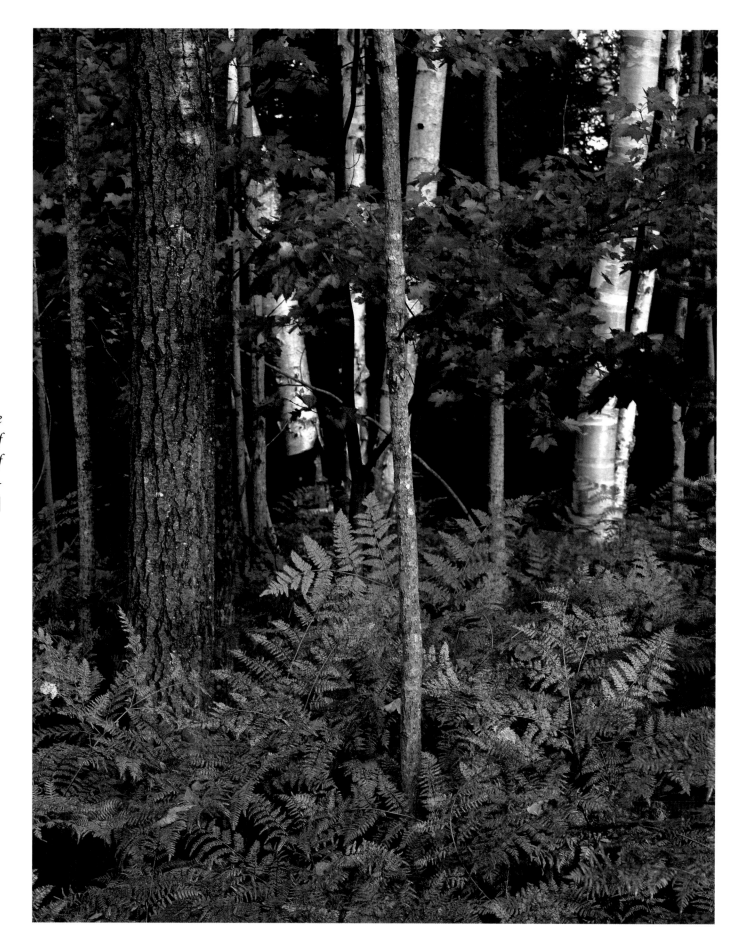

This colorful scene in the Lake Superior State Forest is typical of what can be found across much of Michigan's forests on both peninsulas during autumn. [RL]

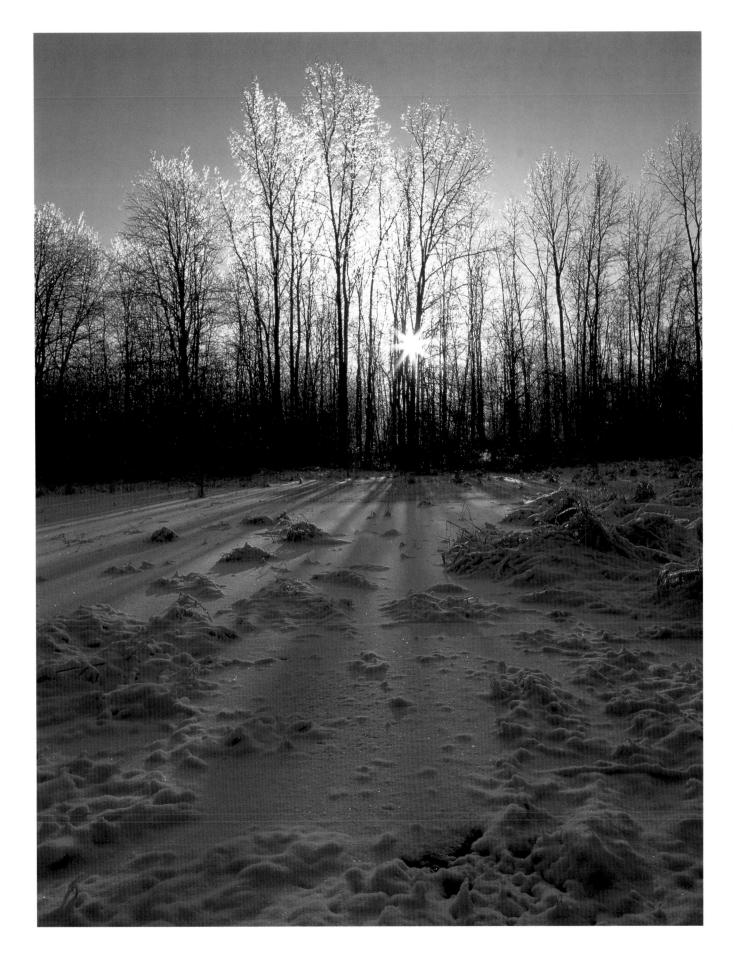

Ice-covered trees glow in early morning light in Lower Michigan's largest state park, the Waterloo State Recreation Area. [CJ]

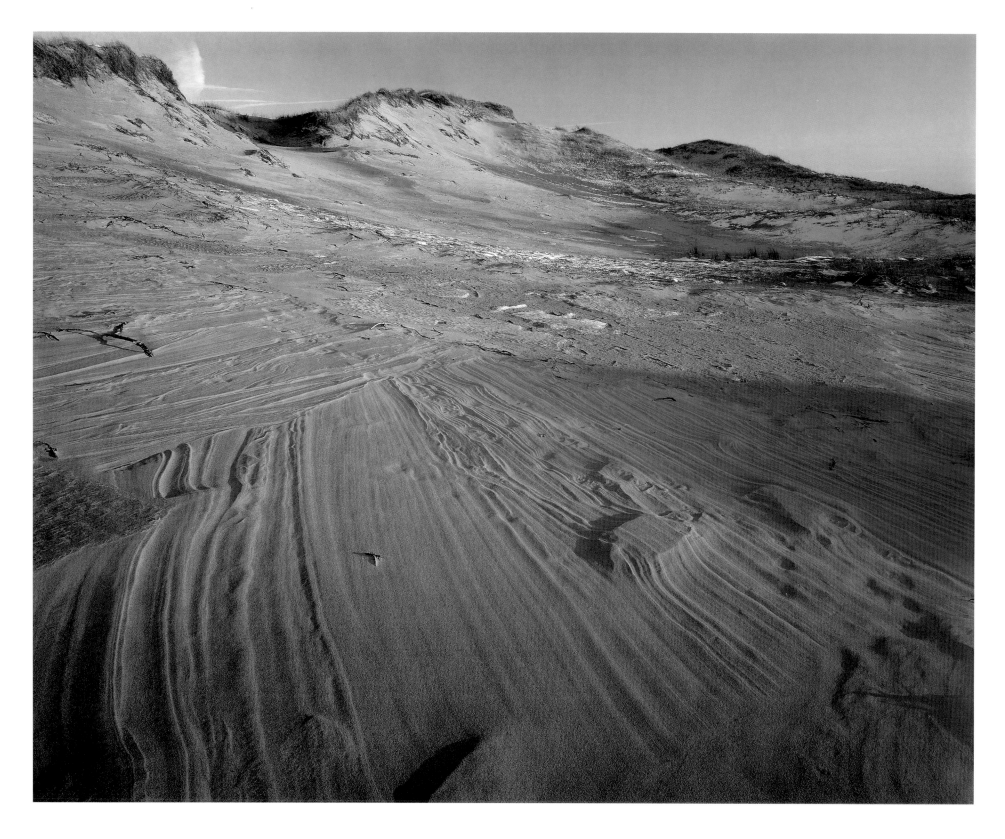

Ripples and wind-blown patterns are frozen in the Ludington Dunes on a blustery December day. [CJ]

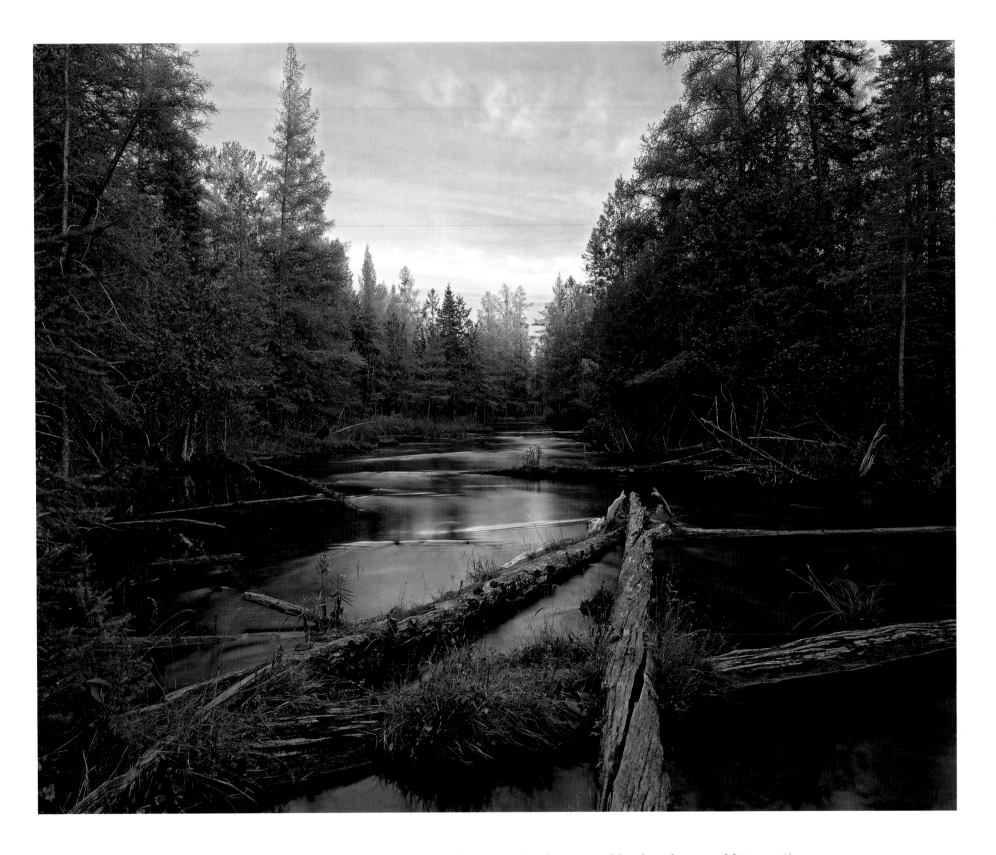

A late-day view upstream along the Jordan River (with a name like that, how could I resist?),
part of the Jordan Valley section of Mackinac State Forest [CJ]

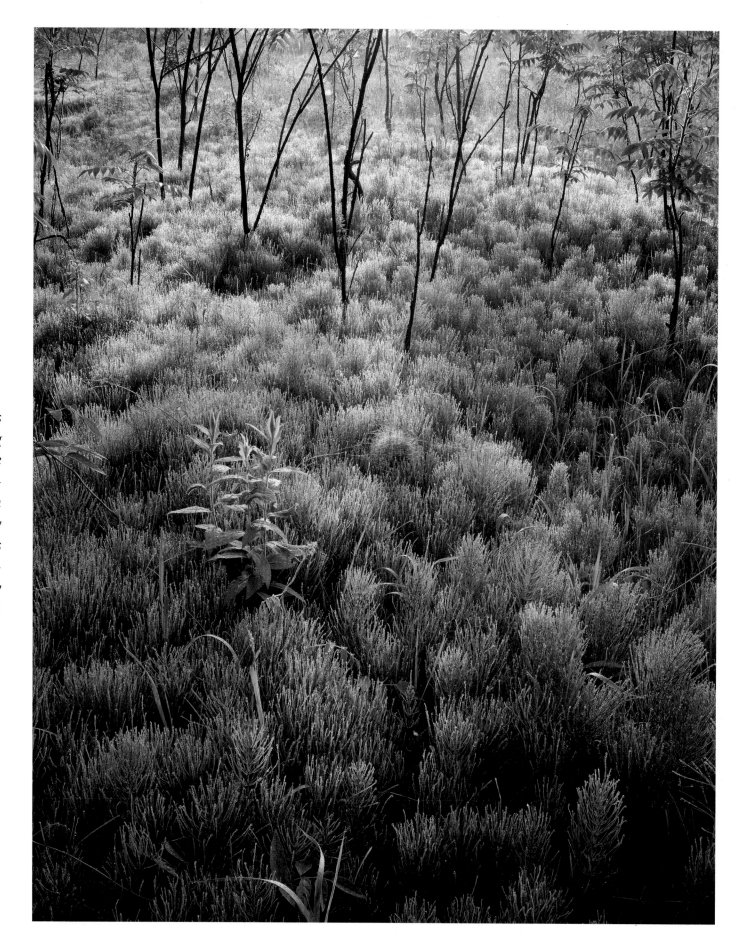

Dew-drenched horsetail creates a plush carpet beneath young sumac at the Michigan Nature Association's Lakeville Swamp Nature Sanctuary. This sanctuary in northeast Oakland County protects more than 400 species of native plants, including twin-flower, Clintonia, *and the showy lady slipper.* [RL]

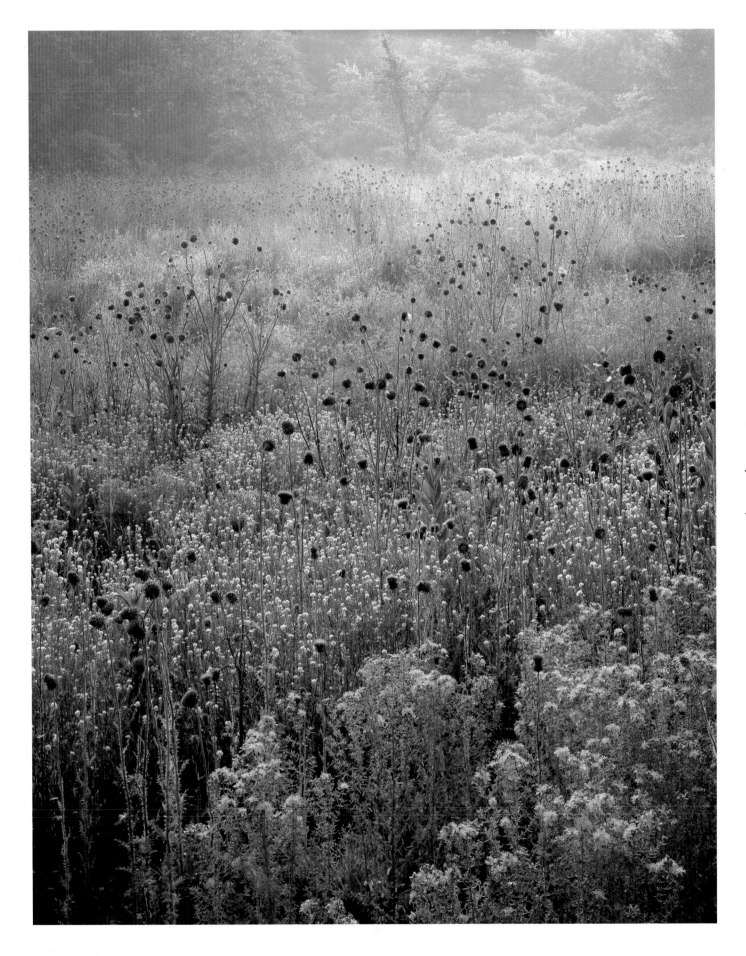

An early morning fog casts a soft shroud over a colorful field of flowers including nodding thistle and Saint-John's-wort. This area just south of Milford has been developed and is now a residential community. [RL]

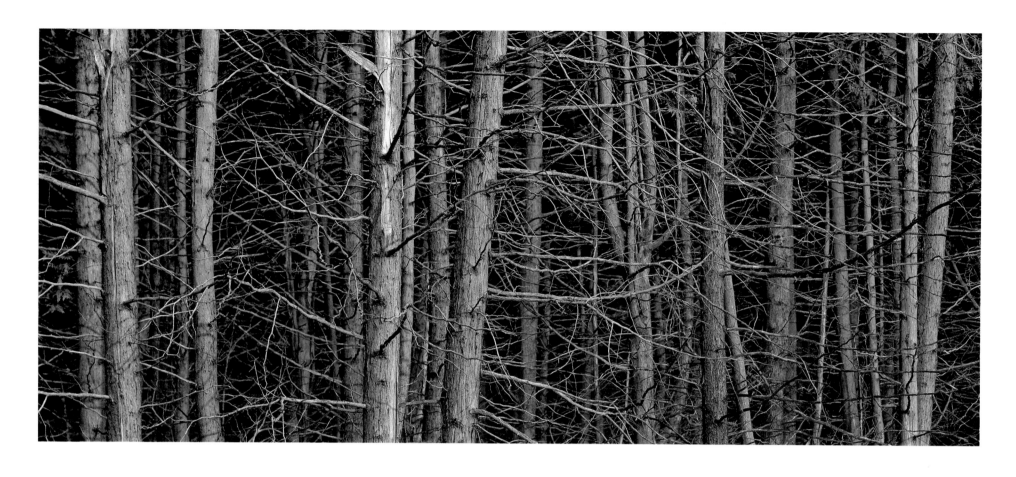

The trunks of dead cedars are painted with the warm hue of late-day light in Alpena County. [RL]

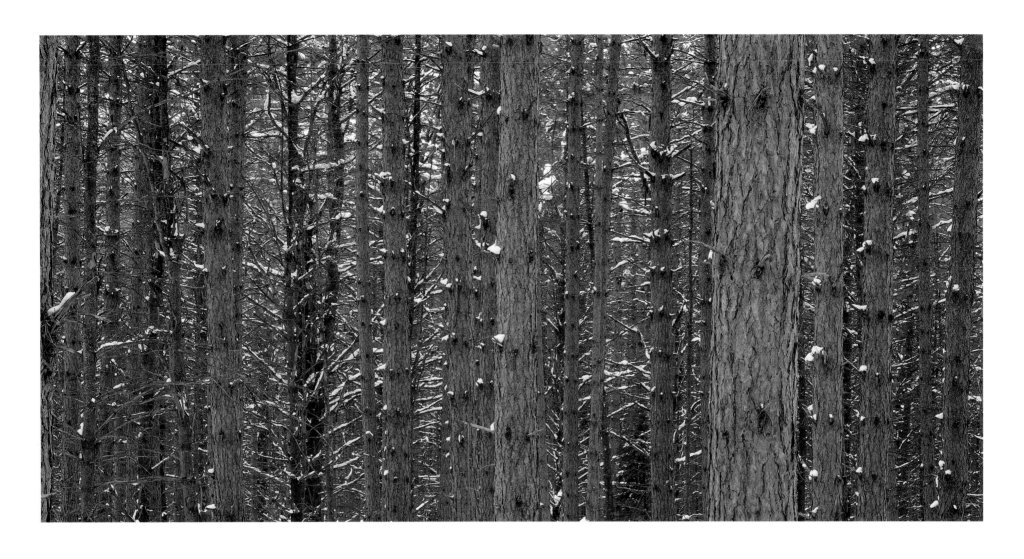

Winter arrives gently in a quiet pine grove at Hartwick Pines State Park. [CJ]

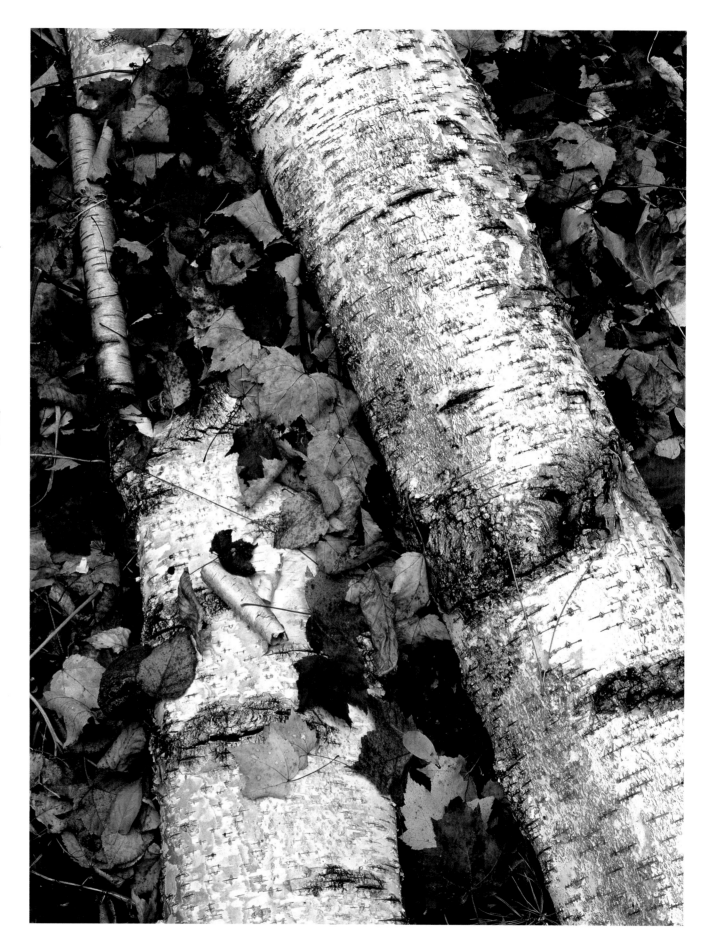

Colorful leaves decorate the ground around a fallen birch tree in the Pigeon River Country. [CJ]

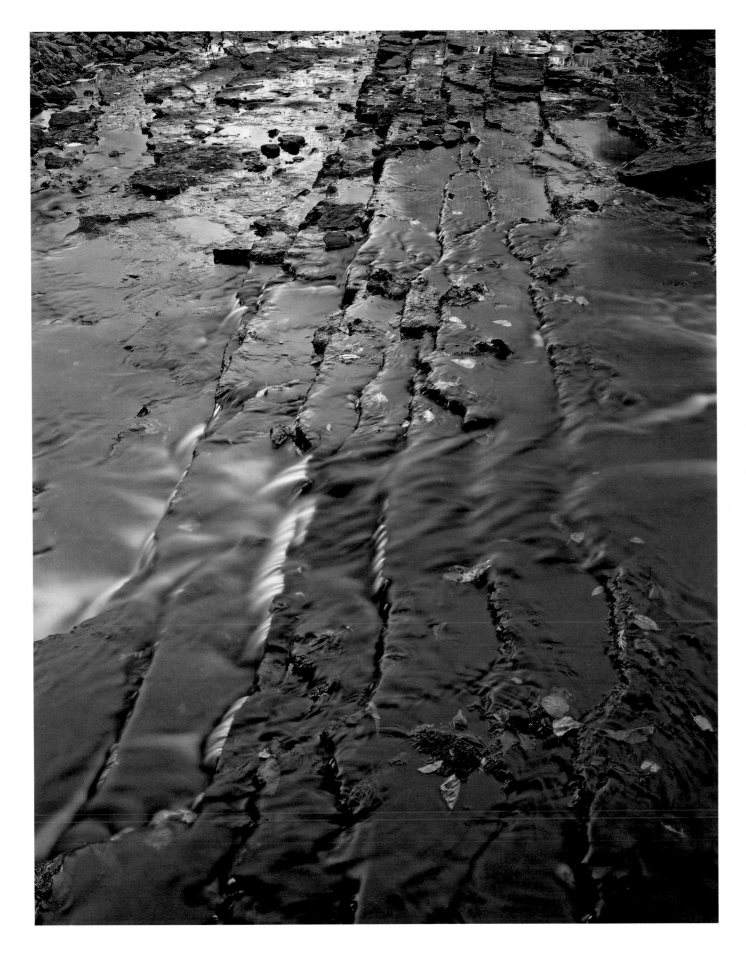

In the shadowed canyon of its upper reaches, the Au Train River is painted in autumn's morning color. [RL]

Lake Michigan ~ Clouds

Landscape photography is always an unpredictable activity. Even with the best of planning, research, and preparation, you just never quite know what you will get or the opportunities that will be presented (or not presented) when you actually put on the photo backpack, shoulder the tripod, and set off. On the occasions when I have combined landscape photography with family camping trips, it seems that the complexity and level of unpredictability is so high that there is only one attitude and approach possible—"We'll see what happens!"

In the spring of 2007, our family decided to visit the Holland, Michigan, area and investigate a couple of photography locations while also visiting the Tulip Festival. When we got there, we found that the state park campground was not quite as isolated as we had hoped. In fact, our site was right next to a county road as well as a fairly busy restaurant. To complicate life further, we had gotten a late start and so were forced to set up a brand-new tent for the first time in the dark. This was eventually completed, and we somehow managed to get our two very excited children (ages 3 and 1) to go to sleep. (And for those of you who just raised your eyebrows, yes we went camping with our kids that young. It was, in fact, Solomon's first-ever camping trip. Iris was already a veteran!)

My favorite, and most productive time to photograph, is first thing in the morning, around sunrise. When my alarm went off the next morning, I turned it off and rolled over. I was too tired from the night before to get up and look for photographs, and it did not appear that the area around the campground would be that interesting anyway. Fortunately, two things occurred fairly quickly. One, the kids awakened early and fired up to explore, and two, my wife, Carrie-Ann, suggested that we take an early beach walk before doing anything else. When we got down to the beach we were confronted with one of the calmest, prettiest mornings I can recall in all my visits to Lake Michigan. The combination of bright morning light, low-lying fog over the lake, and almost complete lack of wind prompted me to hurry back to the van and grab my camera. The resulting image conveys, I hope, the sense of calm, quiet, and mystery that I experienced that day.

CJ

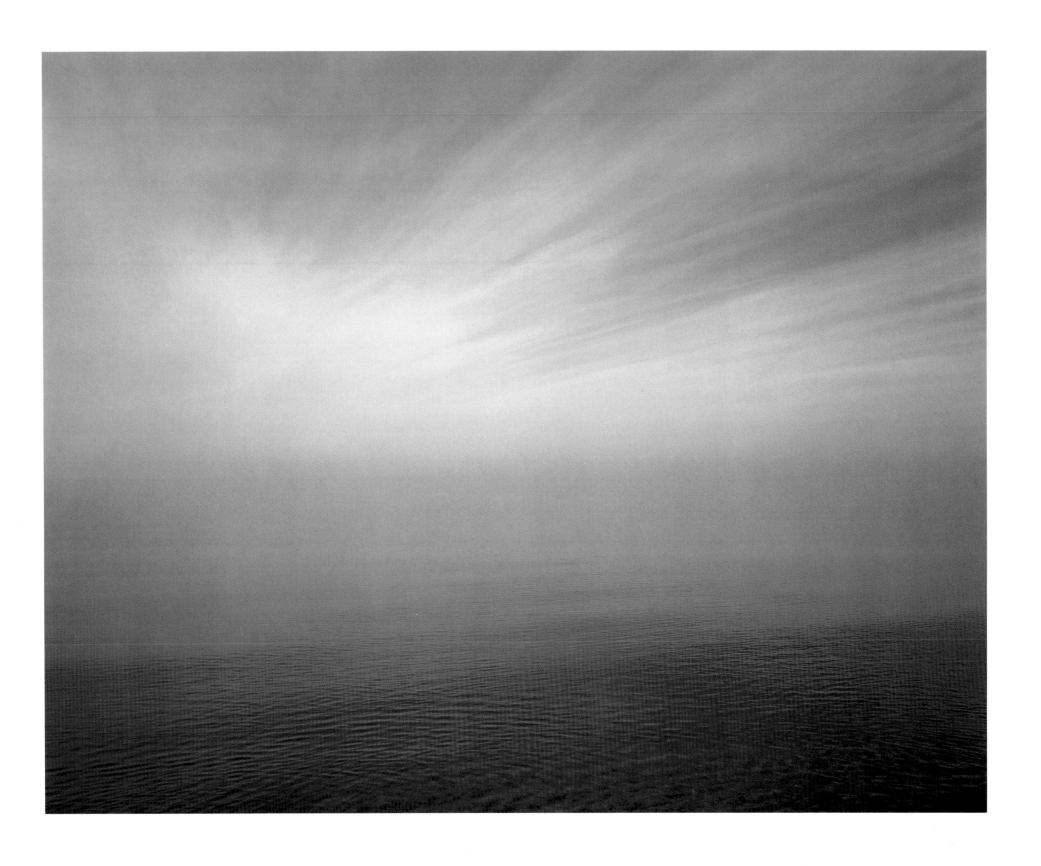

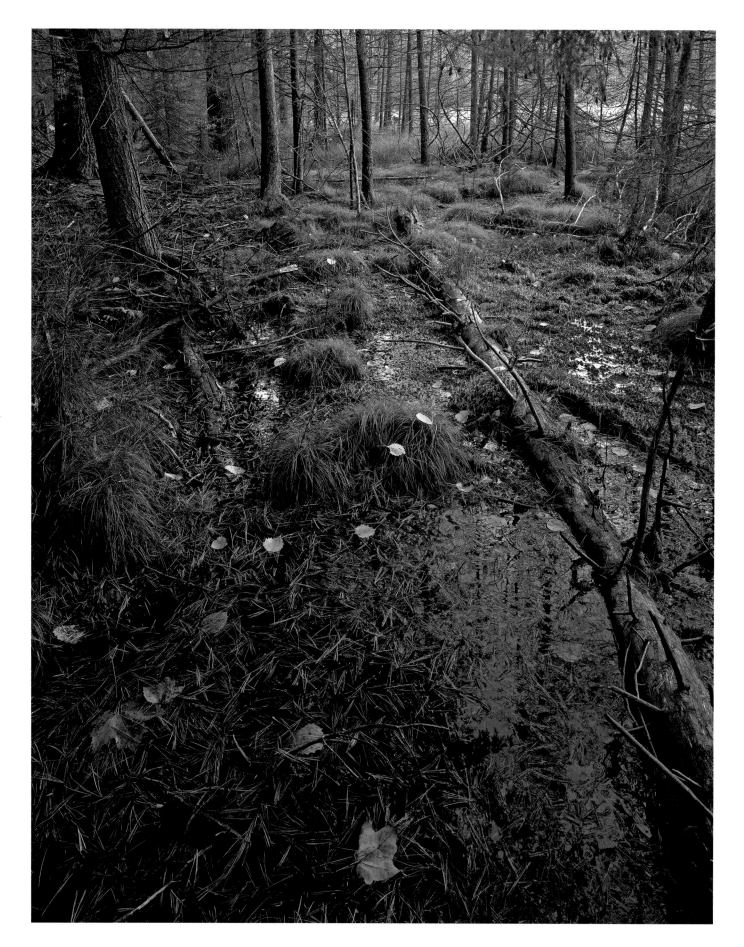

A small swamp reflects a brilliant blue sky near the Weber Lake campground, Mackinac State Forest. [CJ]

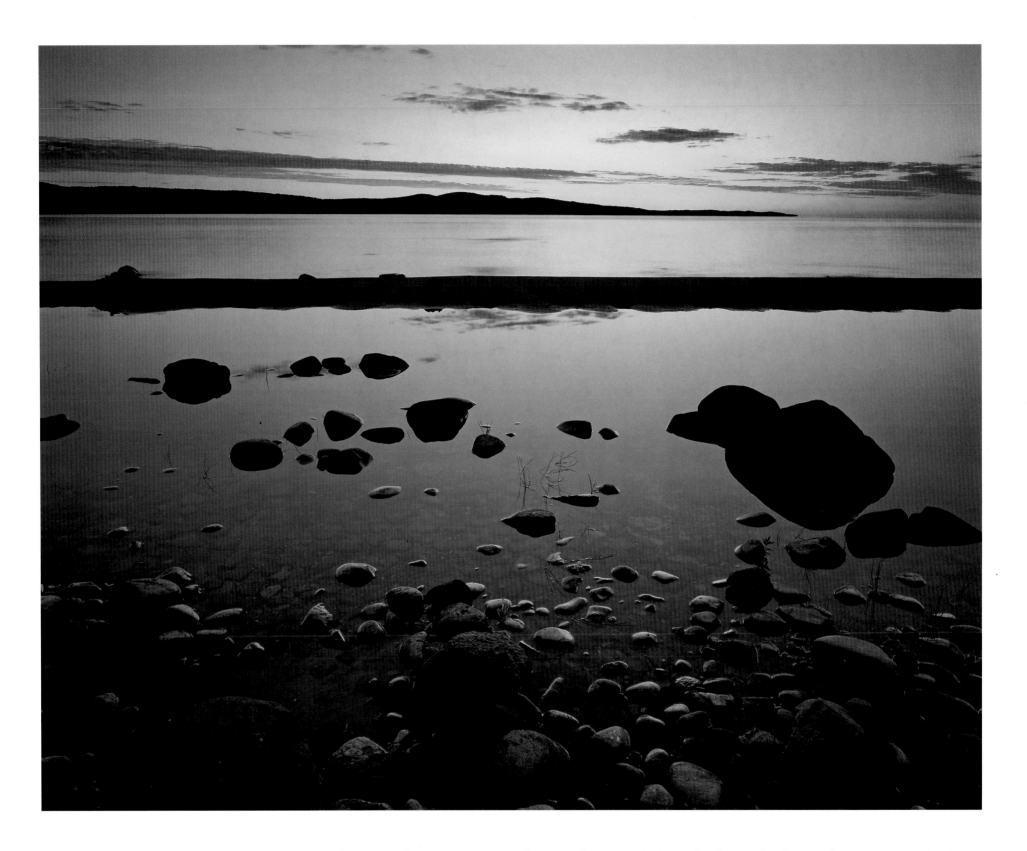

A colorful dawn reflects upon the tranquil waters of Bete Grise Bay indicating the arrival of another beautiful day in the Keweenaw. [RL]

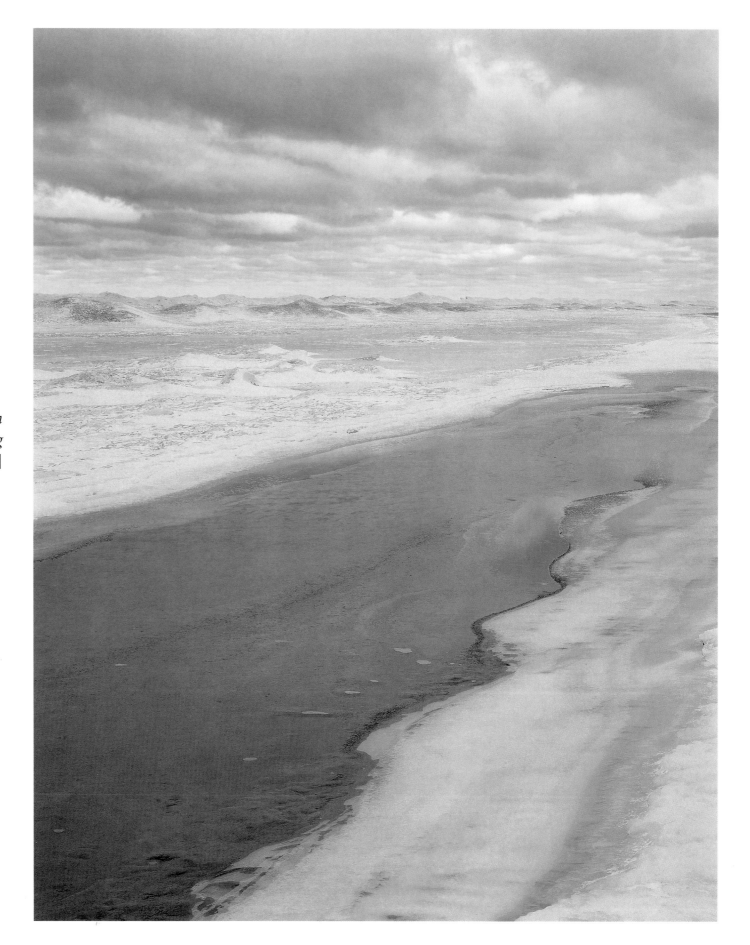

Shelf ice along the Lake Michigan shoreline forms interesting lines and shapes. [CJ]

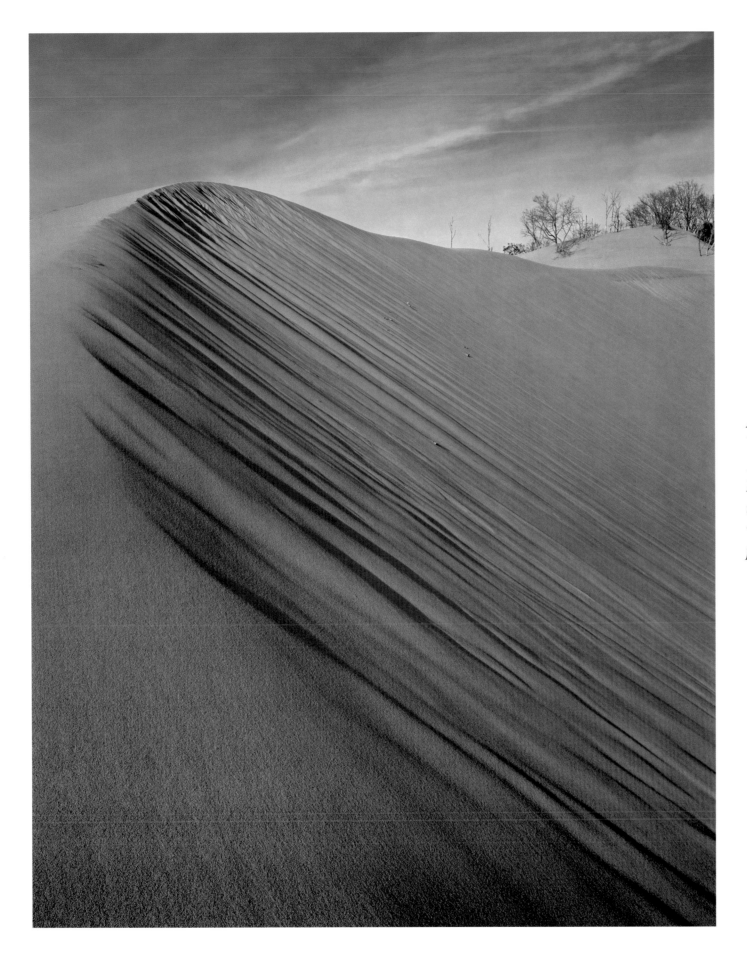

A dune side view of Tower Hill in Warren Dunes State Park. This 1,952-acre state park located on Lake Michigan in Berrien County is named after a local businessman who purchased the area in order to preserve it. [RL]

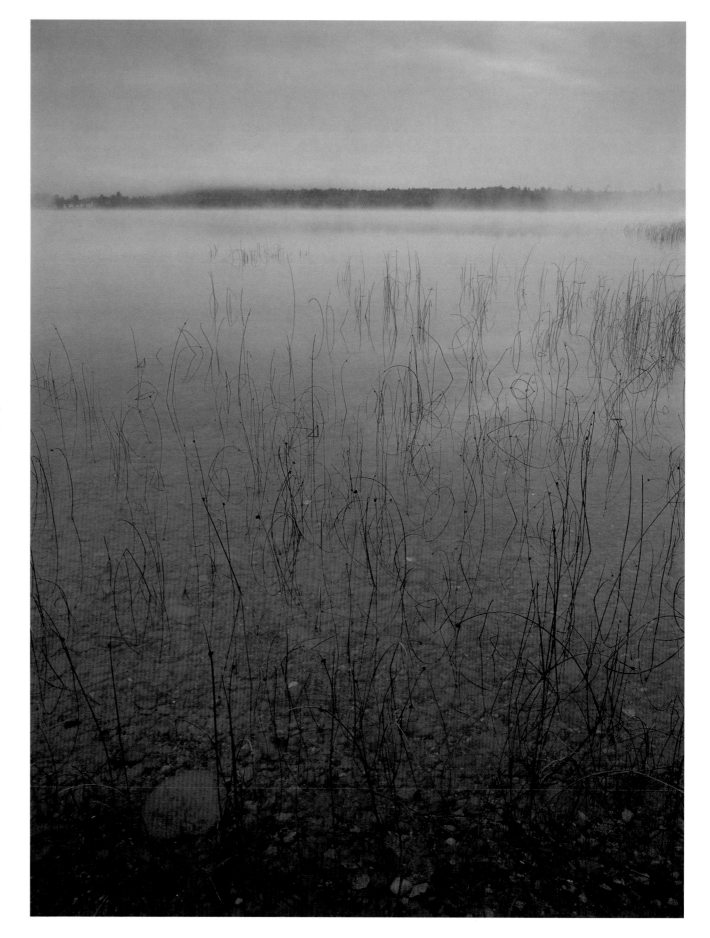

A misty morning view, looking toward the Round Lake Nature Preserve near Petoskey [CJ]

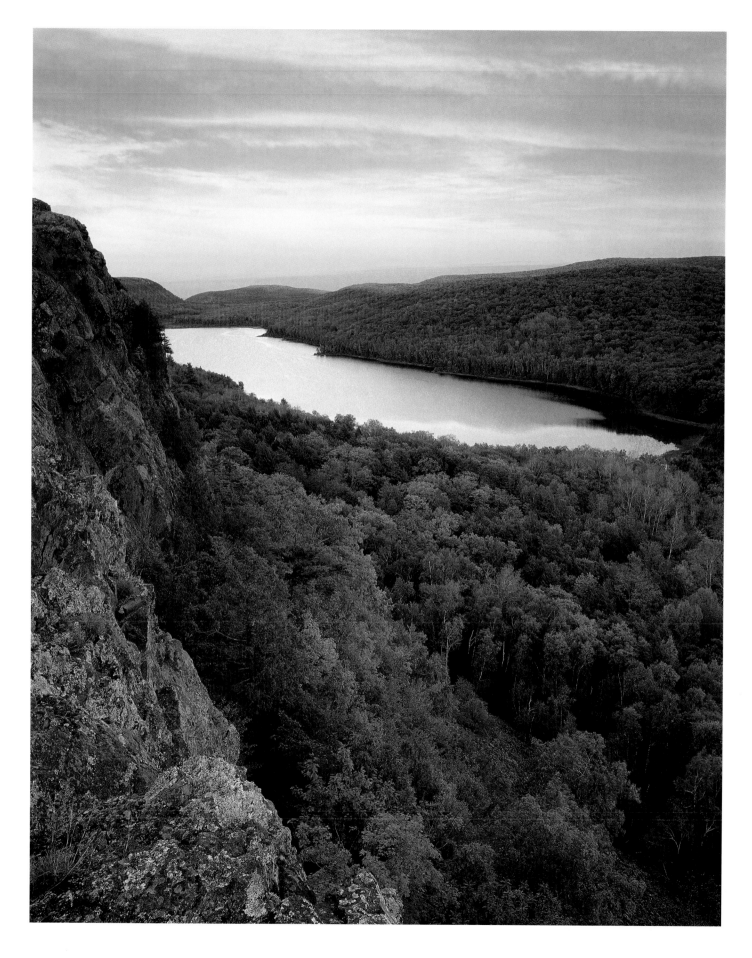

Last light touches the ridges above Lake of the Clouds, Porcupine Mountains Wilderness State Park. [CJ]

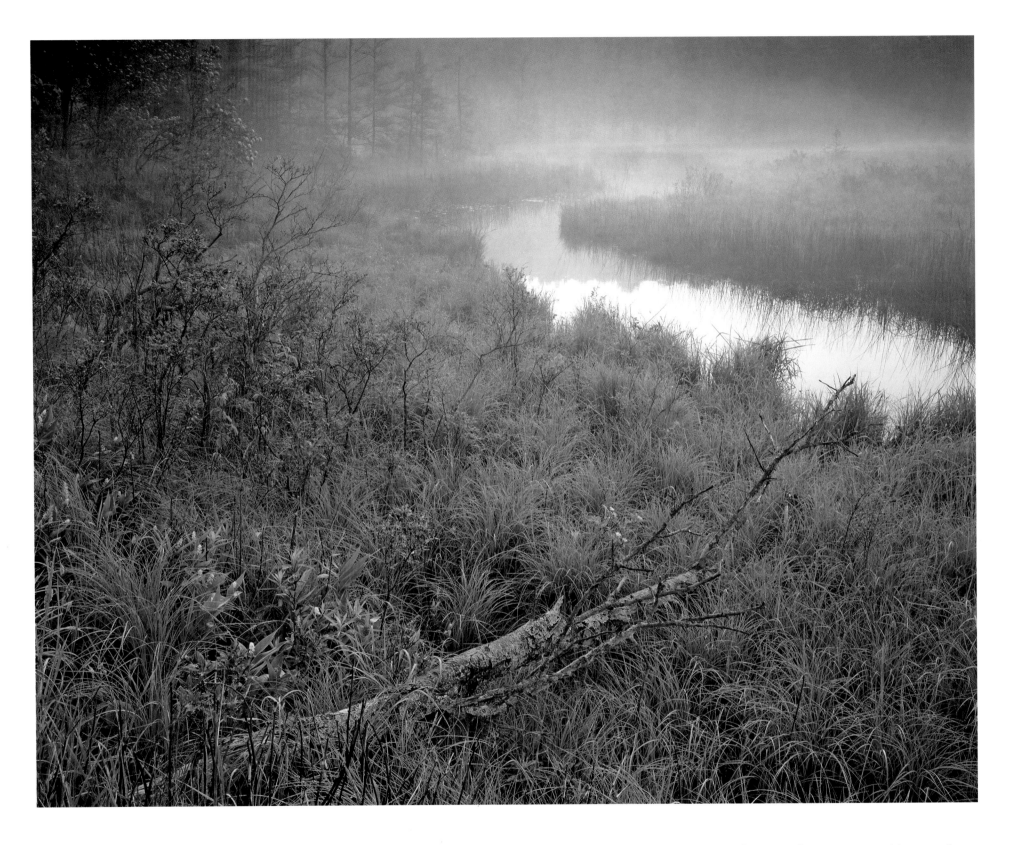

On a misty May morning the Shiawassee River quietly meanders through the Michigan Nature Association's Burr Plant Preserve. Tamarack, pitcher plant, and the diminutive white lady slipper thrive here. [RL]

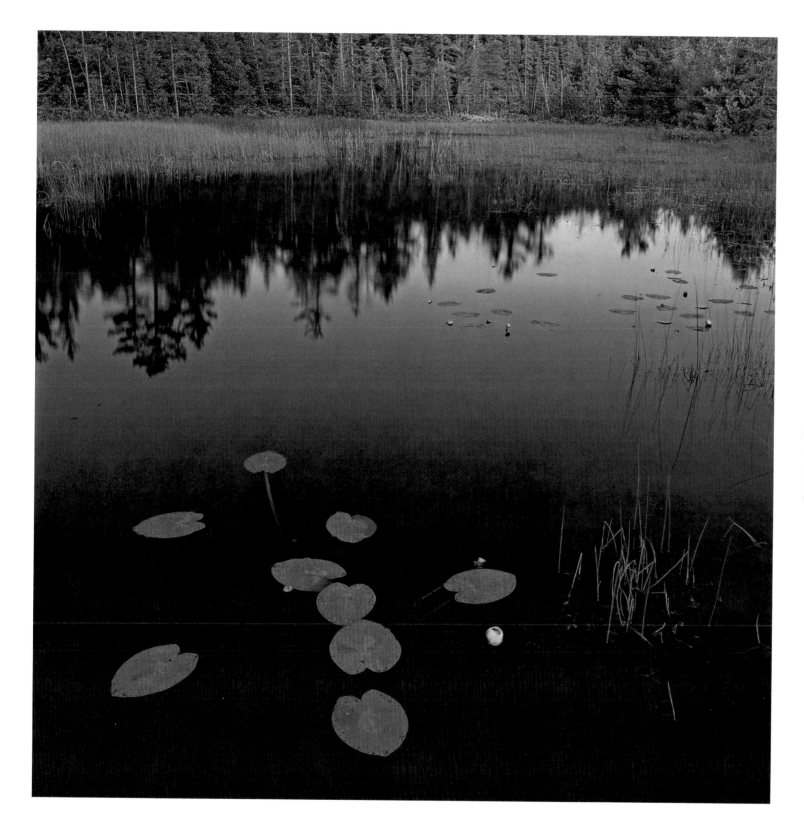

A single spatterdock decorates an interdunal wetland pool near the Lake Huron shore. [CJ]

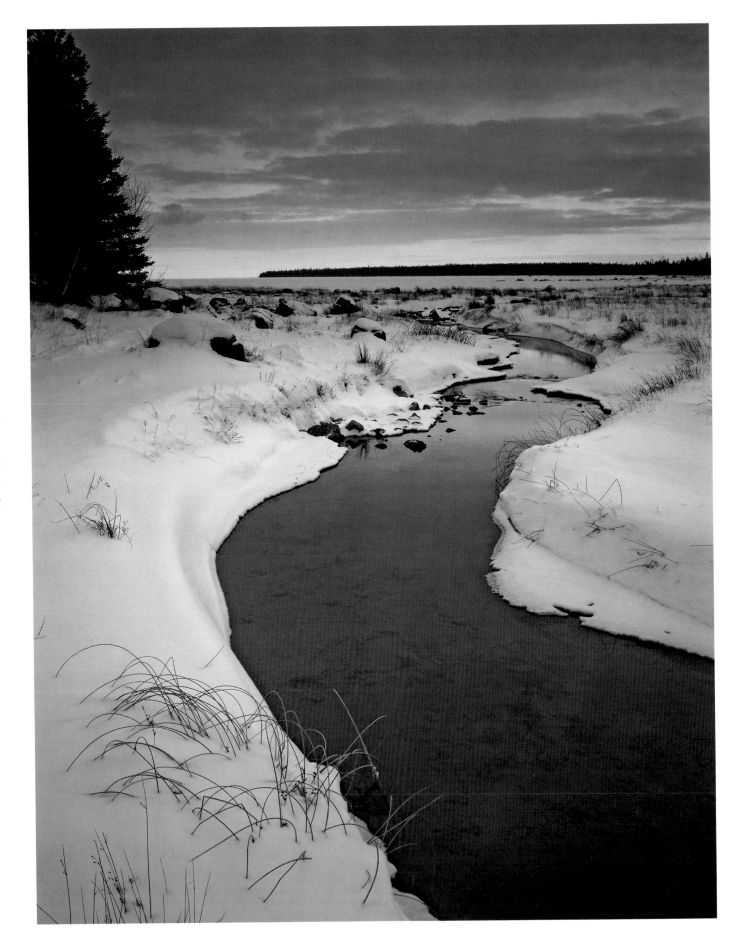

A winter's repose at The Nature Conservancy's Bush Bay Overlook. The Nature Conservancy protects more than 8 miles of Lake Huron shoreline between Cedarville and De Tour Village. [RL]

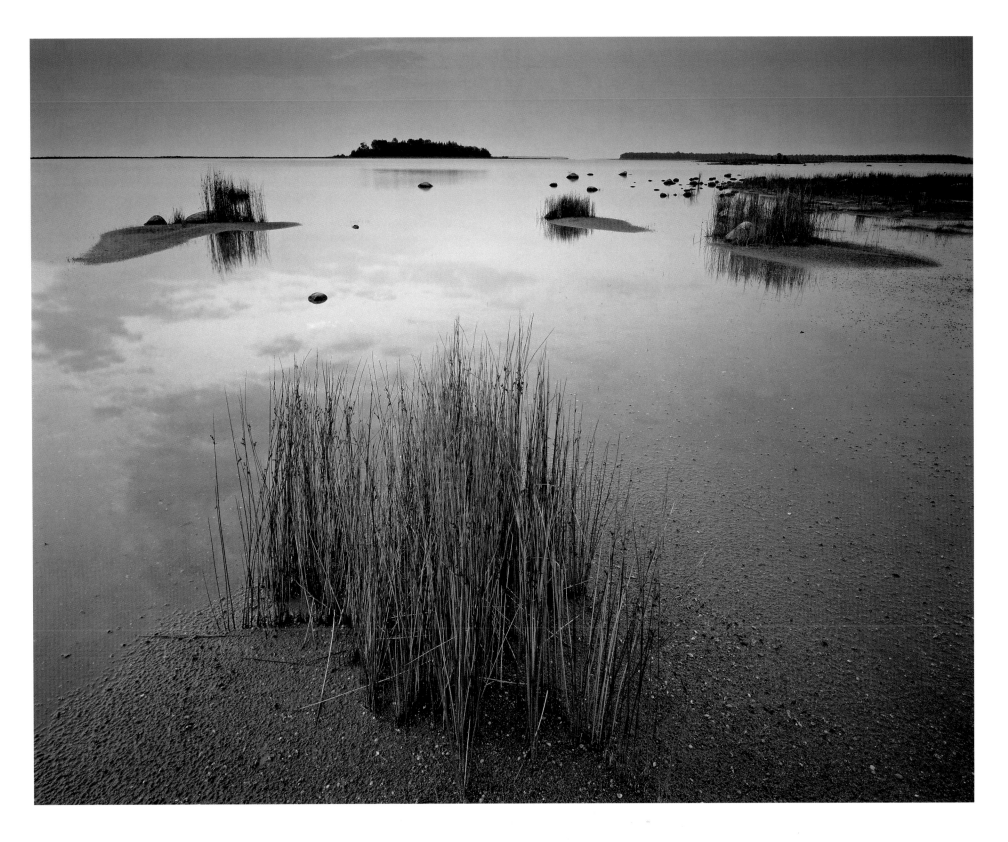

The reflection of a dramatic sky upon the shallows at Misery Bay forewarn of a morning thunderstorm. This Nature Conservancy preserve is located north of Alpena on Lake Huron. [RL]

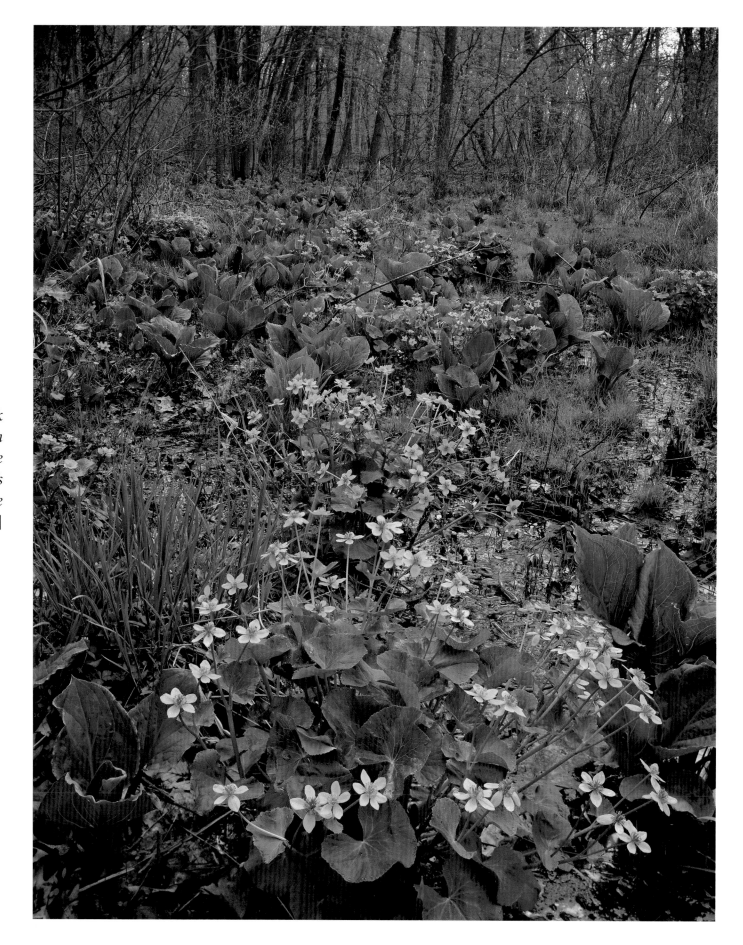

Marsh marigold and skunk cabbage share the nutrient-rich hardwood bottoms in the Michigan Nature Association's Dowagiac Woods Nature Sanctuary. [RL]

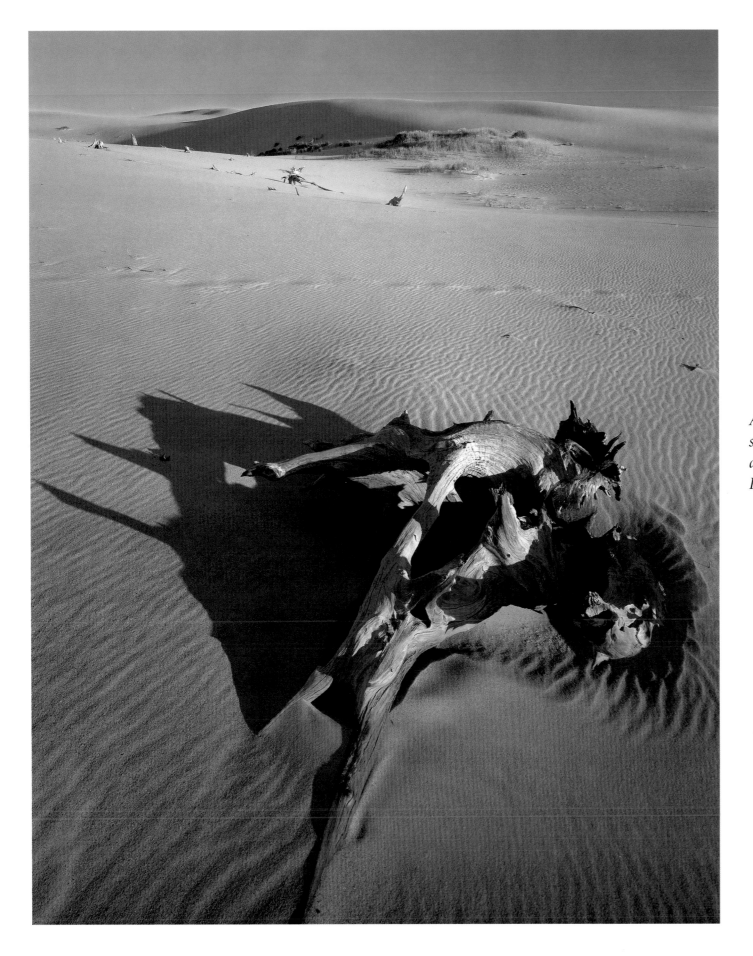

A sand- and wind-blasted stump sits alone amid the sand ripples and dunes of Silver Lake State Park. [CJ]

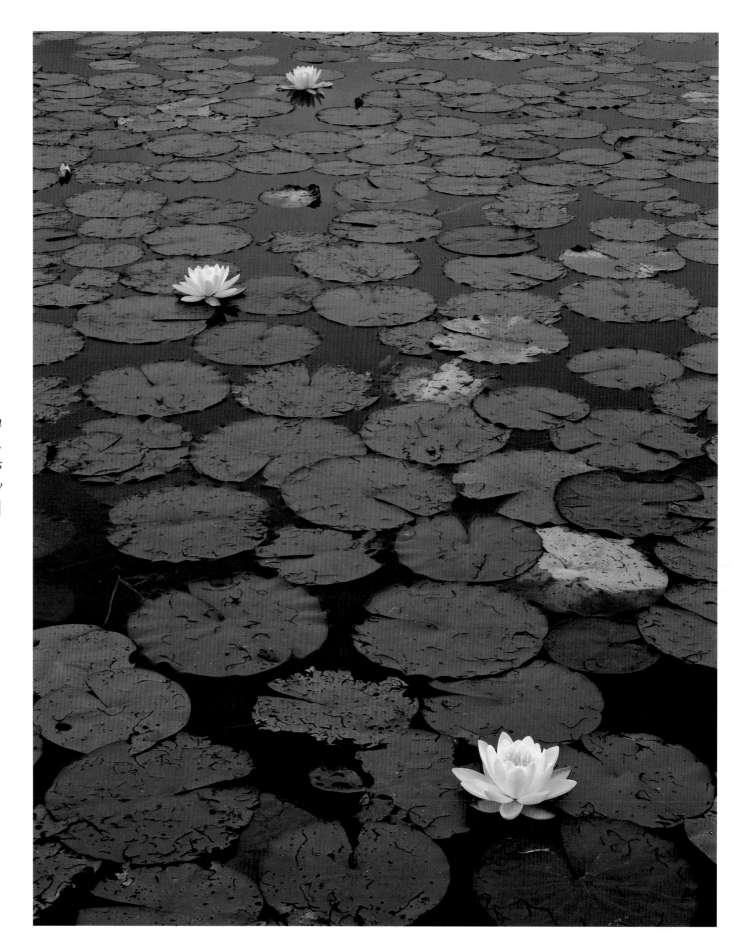

A bed of fragrant water lily on Little Wolf Lake near Lewiston. The showy flower only blooms from early morning until early afternoon. [RL]

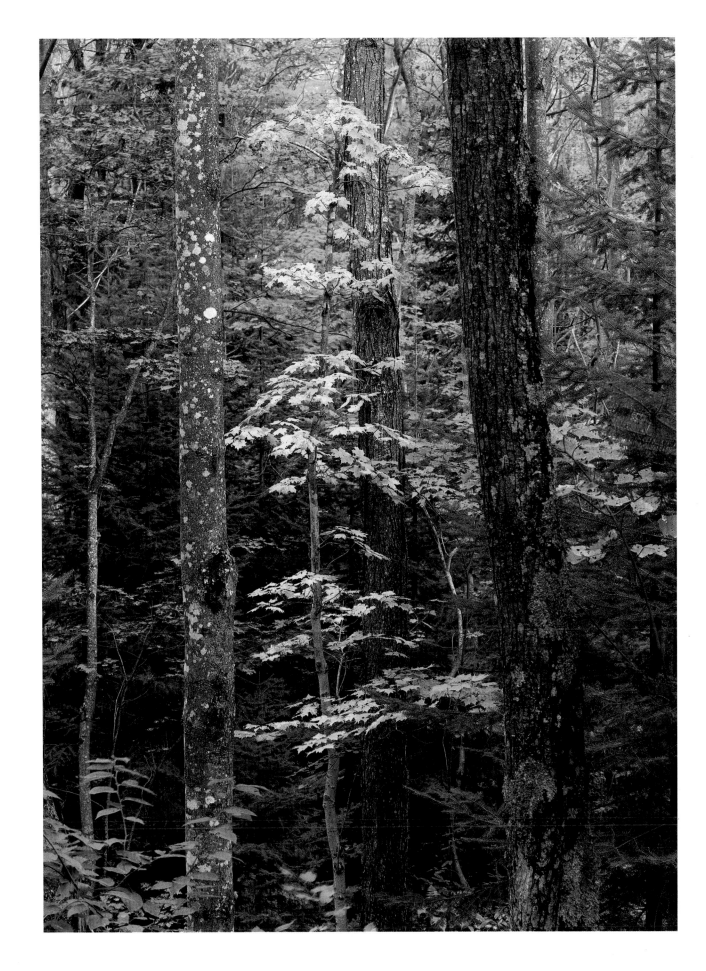

A young maple tree in fall color sits quietly in the center of a forest area near Chapel Falls. [CJ]

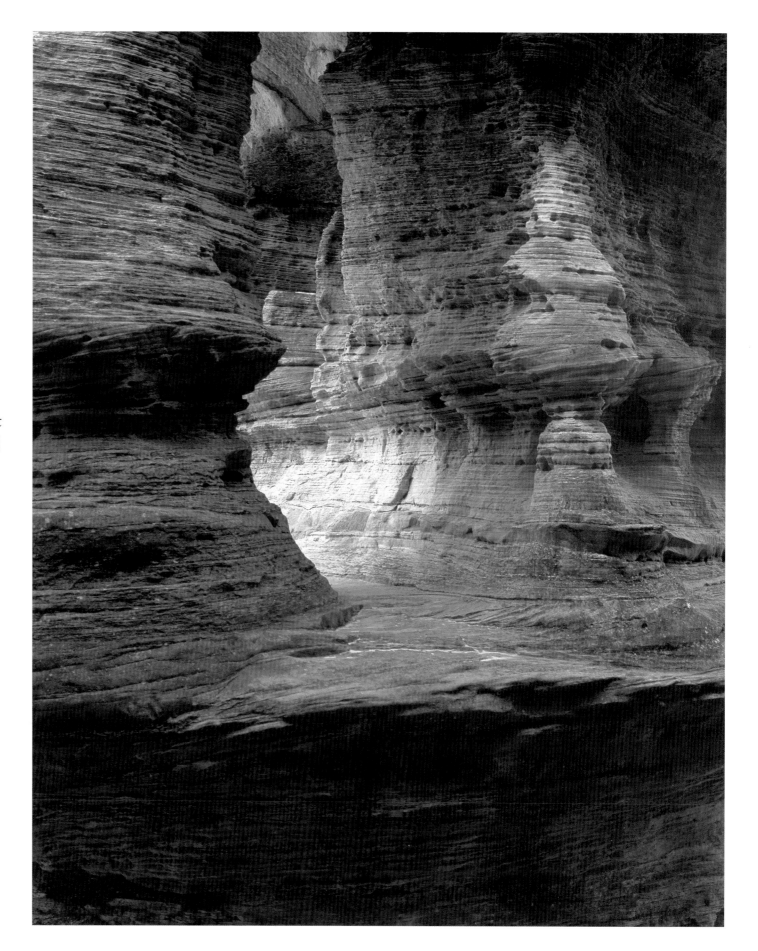

An intimate view of Chapel Rock
[CJ]

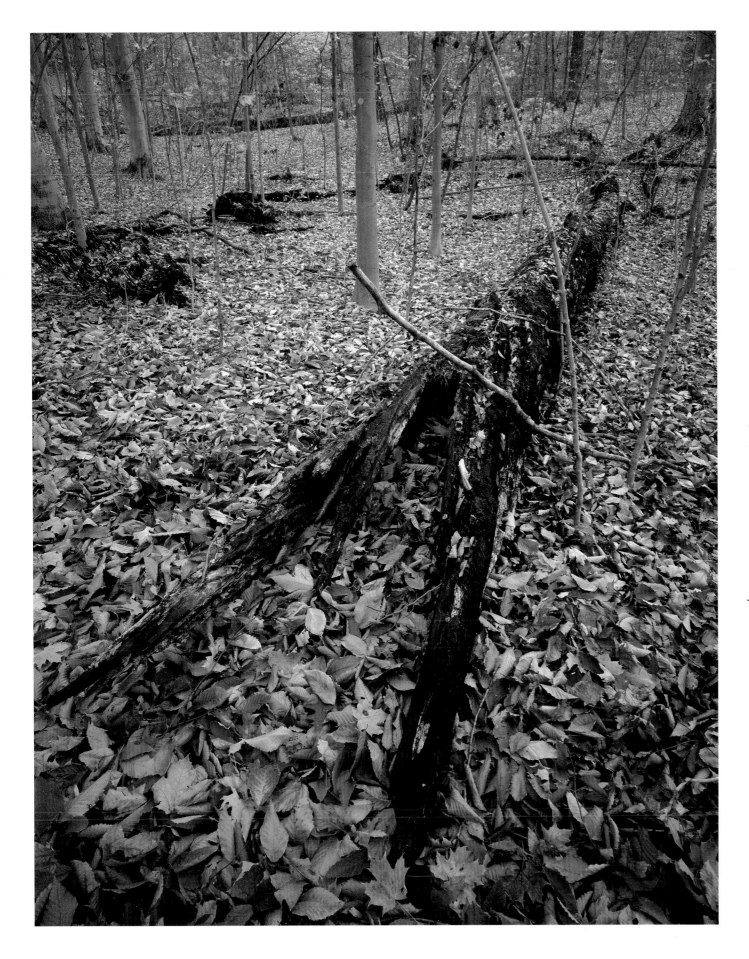

A giant beech finds its final resting spot on the forest floor in Warren Woods Nature Study Area. The 312-acre preserve north of Three Oaks is a climax community of beech-maple forest known to contain trees that are up to 5 feet in diameter and more than 120 feet tall. [RL]

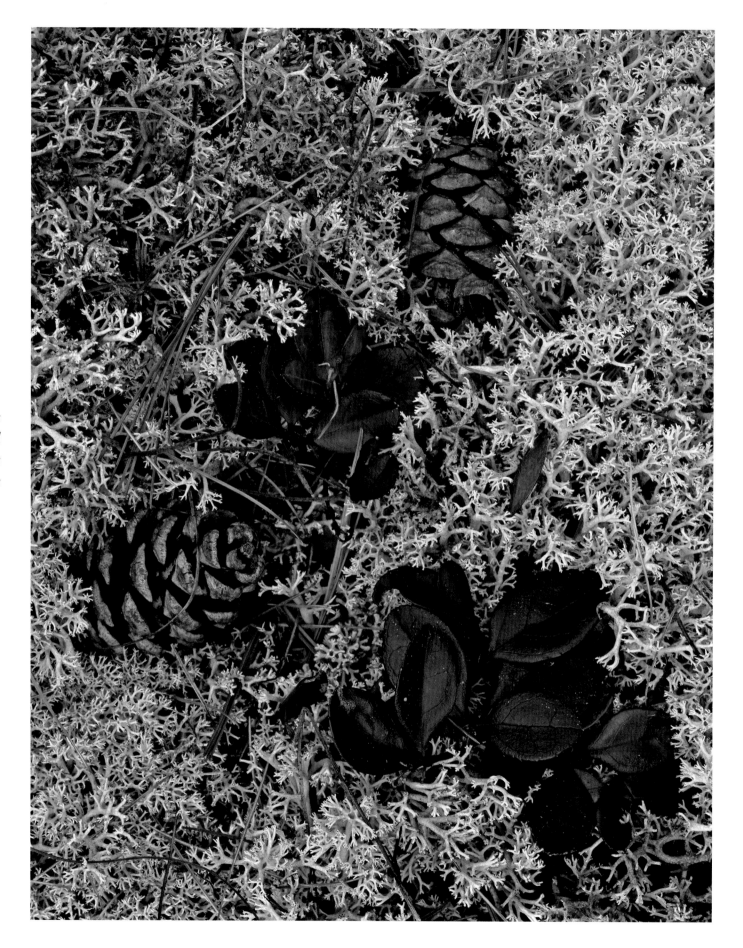

Multi-colored caribou moss makes a soft bed for autumn-colored blueberry and fallen pine cones along the Lake Superior shoreline near Munising. [RL]

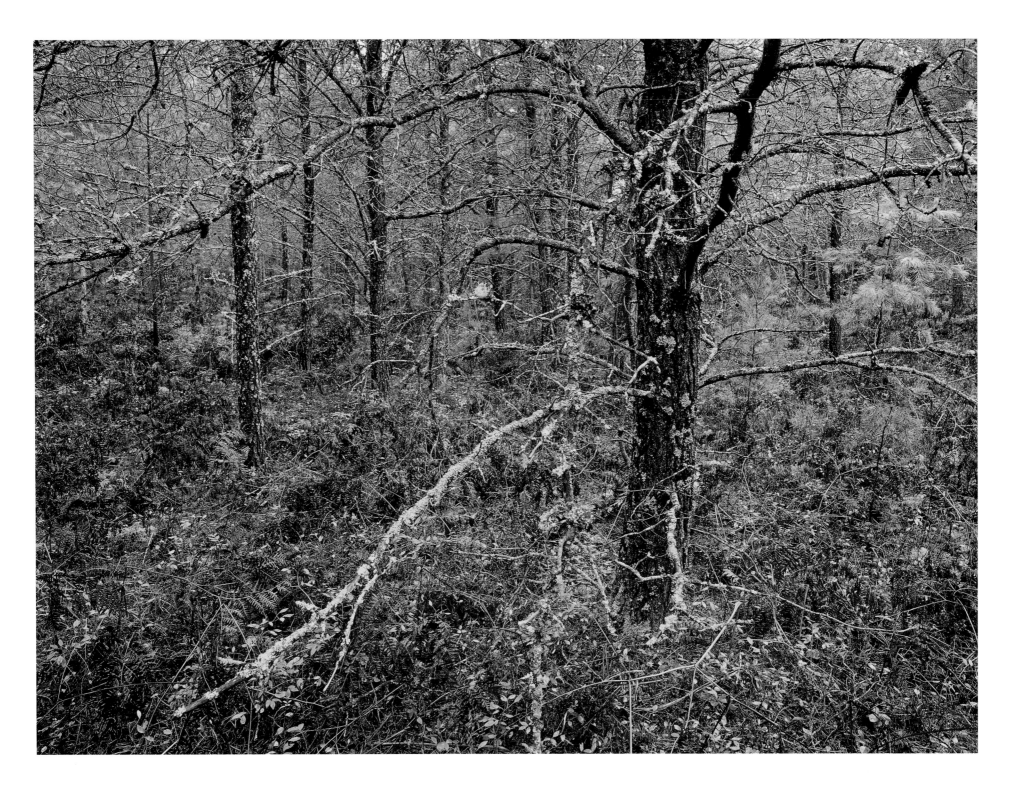

Moss-covered branches reach toward the surrounding ferns on a quiet autumn morning deep in the Pigeon River Country State Forest. [CJ]

Nothing Remains Unchanged (Except Good Memories)

Most of the images in this book have an interesting story or two behind the making of them. The story prompted by this image of Little Presque Isle Beach is one of reminiscence and the premise that change is the only constant through time. Growing up, I always enjoyed the outdoors but it was during the five years I lived in Marquette as a college student that I truly discovered my passion for nature and photography.

Moving north to Minneapolis halfway through this book project afforded me multiple opportunities to revisit my old stomping grounds. My memories of wild and pristine places, especially in the Marquette area, made me eager to get back to them. I was glad to find that many spots were much like I remembered. I was also surprised and disappointed at the amount of development that has occurred there in recent years.

The area from Marquette to Big Bay has changed much since "my time." Road signs for places like Wetmore's Landing and Little Presque Isle make it easy for visitors to locate them. With formal trails, parking lots, and even toilet facilities, visiting these once wild and relatively unknown places almost seems too civilized. County Road 550 or Big Bay Road has been straightened in one stretch and is sprinkled with homes along the entire route. Places like Pinnacle Falls and the Yellow Dog Plains were very remote and difficult to get to. Now this same area that contains the Yellow Dog watershed and the Salmon-Trout River, known for its wild beauty and premiere trout fishing, is threatened, as it is being pursued by mining interests.

After taking this image I hiked the trail north to where Harlow Creek enters Lake Superior. Standing alone at the mouth of the creek I stared out at the lake. A smile materialized as I remembered another time I was here more than thirty years ago. Scot Stewart and I bushwhacked our way through tag alders to the lake from the road with fishing rods in hand. When we got there we started throwing silver and blue Cleo spoons as far out as we could. Suddenly we both had fish on. Scot lost his and I landed a nice-sized salmon. I still have the negative from the photograph he took of the fish and me with long hair looking like some backwoods fishing guide.

I took a deep breath followed by a long sigh; it felt good being in this place once again. When it was time to leave there was no need to bushwhack my way out; I just followed the well-worn trail to the parking lot.

RL

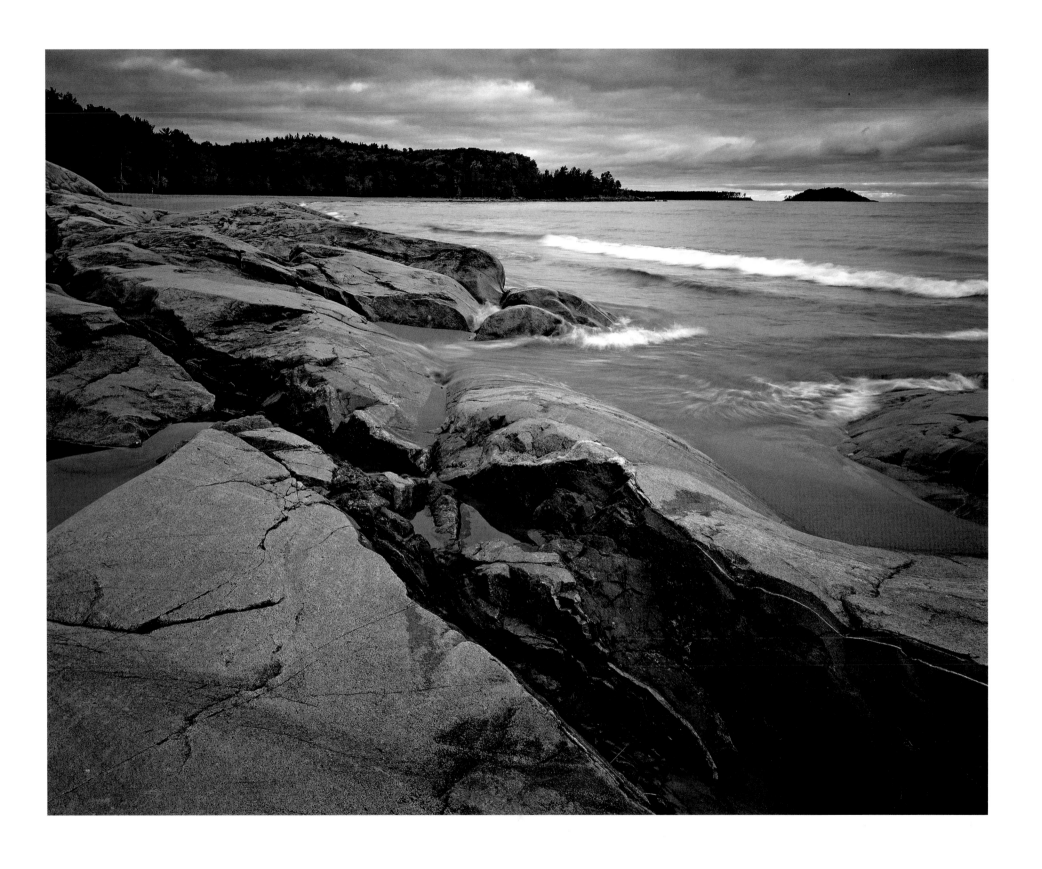

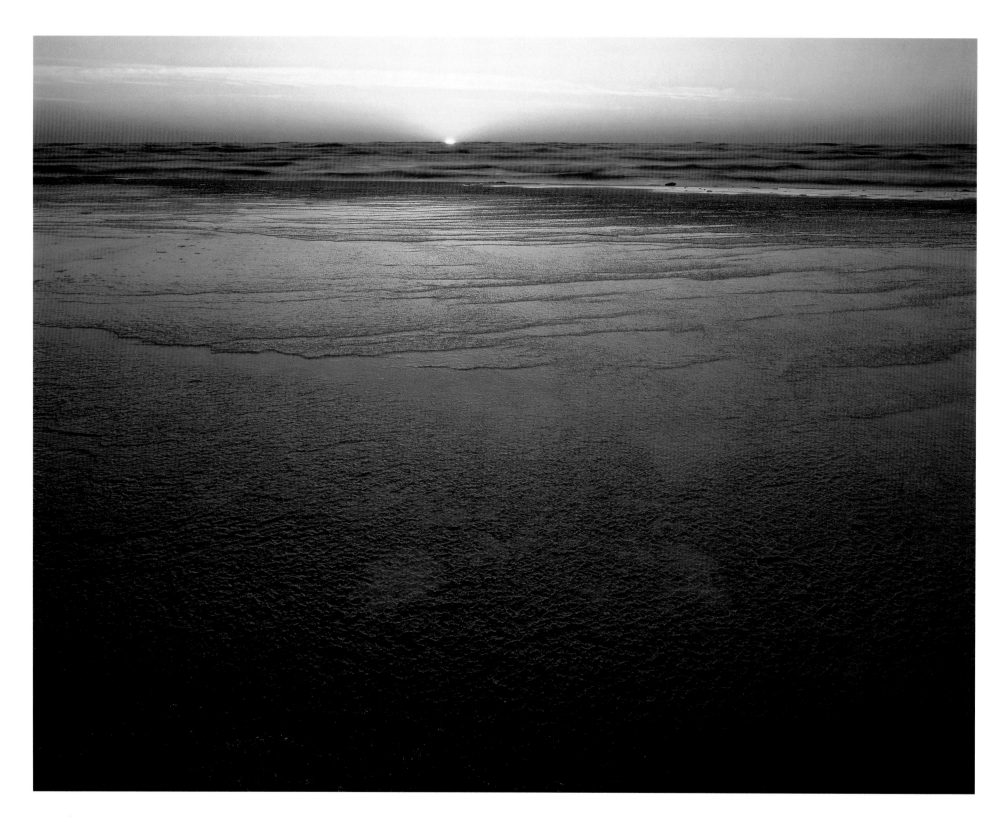

The icy Lake Michigan shoreline at sunset, near the Big Sable Point lighthouse [CJ]

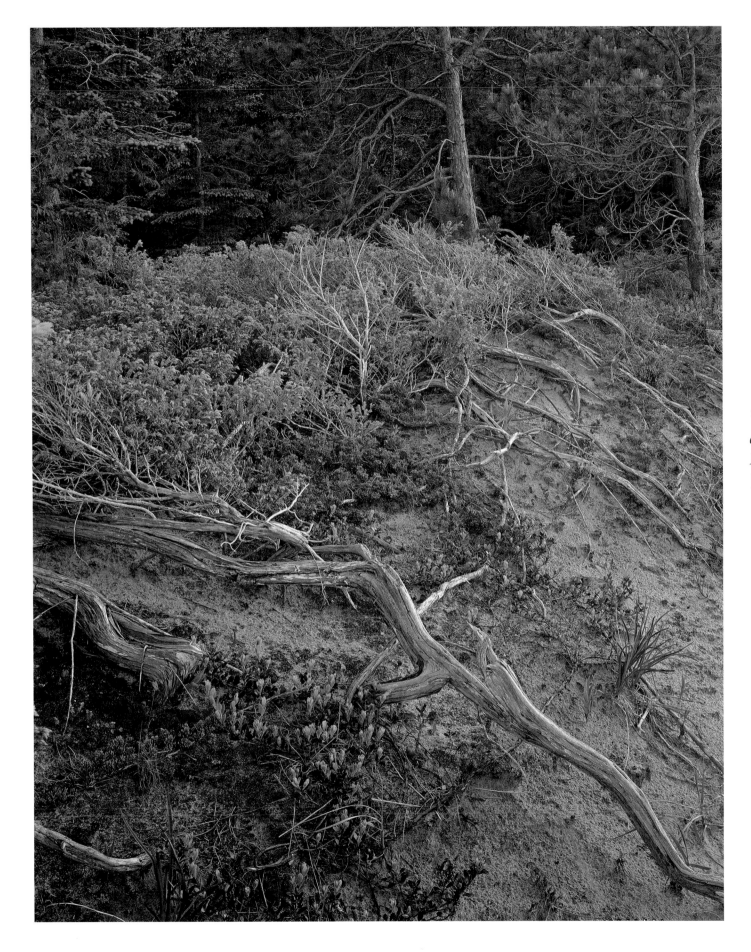

Wind-scoured shrubs grow along a low dune ridge next to Lake Huron, in P. H. Hoeft State Park. [CJ]

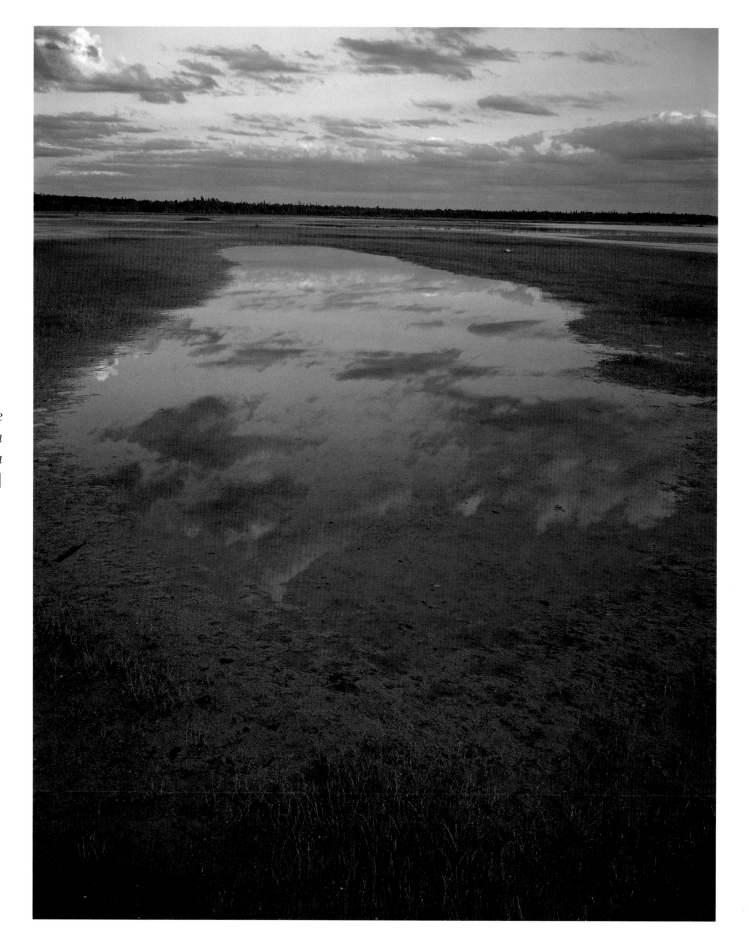

Earth and sky become one as the shallow pools of Isaacson Bay reflect the late afternoon sky above them. [RL]

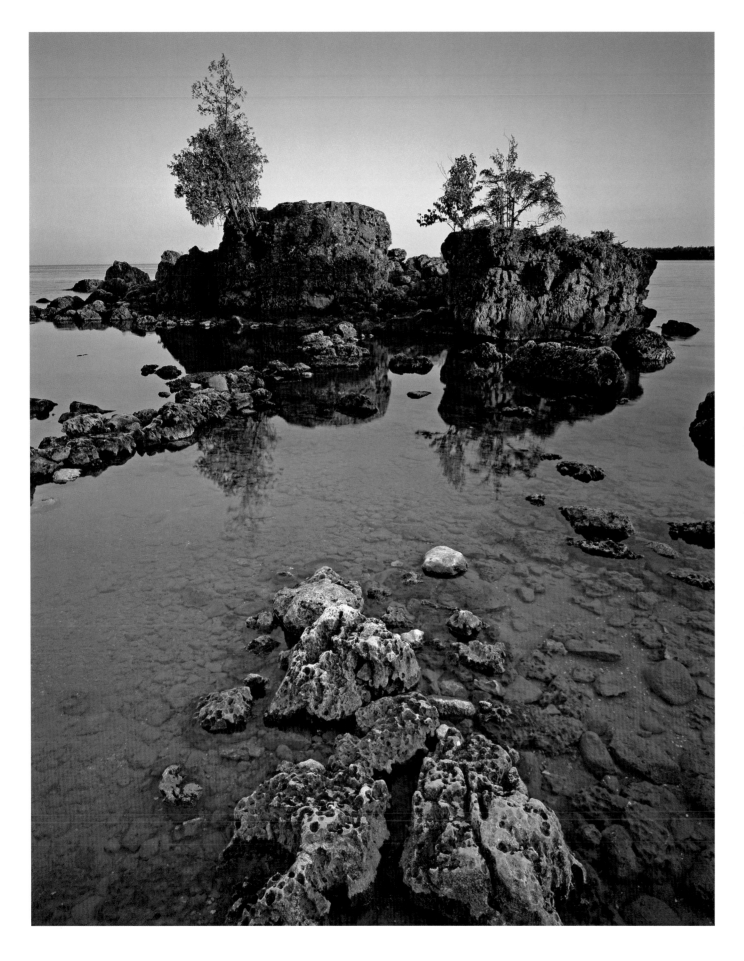

Large limestone outcroppings adorned with vivid orange lichens and stunted cedars are bathed in late afternoon light. This stretch of Lake Huron shoreline in the UP is protected by The Nature Conservancy. [RL]

A member of the Lily family, the large-flowered trillium grows profusely in much of Cass County's Dowagiac Woods Nature Sanctuary. Other prolific bloomers include Dutchman's-breeches, blue-eyed Mary, and marsh marigold. [RL]

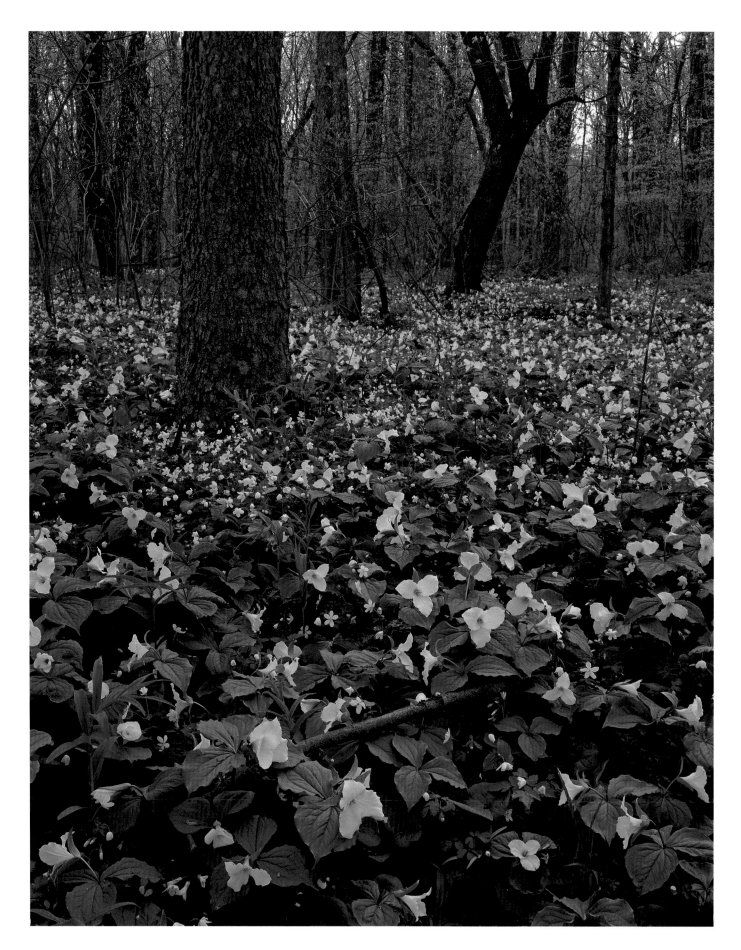

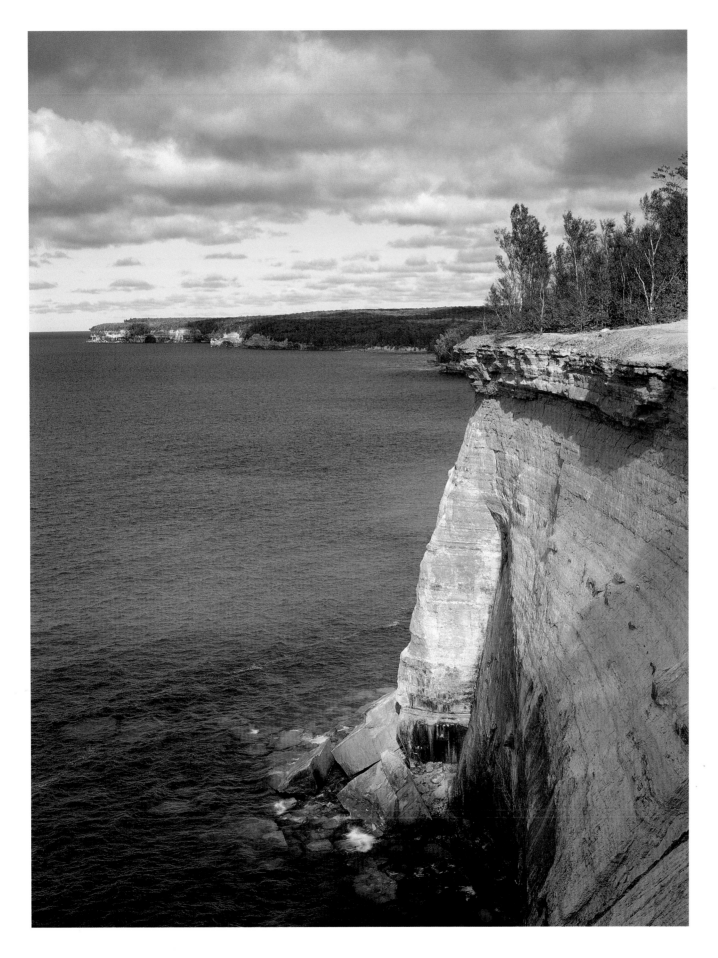

The massive, multi-colored cliffs of the Pictured Rocks spring 200 feet above Lake Superior. [CJ]

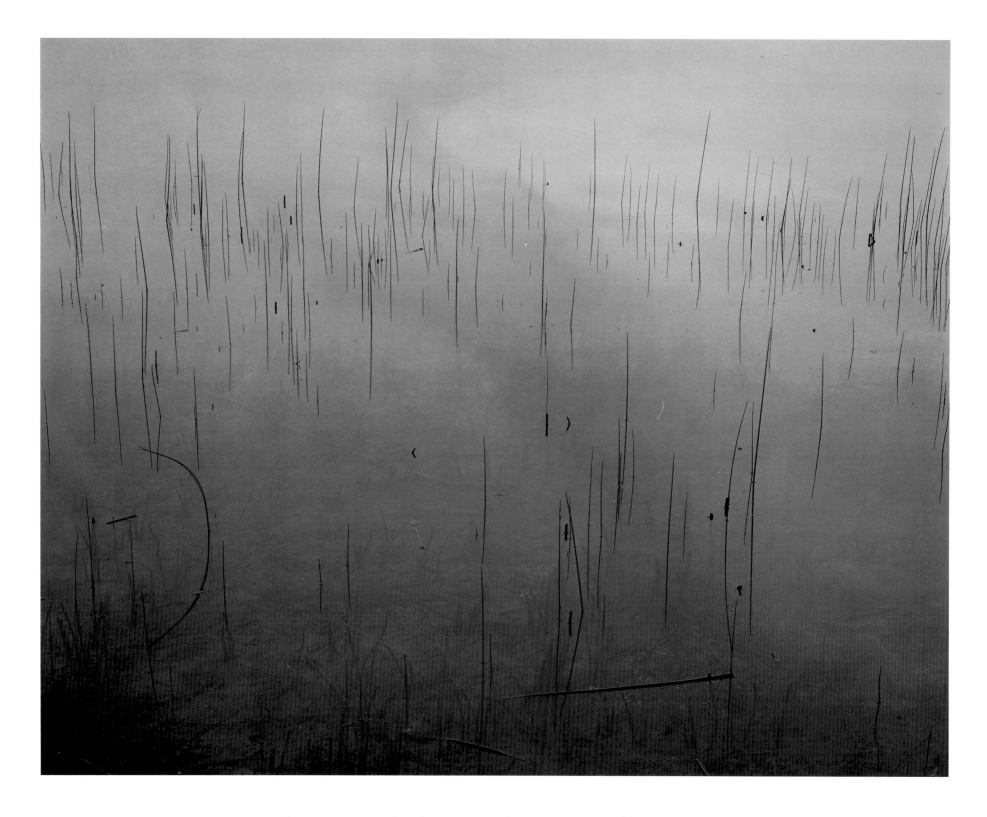

A random scattering of reeds in Otter Lake punctuate a reflected sunrise. [CJ]

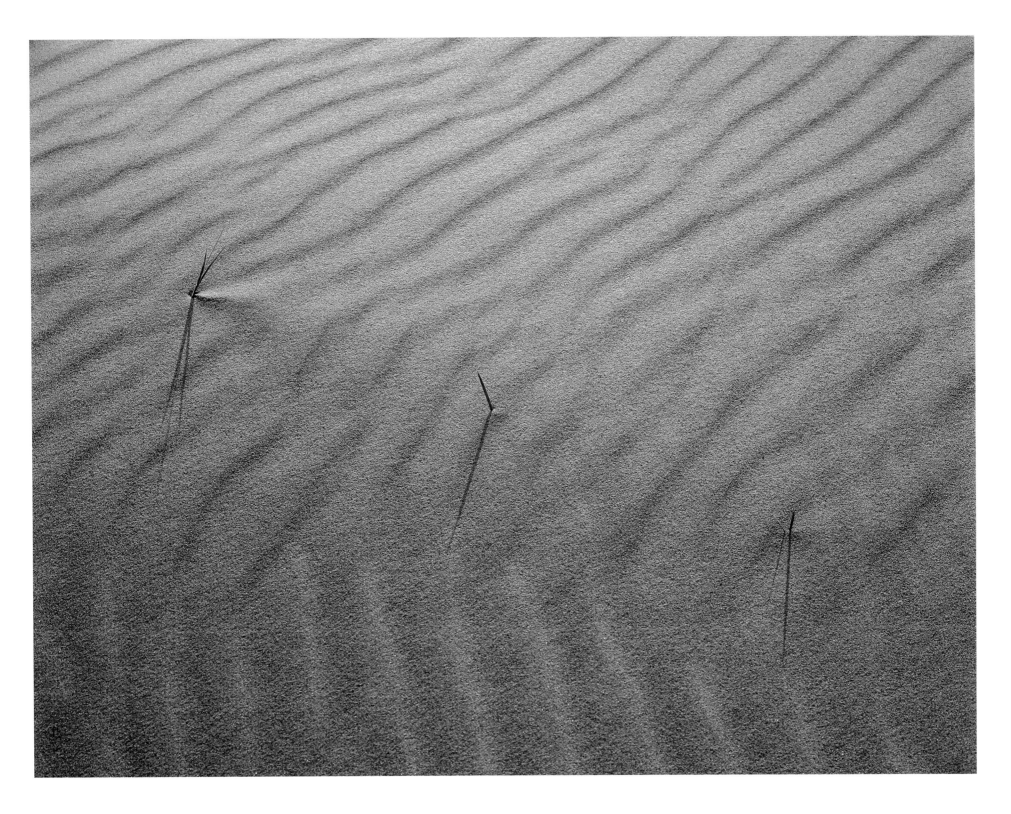

Marram grass is an important plant for stabilizing sand dunes along the Lake Michigan shore. [CJ]

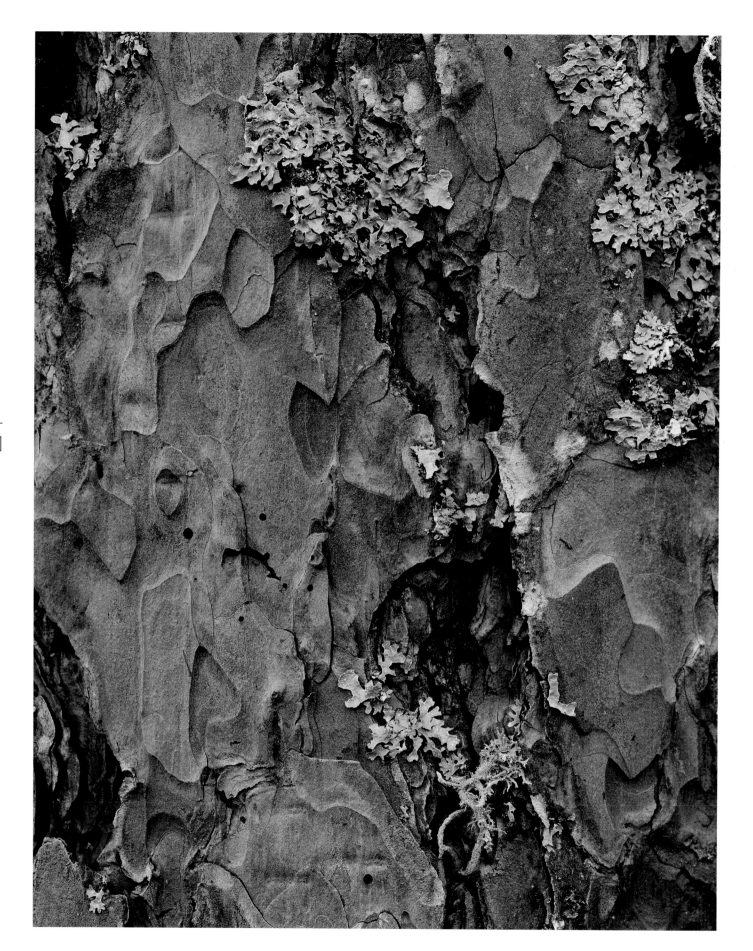

A close-up study of a chiseled-looking red pine tree's bark [RL]

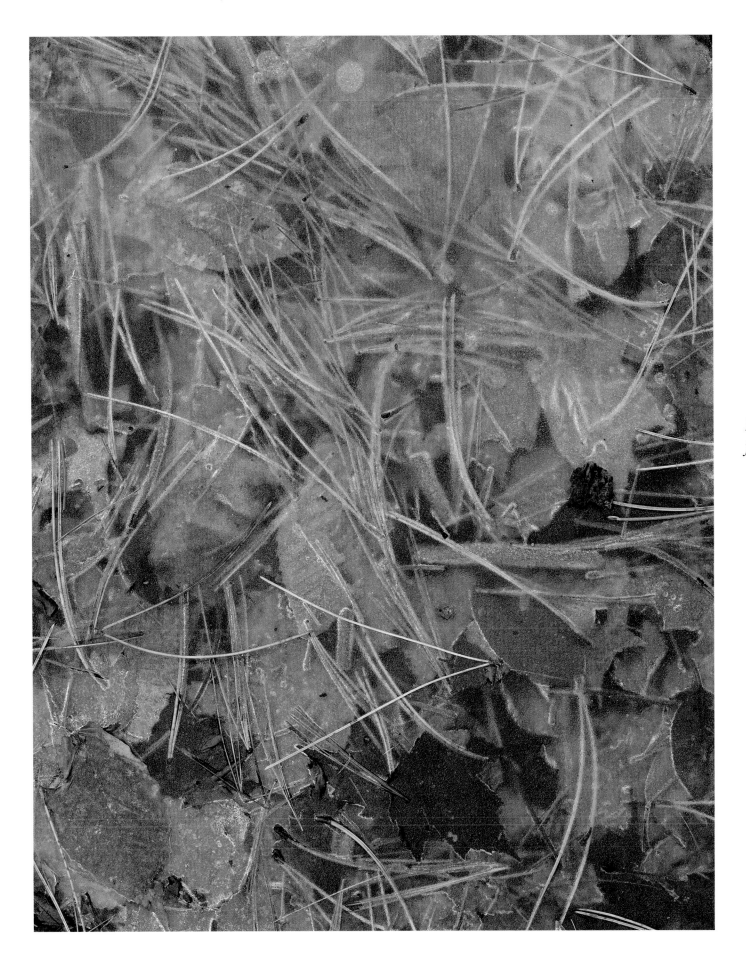

Frozen leaves and pine needles form an abstract display. [CJ]

Limestone boulders break through the deep snow along the north shore of Lake Huron at Dudley Bay, east of Cedarville. This area is part of The Nature Conservancy's 879-acre Carl A. Gerstacker Nature Preserve, which includes interdunal wetlands, conifer swamps, pristine shoreline, inland lakes, and mixed-hardwood forest.
[RL]

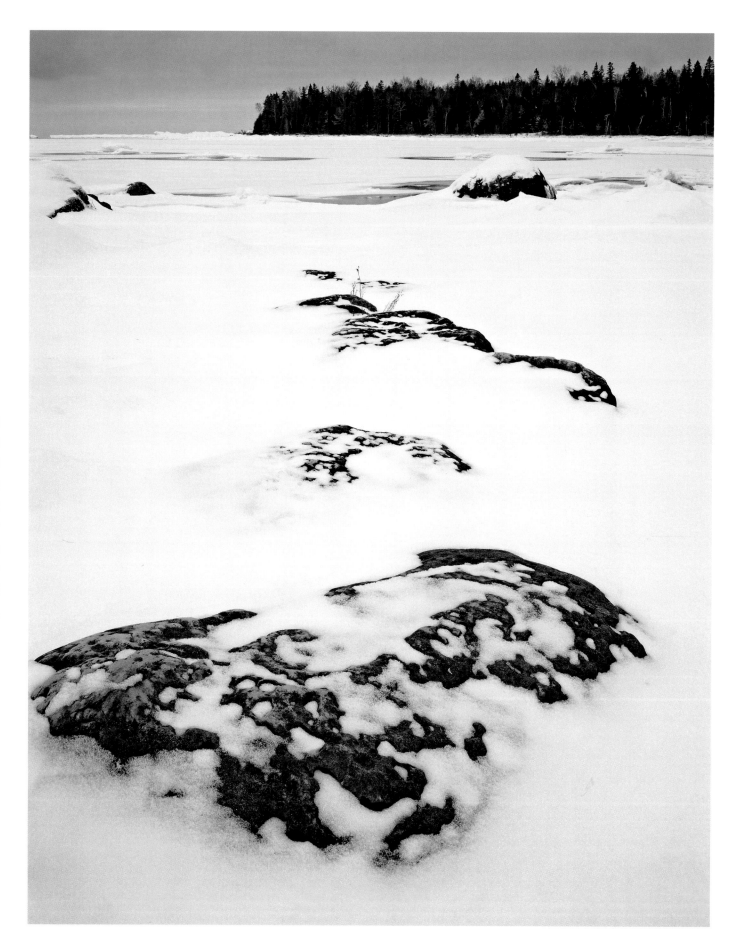

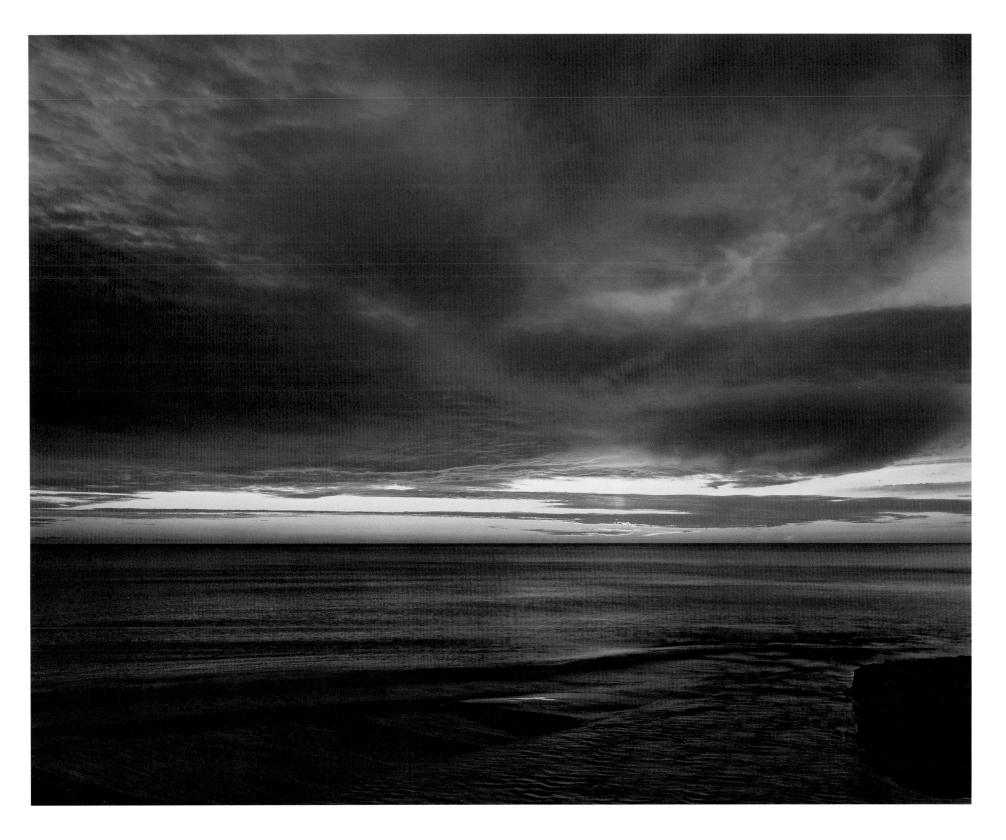

A vivid sunset over Lake Michigan, next to the Duck Lake outlet in Duck Lake State Park [CJ]

Multi-hued maple leaves find a temporary resting place atop a sensitive fern in a northern Oakland County forest. [RL]

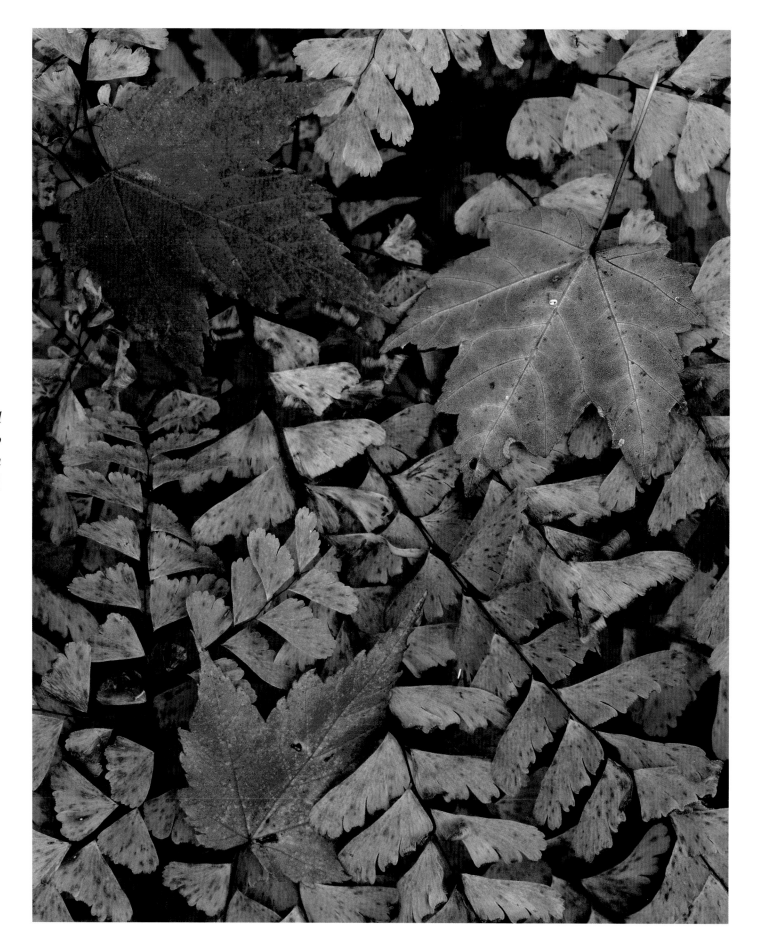

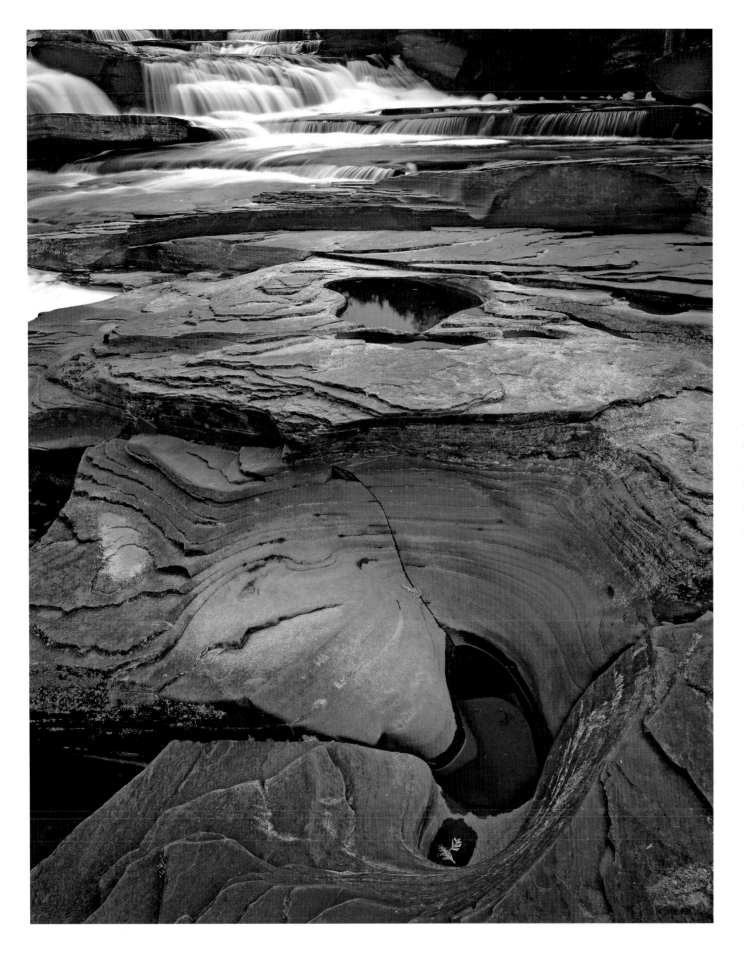

Below Manido Falls the Presque Isle River leaves many remnants of its force as it carves its way to Lake Superior on the western end of Porcupine Mountains Wilderness State Park. [RL]

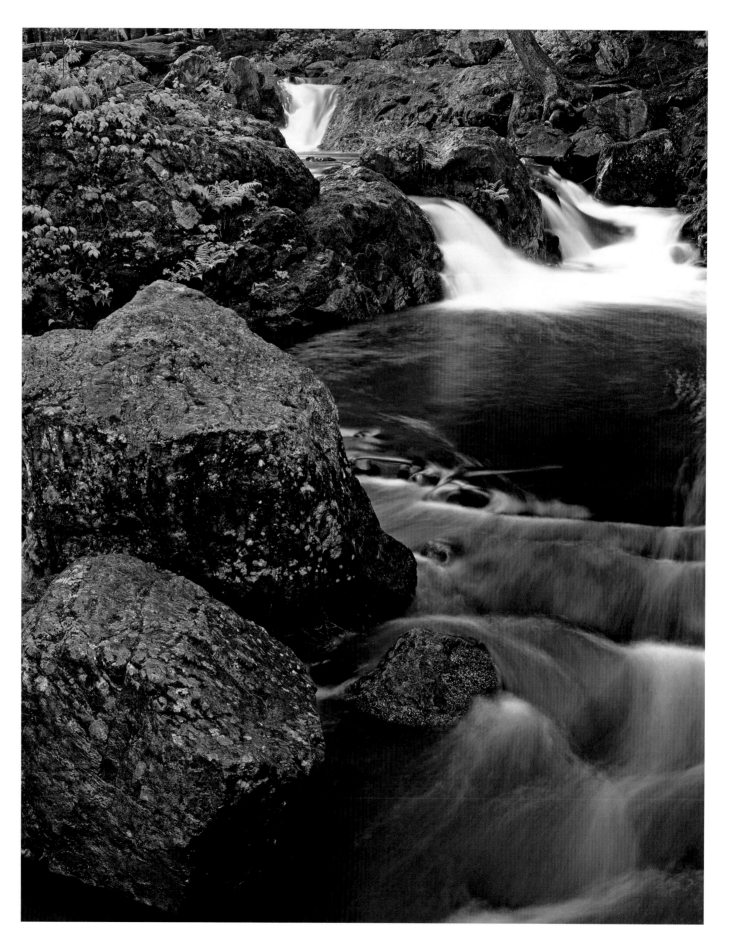

Overlooked Falls is one of several falls that can be found on the Little Carp River in Porcupine Mountains Wilderness State Park. There are more than 200 waterfalls in Michigan with all but one being in the UP. [RL]

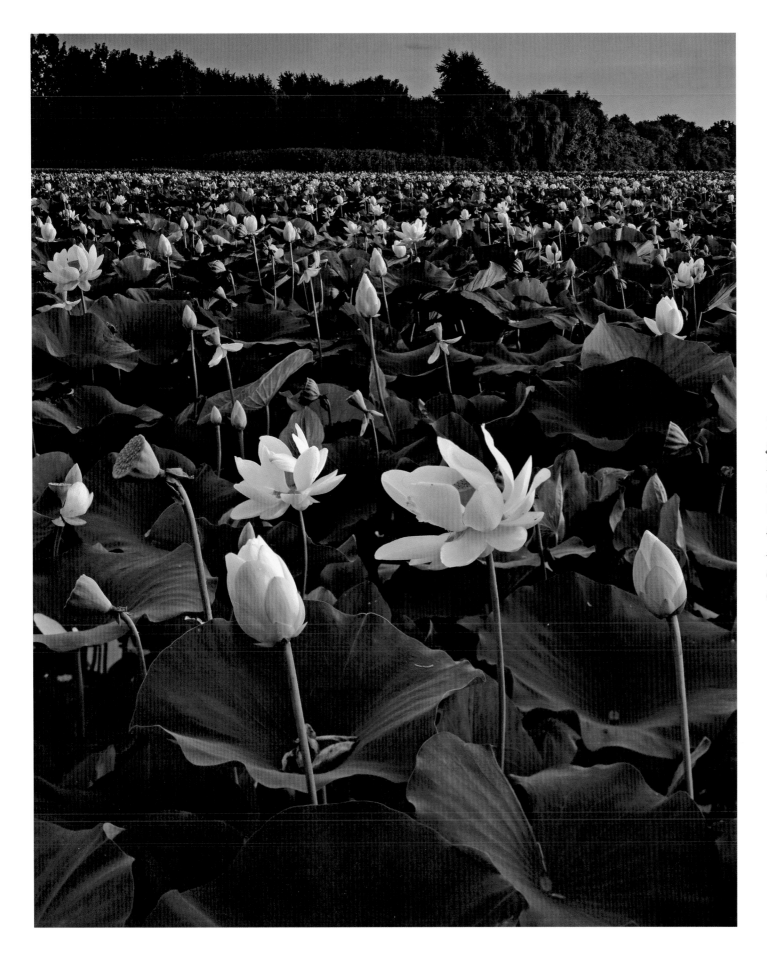

The fragrant American lotus grows in massive beds along the Lake Erie shoreline and backwaters from Monroe to below the state line. The bloom, which starts around the beginning of August, attracts visitors from all over to view the spectacular display. [RL]

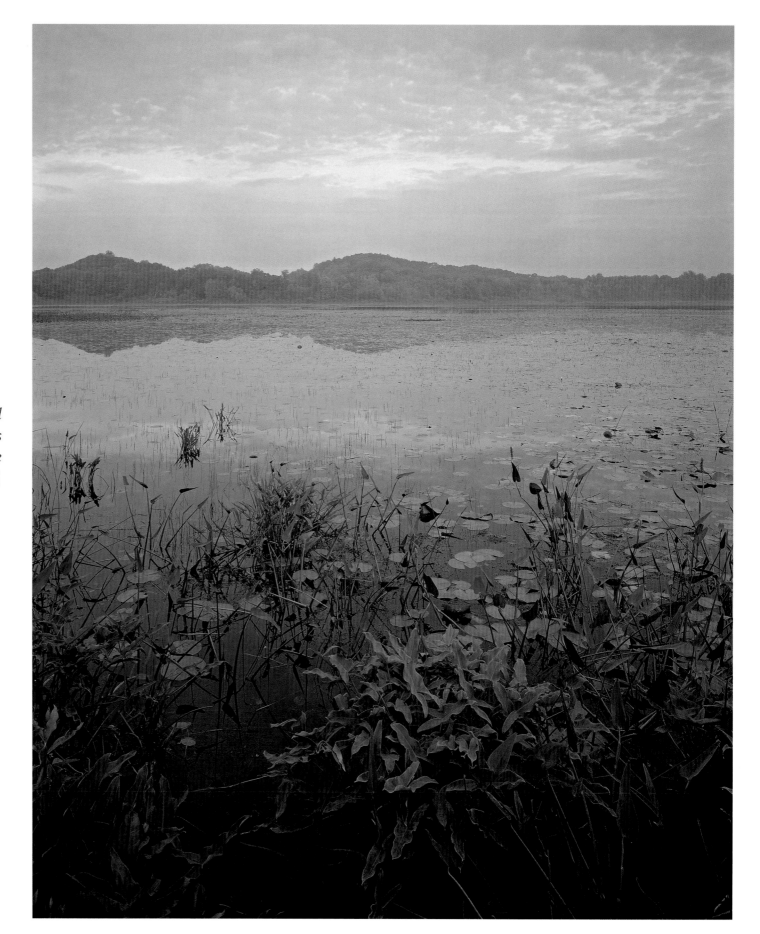

Arrowhead and pickerelweed grow along the shallow edges of Middle Lake in Grand Mere State Park. [CJ]

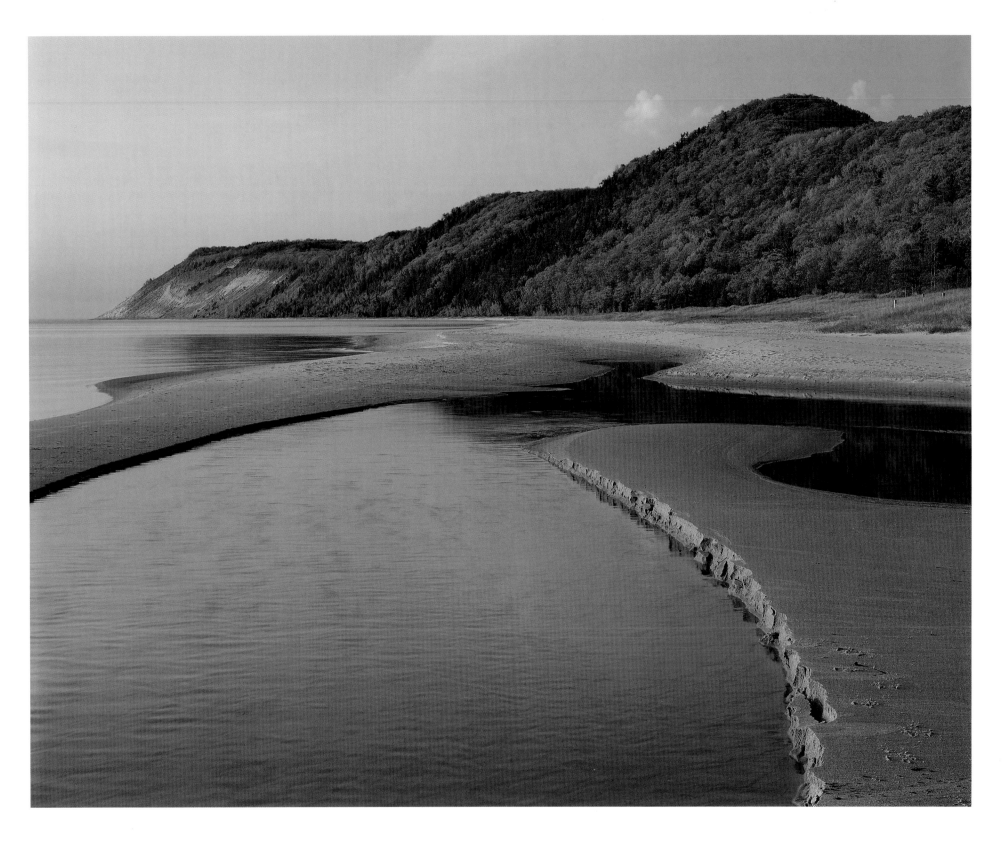

Otter Creek loops around the sand before depositing into Lake Michigan, with the Empire Bluffs in the distance. [CJ]

Reeds~Rocks~Reflections

Ron and I had relatively few opportunities to shoot together as we worked on this project (unfortunately). The last joint photo trip we took was in June of 2007, and we planned to visit Wilderness State Park and explore the area along the northern coast of Lower Michigan. As I was driving to meet up with Ron, he called and informed me that the forecast for the area was predicting a major storm to come through overnight, with winds of up to 70mph. These were clearly not ideal conditions for our planned (tent) camping stay. Fortunately Ron had a contact through The Nature Conservancy who was kind enough to put us up on short notice for one night (thanks Nadine!).

The following afternoon we set up camp at the park and went for a hike around Waugoshance Point, looking for possible photographs. Unfortunately, the weather was still pretty unsettled and very windy—not good for large-format photography. We took a long hike all the way around the Point, without either of us attempting even one photograph. At the end of the hike, Ron looked at me and asked, "How long do you suppose you would have to wait until there were good conditions out here?" Considering the flatness of the land and proximity to constant winds coming off of Lake Michigan, we thought it might be a long time.

The next day we drove along the Lake Huron shoreline exploring several locations (and eventually shooting the images from P. H. Hoeft State Park seen elsewhere in the book). That evening we returned to camp and decided that since we both had to leave early the following day, we would take a chance on finding better conditions on the Point since it was the closest location of interest for us. As luck would have it, when we got out there the following morning the conditions were nearly perfect, calm and quiet with just the slightest breath of wind. We immediately hiked to a particular area we had noted from the previous visit, and began looking for images. I found this small cluster of reeds just as the clouds were starting to light up with sunrise color. I quickly set up and composed this image, taking the photograph just as the color was starting to fade. We spent a very pleasant and productive morning taking a variety of images in the area.

After we finished our shoot, we met up again for the hike back out and looked at each other. I could tell we were thinking the same thing—the answer to the question is "Two days"!

CJ

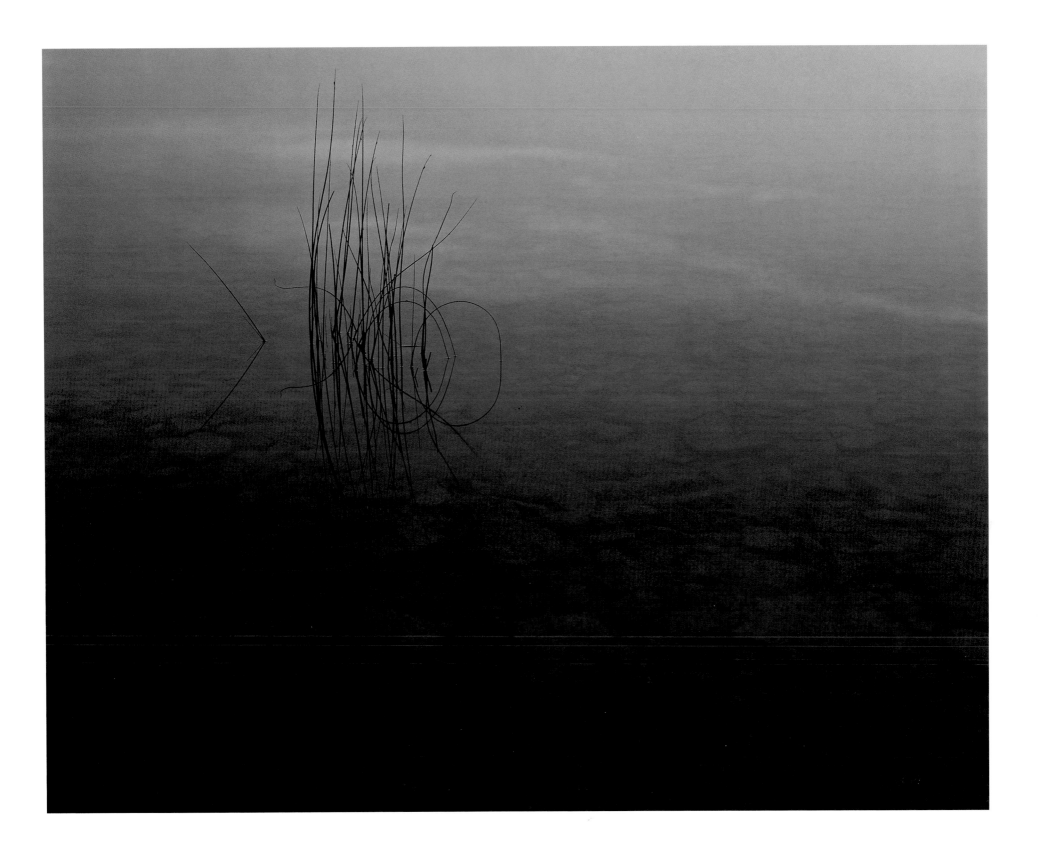

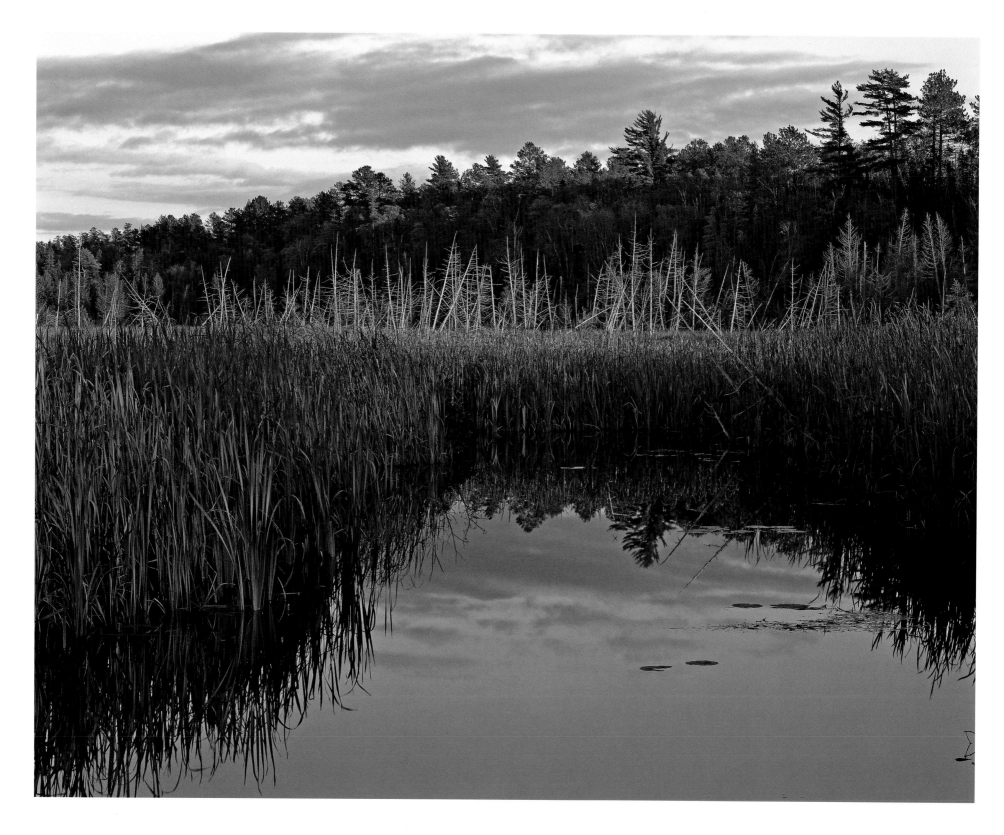

The warm light of late day plays on a marsh scene near Vermillion in the eastern UP. [RL]

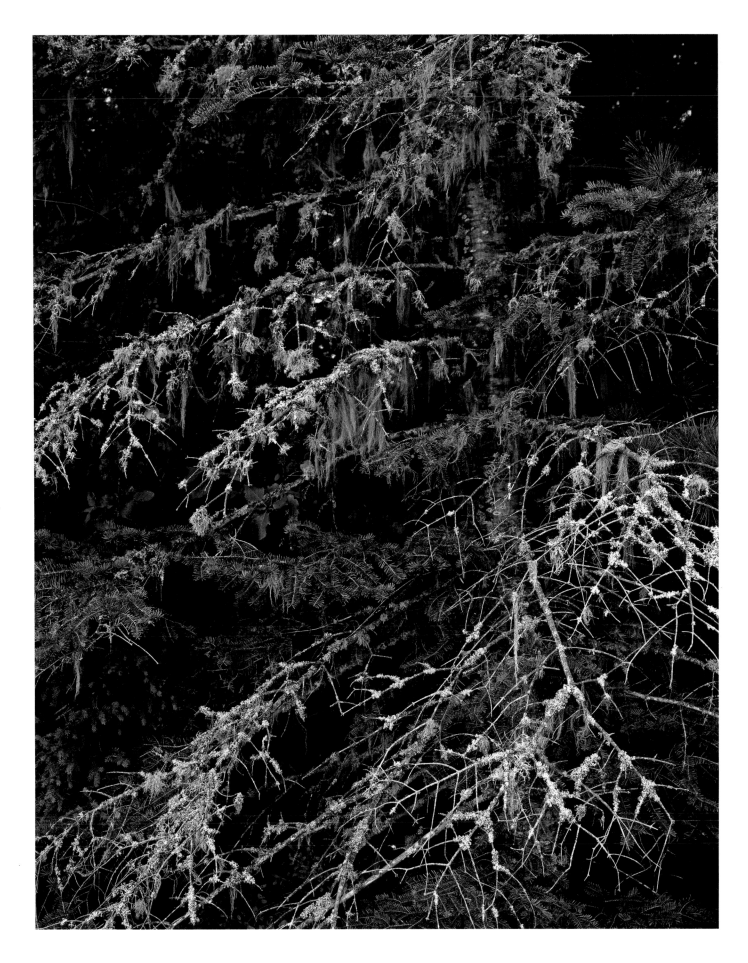

Along the Lake Superior shore-line you will find trees covered in old-man's beard and other lichens where cool, damp conditions pre-vail as exemplified by this fir near Copper Harbor. [RL]

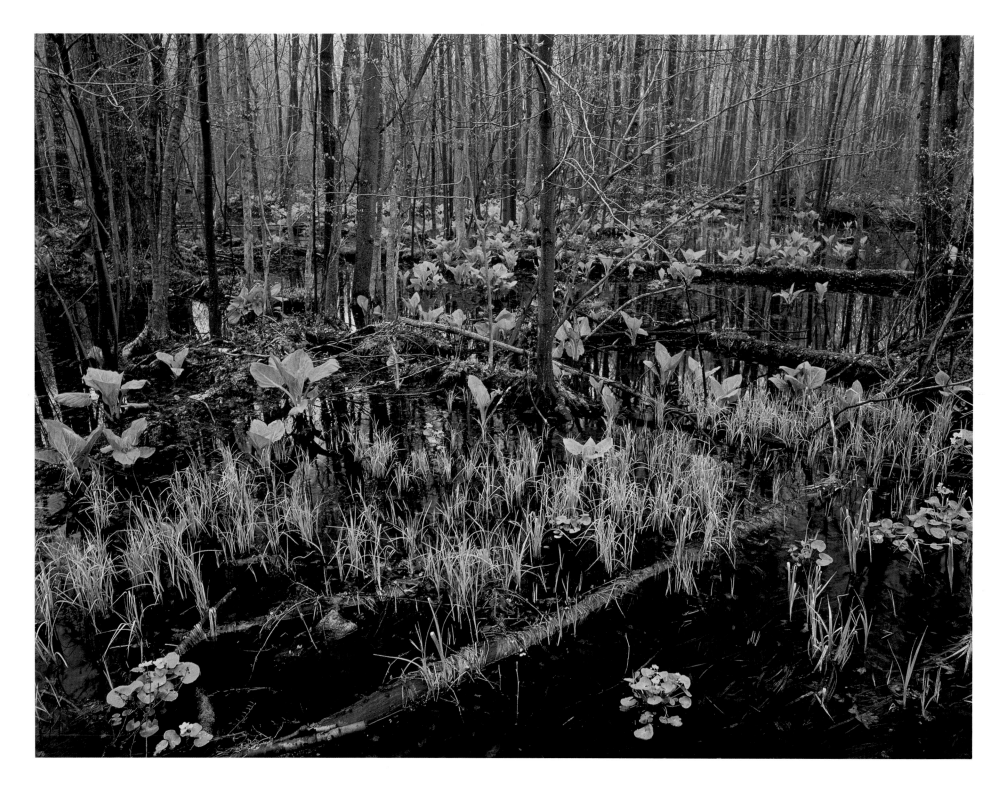

Grasses, marsh marigold, and skunk cabbage are scattered through a swampy area in Proud Lake Recreation Area. [CJ]

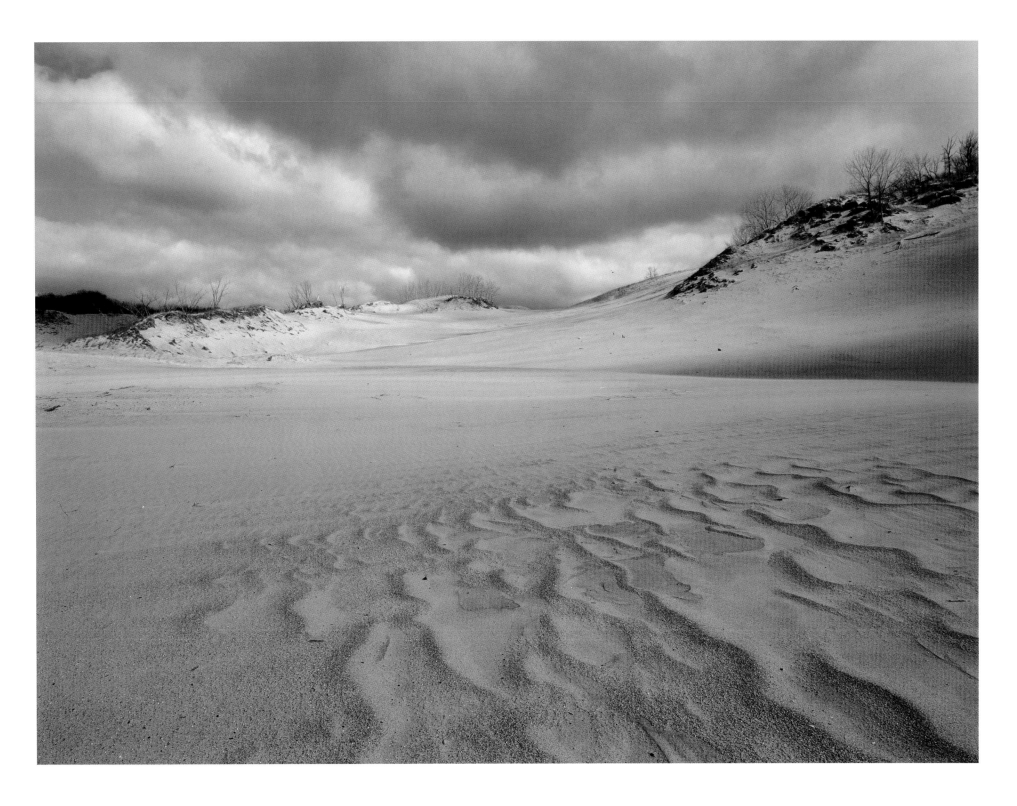

A brooding sky throws dappled light across the dunes near the Warren Dunes beach. [CJ]

South of Point Isabella along the Scenic Shoreline Drive between Bete Grise and Gay, a multi-colored rock beach reaches into Lake Superior. The ongoing movement of the lake tumbles small stones against depressions in the sandstone creating the circular potholes. [RL]

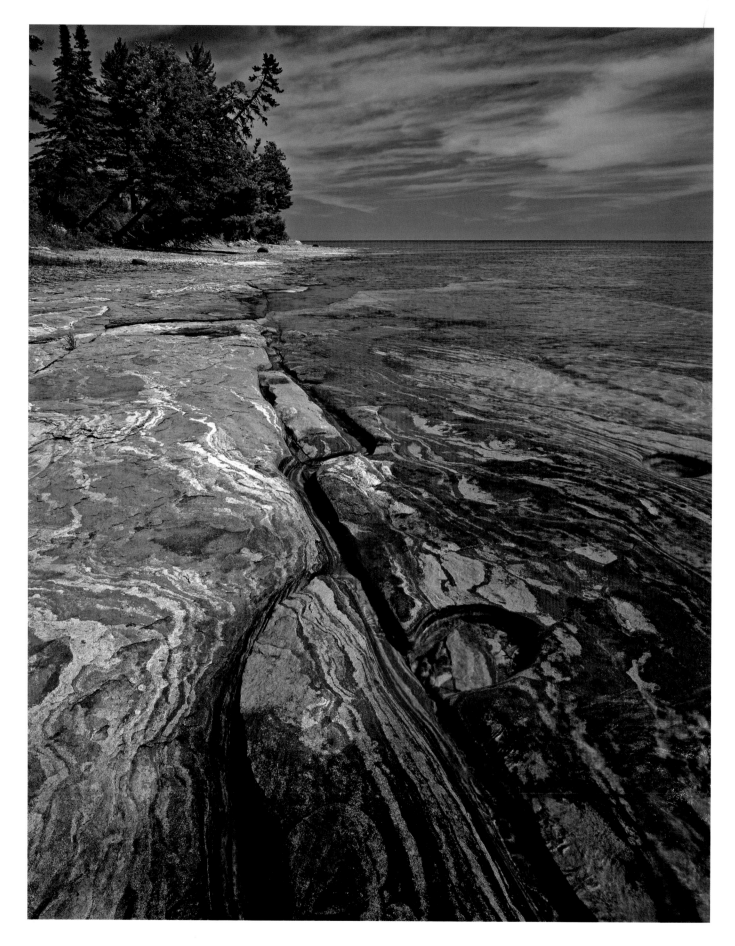

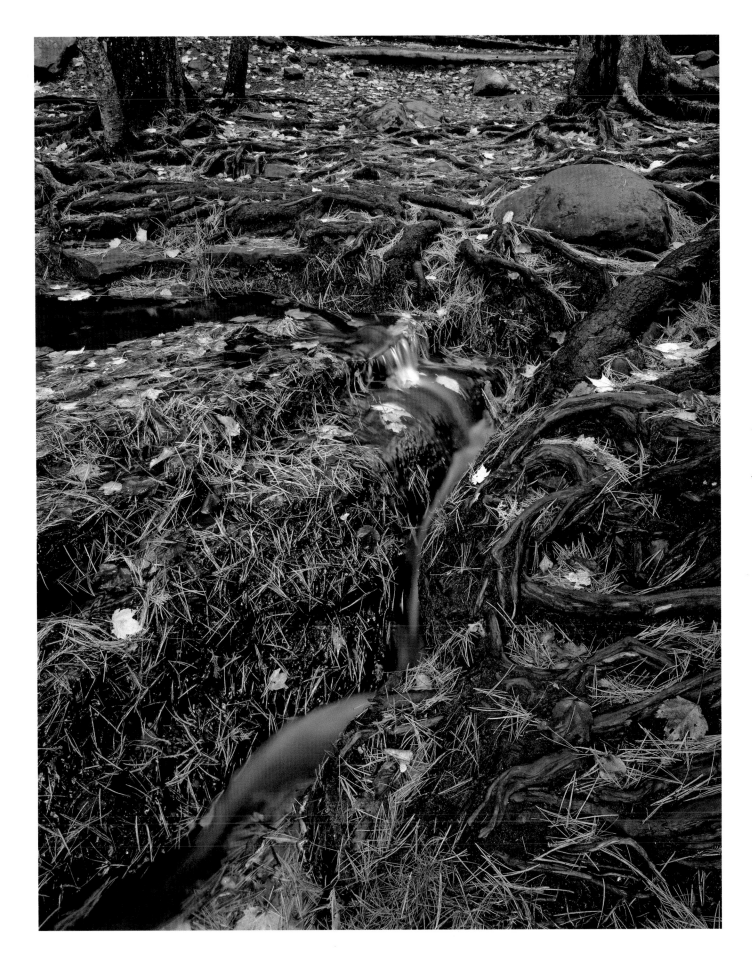

An extensive network of tree roots combine with fallen leaves and pine needles along the bank of the Tahquamenon River creating an interesting natural abstract in Tahquamenon Falls State Park. [RL]

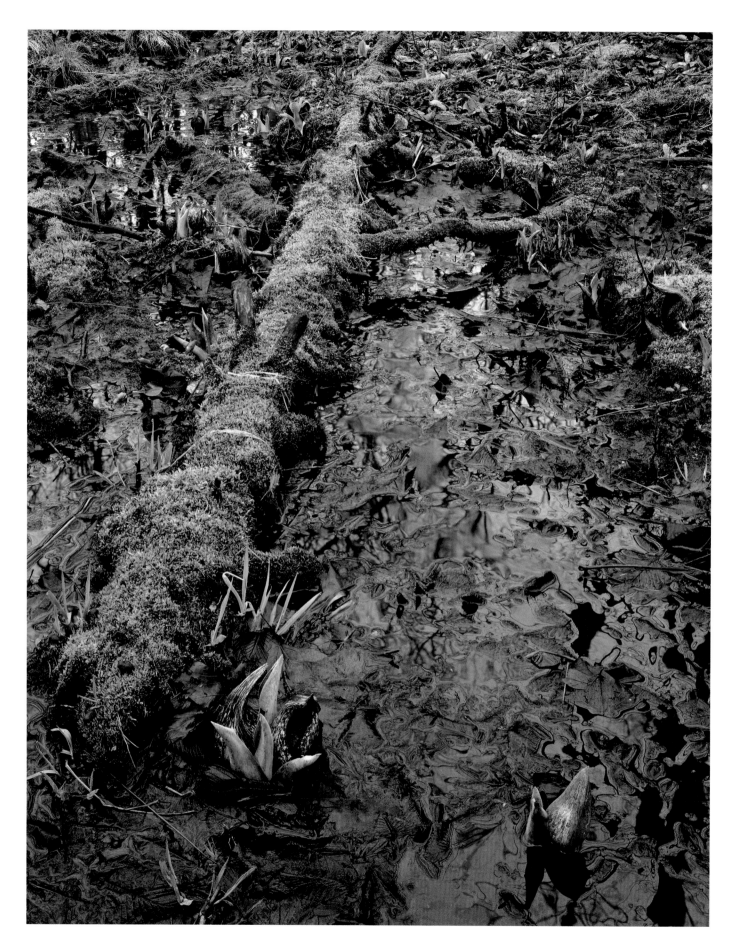

The shell-like flower of the skunk cabbage is one of the earliest blooming plants and can melt snow and ice around it as a result of cellular respiration from rapid growth. They can be found in wet woodlands like this one in western Oakland County. [RL]

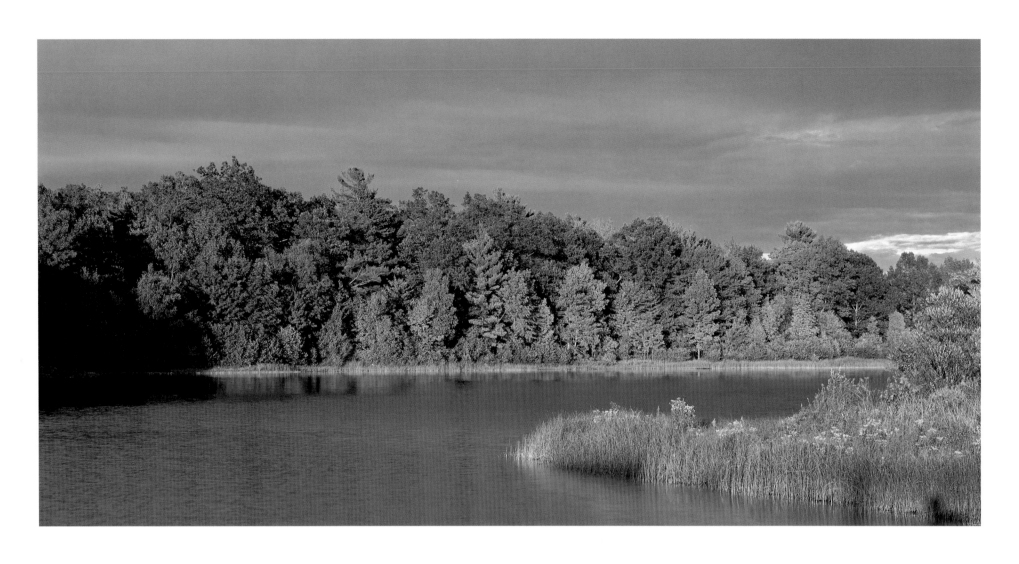

Late-day light breaks through retreating storm clouds and lights up the shores of Duck Lake. [CJ]

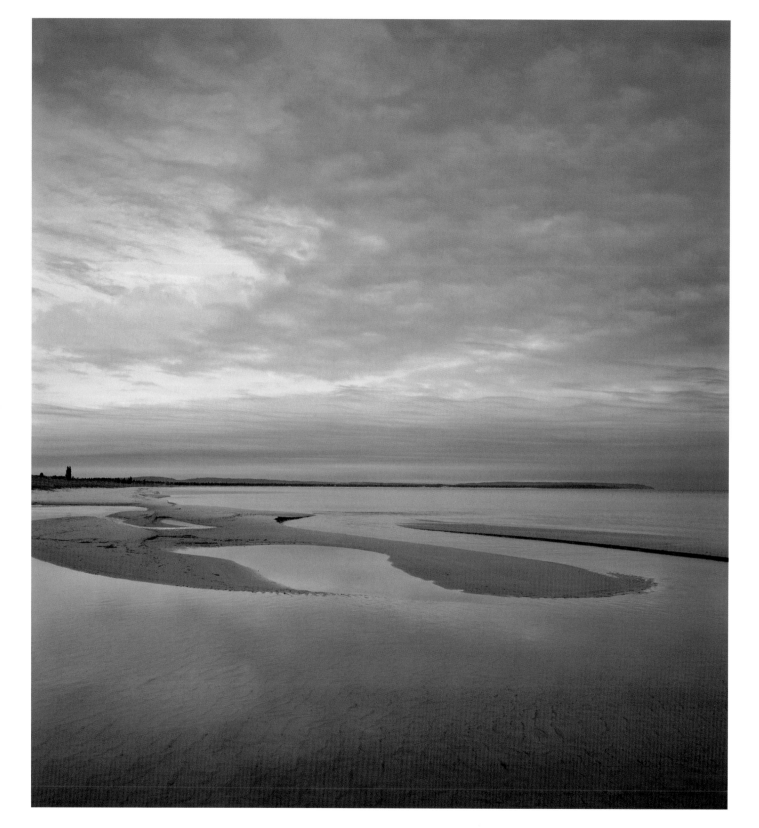

Pastel colors brighten the sky as morning breaks over the shoreline of the Sleeping Bear Dunes. [CJ]

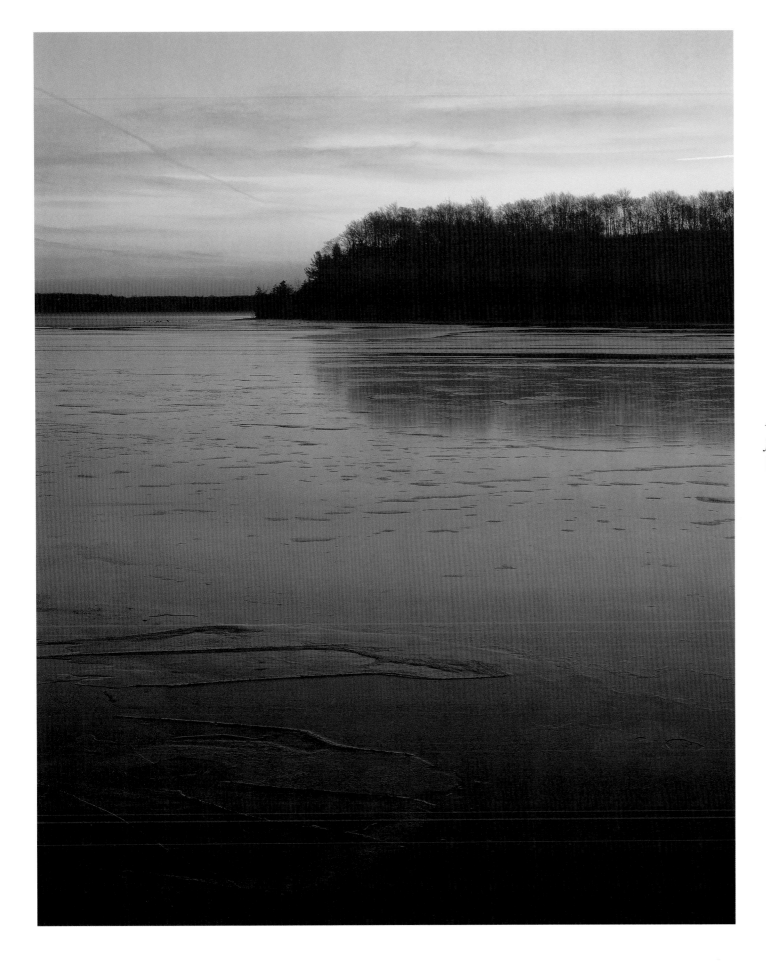

A colorful sunrise over the frozen surface of Hamlin Lake [CJ]

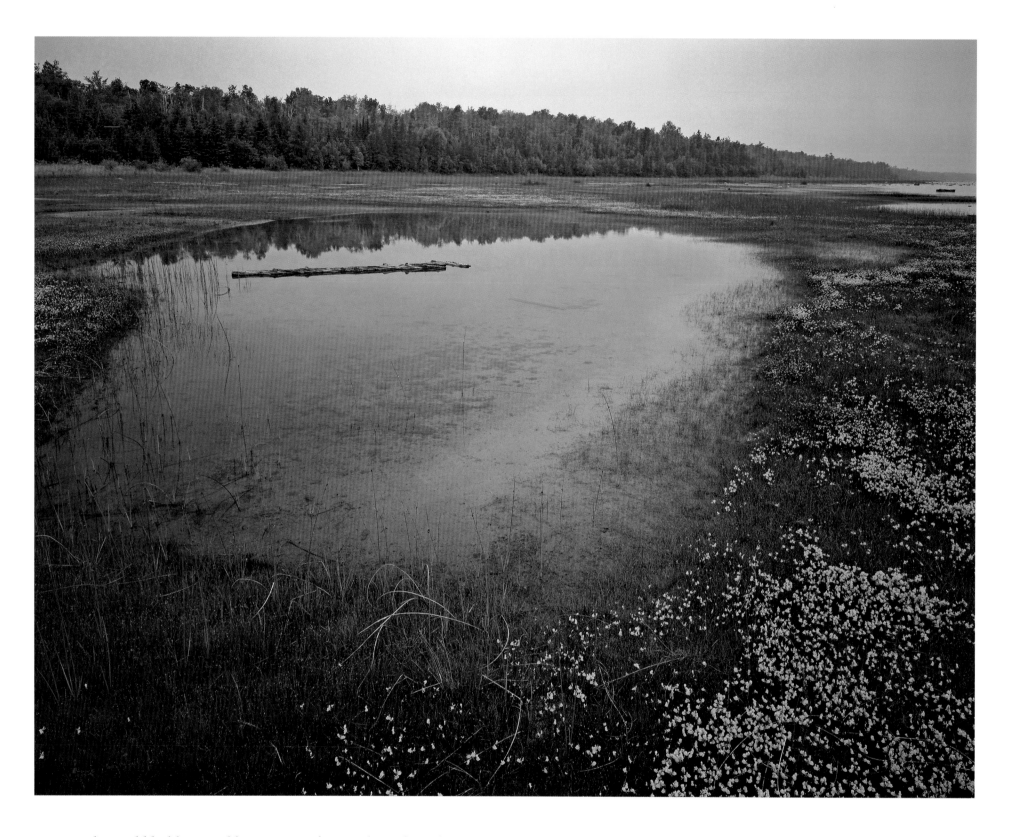

In June, horned bladderwort blooms in profusion along the Lake Huron shoreline at The Nature Conservancy's Grass Bay Preserve. There are 250 species of plants found here, including the rare Pitcher's thistle, Houghton's goldenrod, and the Lake Huron tansy. [RL]

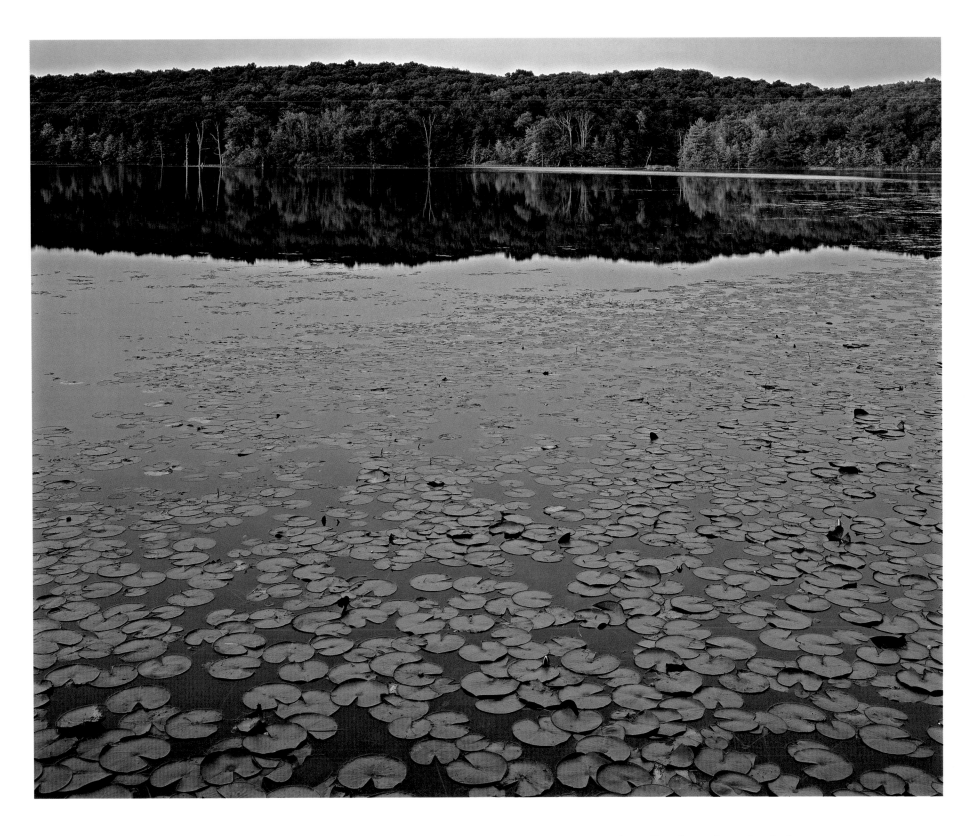

Water lily pads extend well out into Yankee Springs Recreation Area's Hall Lake as late-day light brightens the shoreline and islands in the lake. [CJ]

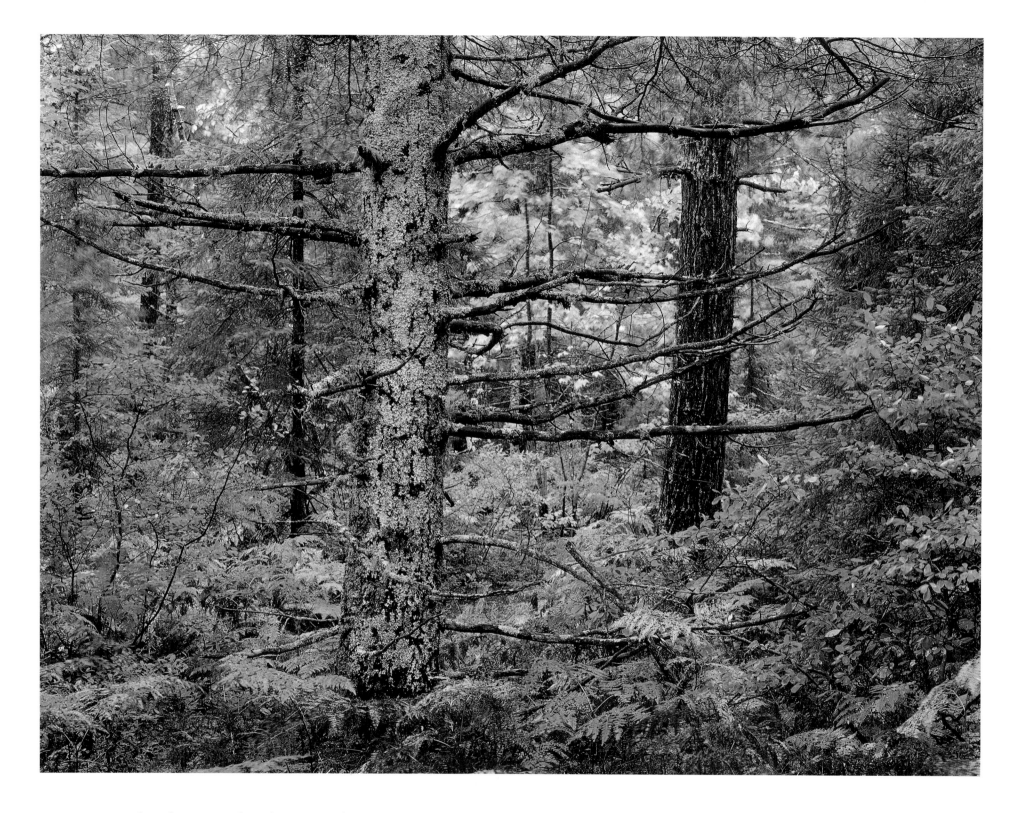

Within the Pictured Rocks National Lakeshore, early autumn color is scattered through the woods near Miner's Castle. [CJ]

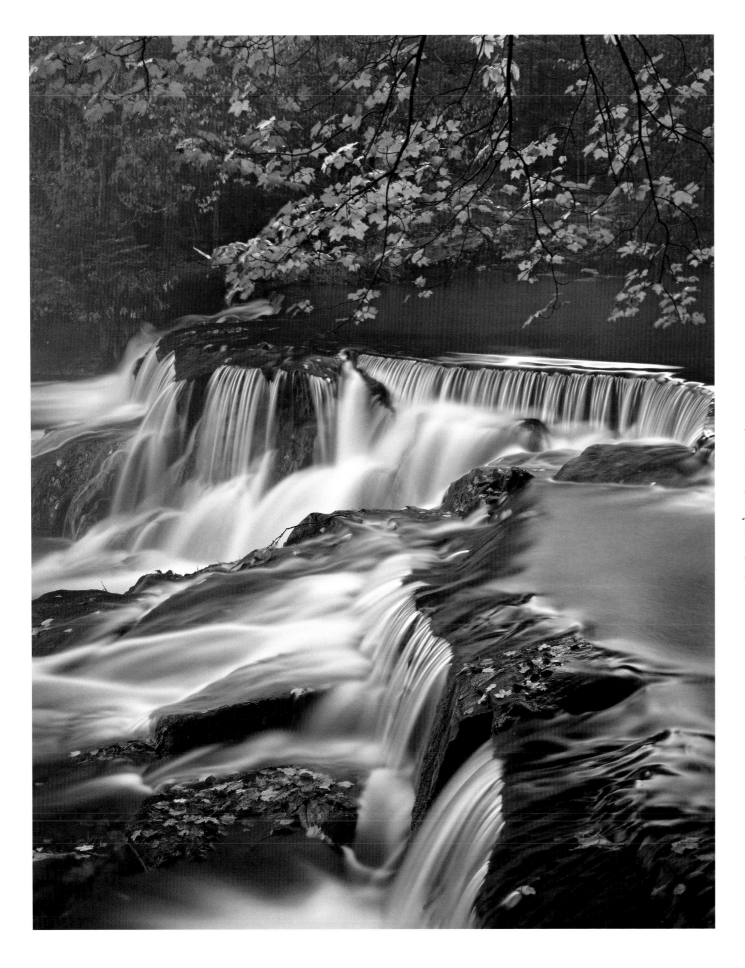

Near Paulding, Bond Falls on the middle branch of the Ontonagon River drops 50 feet. Starting from the Bond Falls flowage just above this section of falls to where the river enters Lake Superior, the Ontonagon drops a total of 875 feet. [RL]

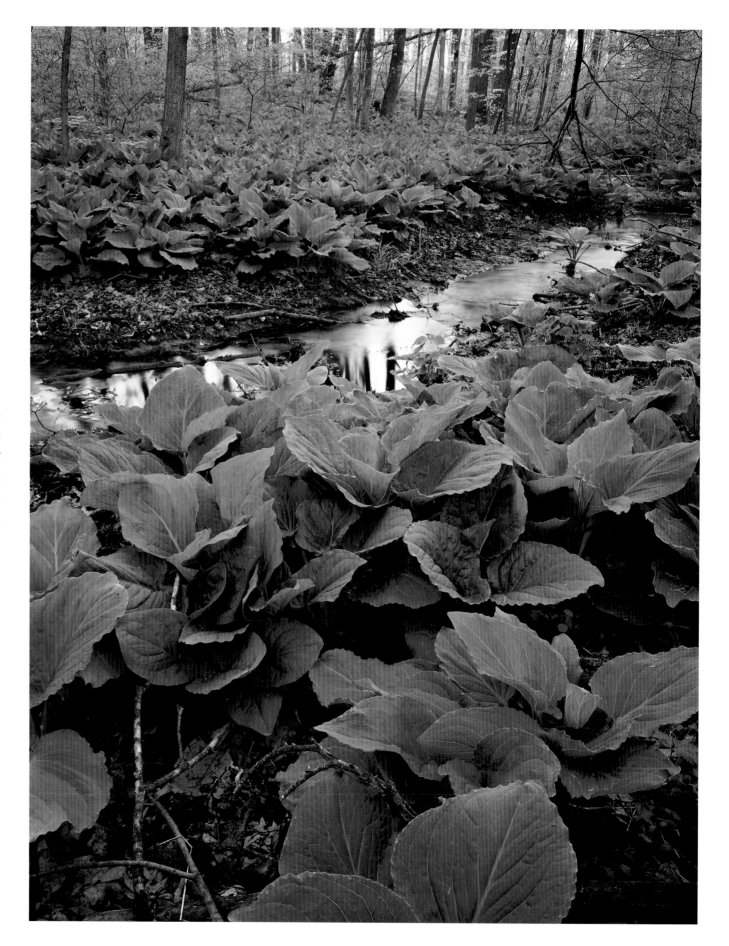

At the Nan Weston Nature Preserve at Sharon Hollow, skunk cabbage flourishes in the wet woodland bottoms. The plant gets its name from the foul odor it emits when the leaves are broken. [RL]

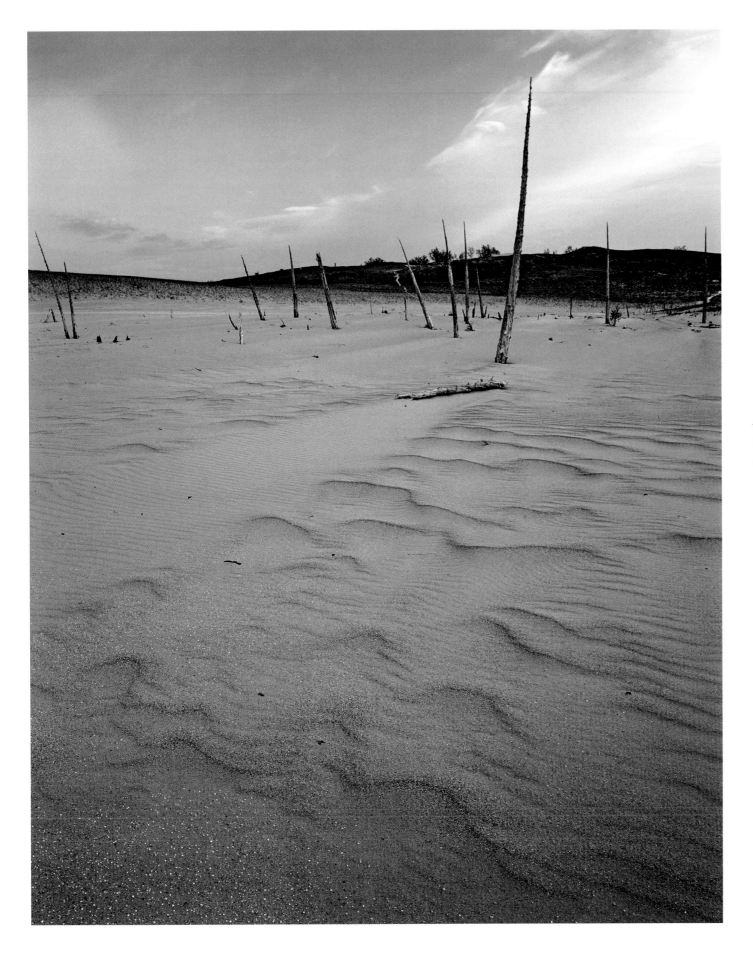

A ghost forest sits in the center of a large bowl carved out of the Sleeping Bear Dunes. [CJ]

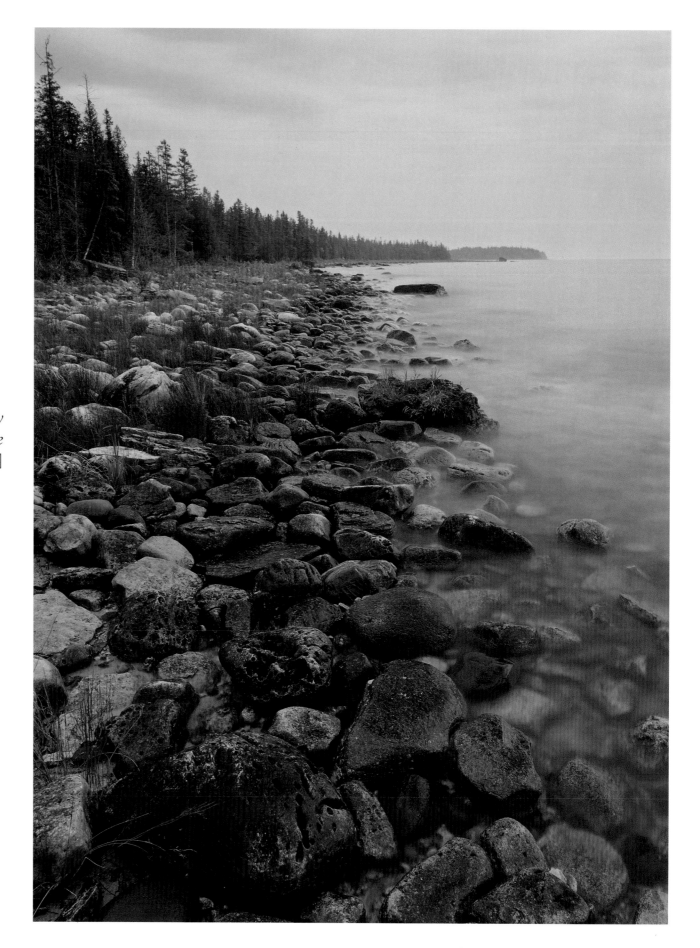

An incoming storm makes a moody backdrop for the rocky shoreline of Dudley Bay. [CJ]

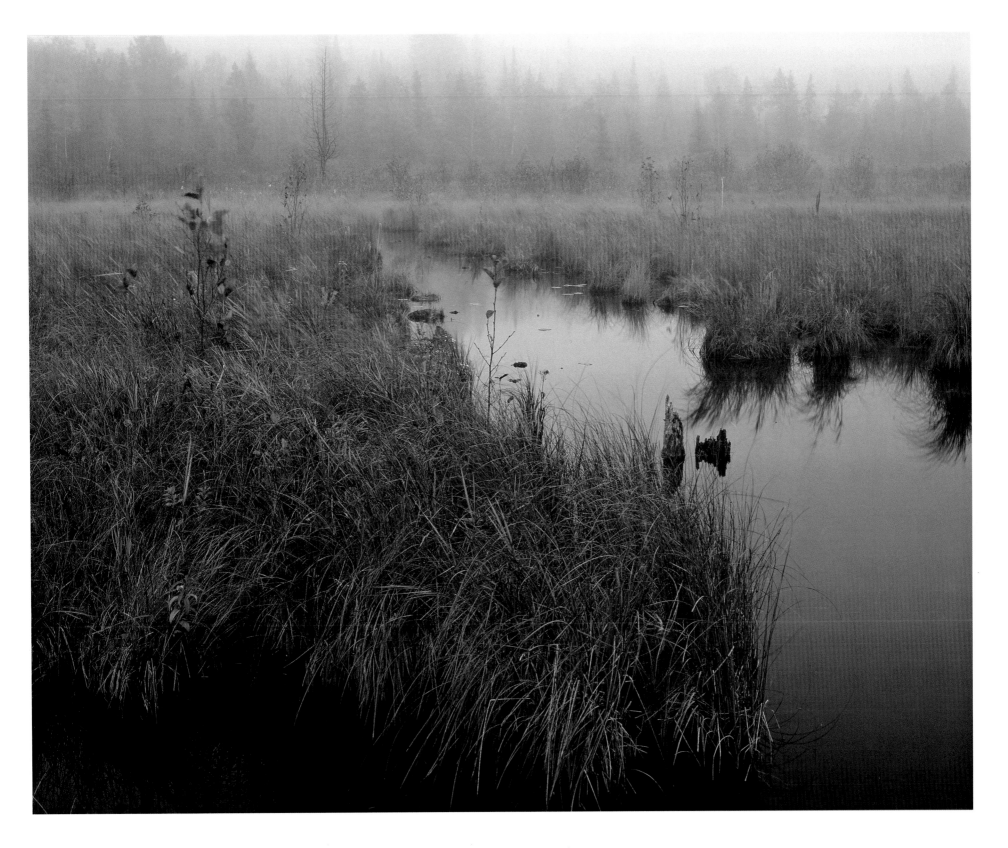

Fog covers the distant treeline surrounding one of the many wetland portions of the Pigeon River Country. [CJ]

Peace on Earth

It is interesting (though not surprising) how many winter landscape shots are used to represent peace and serenity on holiday greeting cards. This image is no exception as the Michigan chapter of The Nature Conservancy selected it for one of their holiday cards. The story behind this image though is not quite so peaceful.

It was February when I traveled to the tip of the Keweenaw Peninsula to capture some images to portray the essence of winter in the UP. I made arrangements to have one of the Conservancy's field people, Brian Carlson, show me where the TNC preserves were near Copper Harbor. We met in Hancock and the weather conditions where getting nasty with high winds and blowing snow. Little did I know that this was only a precursor to what I would experience over the next 24 to 36 hours.

After showing me the sites, Brian headed home and I settled in for the evening at a Copper Harbor motel. As I customarily do, I went over my topographical maps, double-checked the time for sunrise, and prepped my gear for the morning shoot. Early the next morning I stepped out of the motel and into a whiteout. High winds, sub-zero temperatures, and visibility that seemed to extend only the length of my arm prompted me to turn right around and return to my room. Needless to say, I caught up on a lot of reading that day and did no shooting.

The storm blew through that evening and the winds were calm when I left the motel the following morning. When I arrived at the preserve I looked at the temperature indicator in my vehicle and simply shook my head; it was —9. I strapped on my snowshoes, loaded my backpack, and headed down the trail to the beach. After what seemed to be far more than an hour and a few minutes, I had taken a total of five images from two different compositions. In hindsight I find it ironic that in this composition the snow looks a lot like rippling waves of water as they approach this sandy beach during warmer times of the year.

Yes, it was very serene while I was out there but I did not start "feeling the peace" until the heater in my vehicle brought feeling back in my cheeks, fingers, and toes.

RL

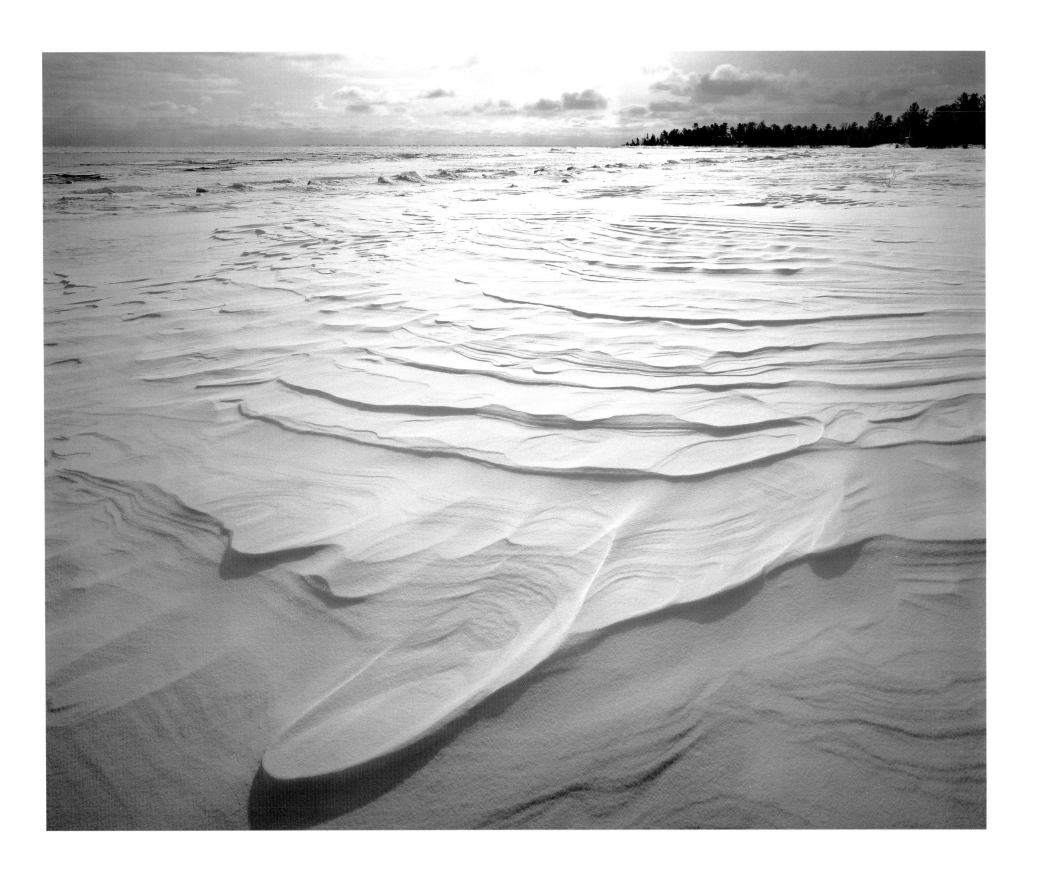

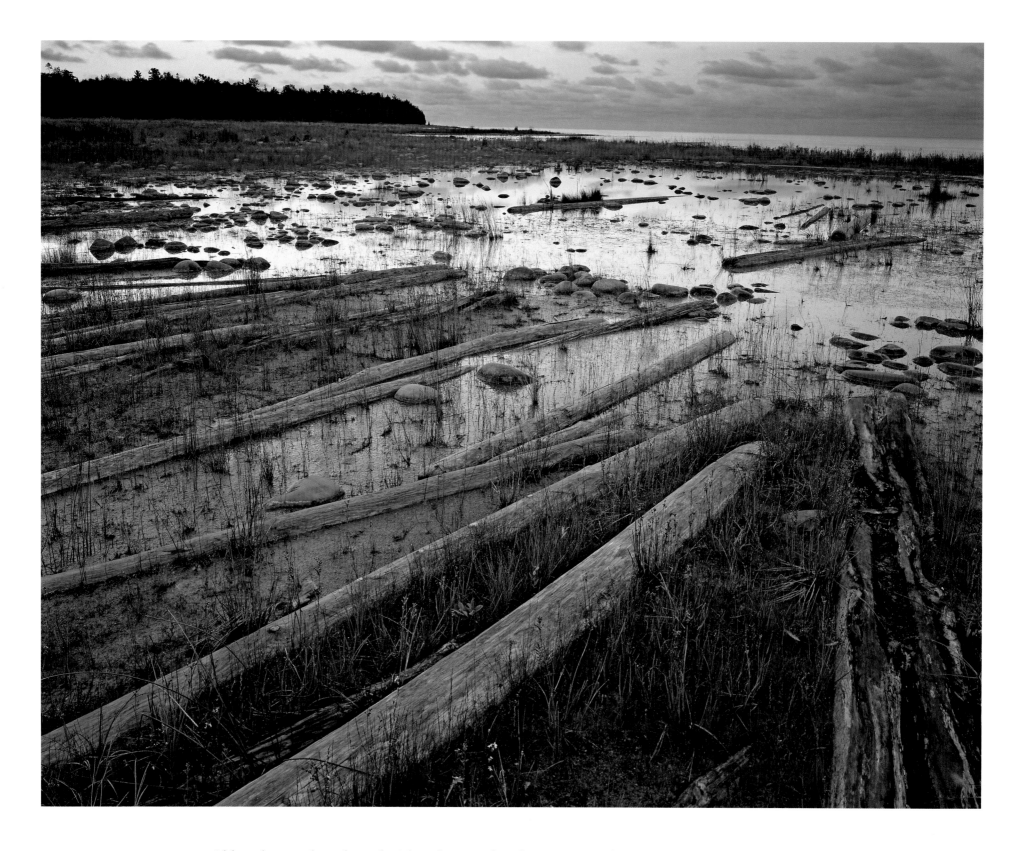

Old timbers gather along the Thunder Bay shoreline near North Point outside of Alpena. [RL]

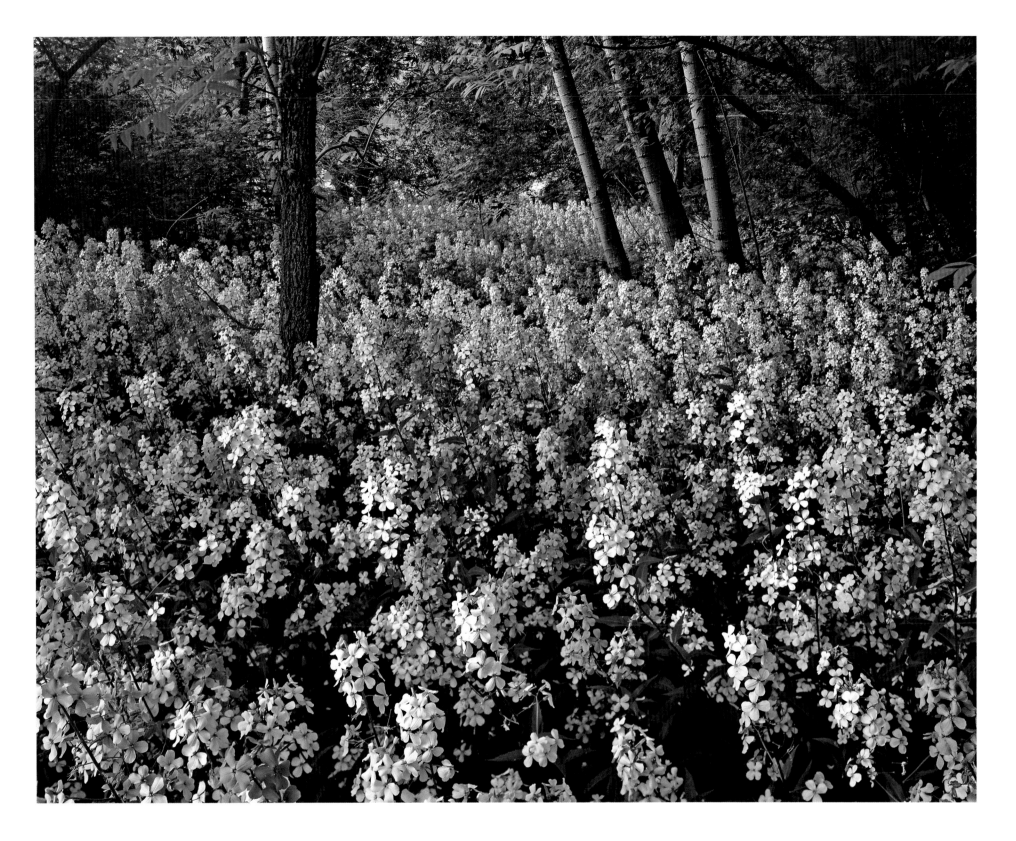

The striking dame's rocket grows along woodland margins in much of the southern Lower Michigan as seen here near Hartland in Livingston County. Often confused with the native Phlox family, this plant is a non-native related to the invasive garlic mustard. [RL]

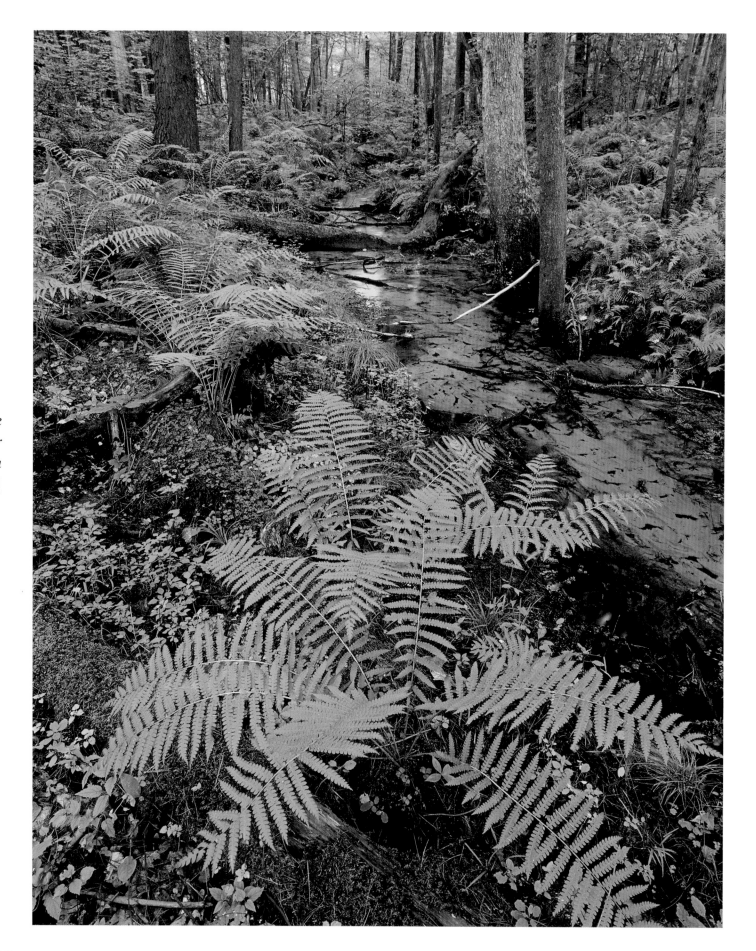

A profusion of ferns covers the banks along a sandy stream near Swan Creek Pond, in the Allegan State Game Area. [CJ]

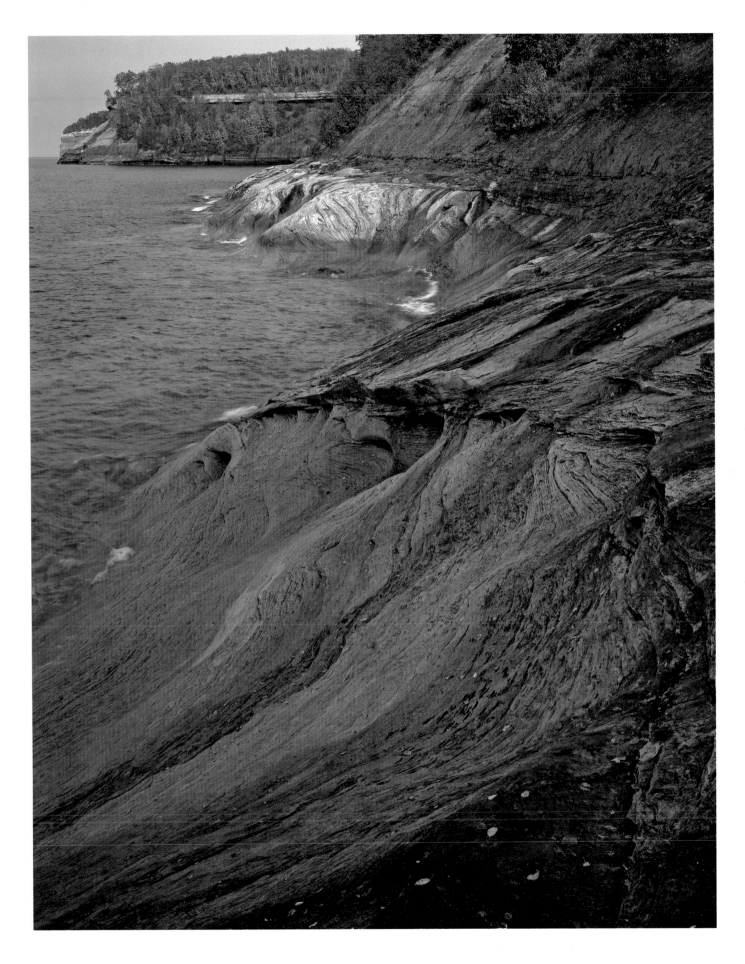

A colorful view of the sandstone cliffs at Pictured Rocks National Lakeshore. Pictured Rocks was the first nationally designated lakeshore in 1966 with a total of almost 73,000 acres. It is managed by the National Park Service and protected with the assistance of state agencies and private owners. [RL]

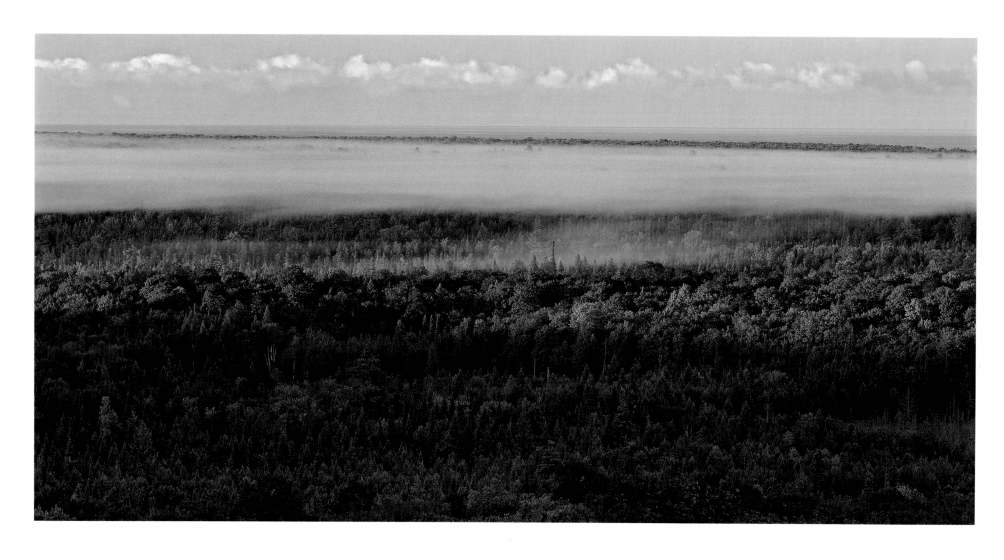

A low-lying bank of fog lends mystery to the area surrounding Beaver Lake. [CJ]

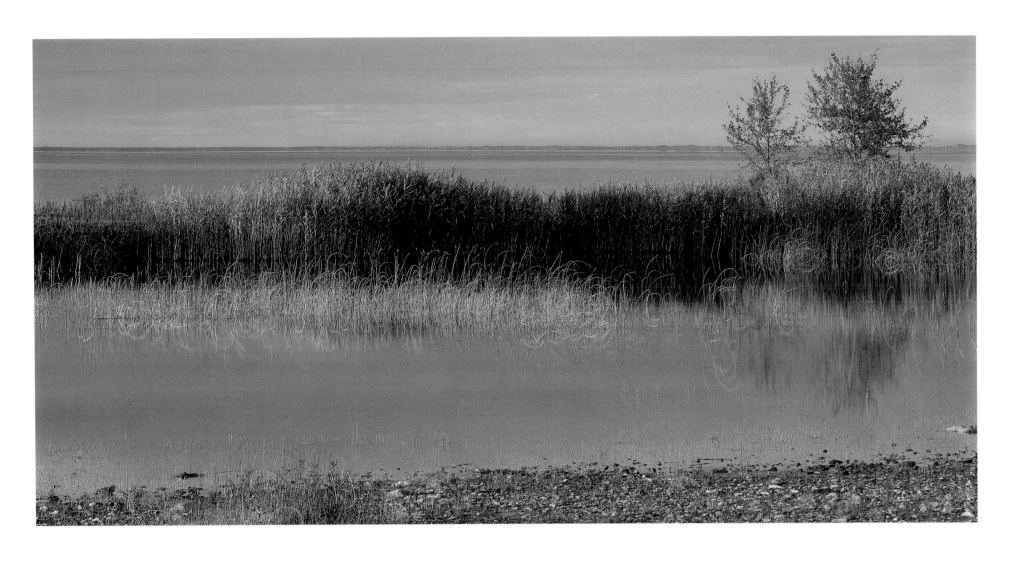

A small pool nestles along the Lake Michigan shoreline, with the Upper Peninsula in the distance. [CJ]

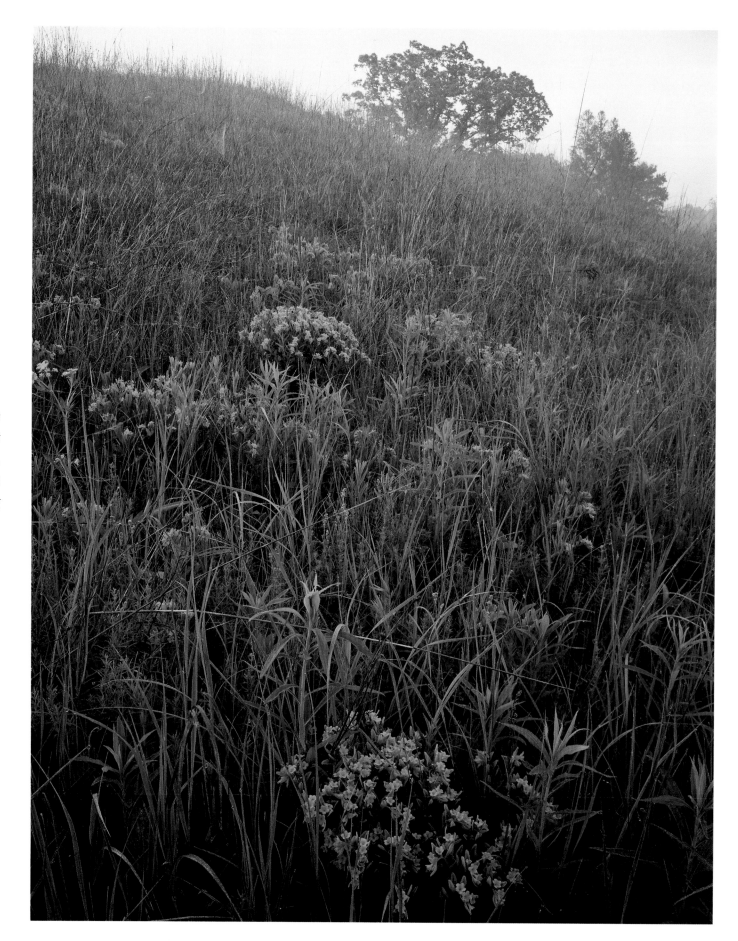

At the Michigan Nature Association's Burr Plant Preserve in Oakland County, hoary puccoon bloom beneath the golden remnants of big bluestem grass. [RL]

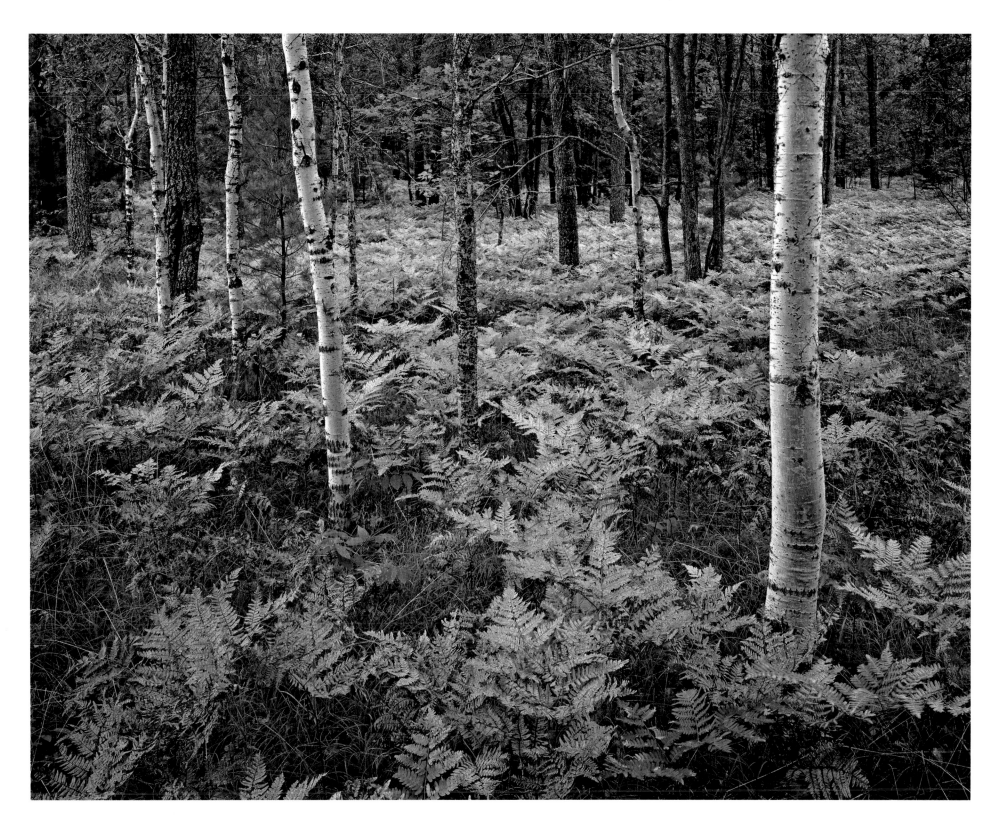

A typical forest scene that can be viewed across much of the northern Lower Peninsula. This particular tract is part of the Au Sable State Forest in Oscoda County. [RL]

A late-winter scene on Lake Michigan near the mouth of the Millecoquin River west of Naubinway in the UP [RL]

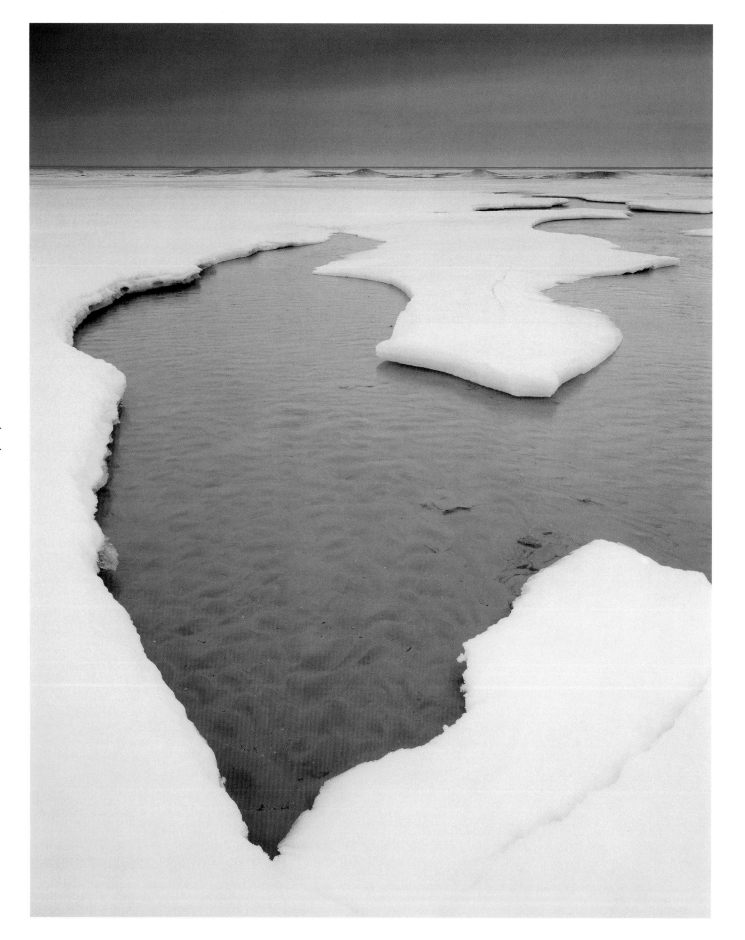

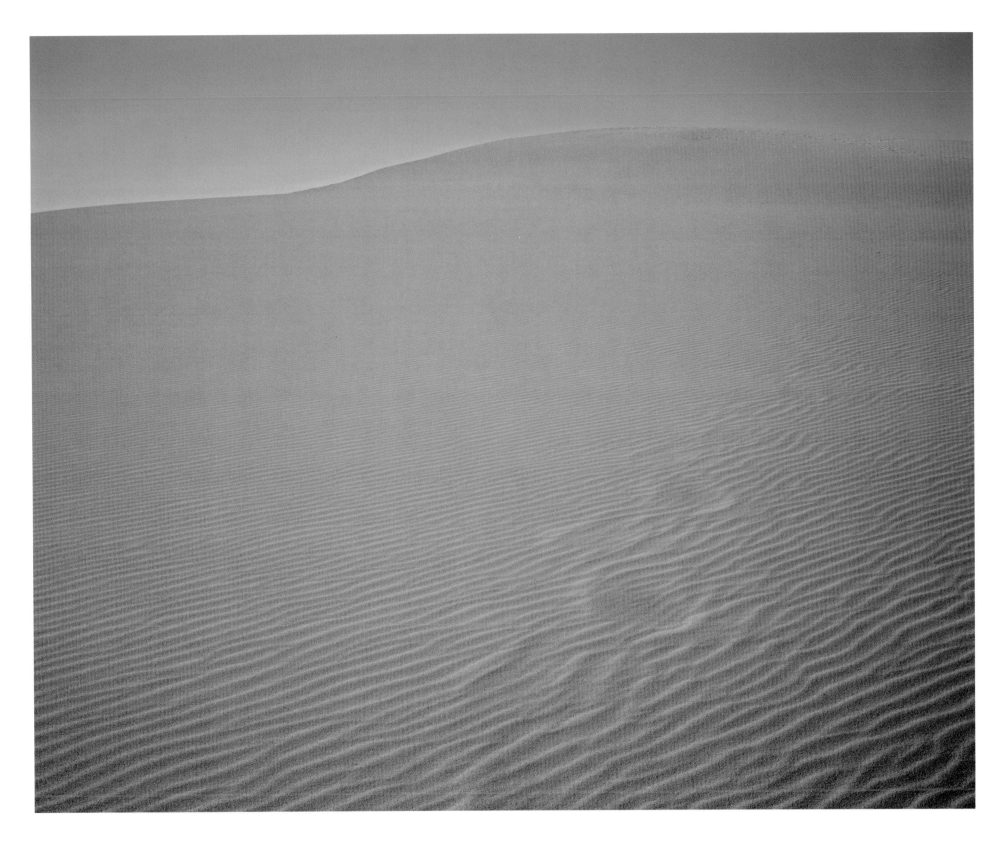

Sand ripples line the dunes at one of the largest stretches of open sand along the Lake Michigan coast, within Silver Lake State Park. [CJ]

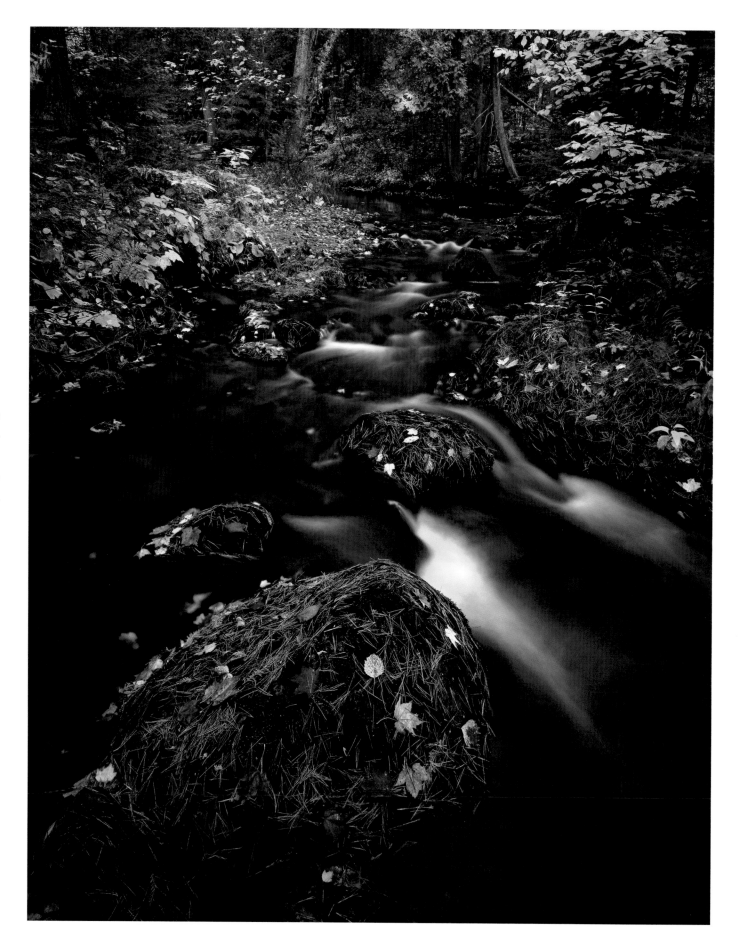

An autumn scene on Reany Creek in Marquette County. At over 1,800 square miles in size, Marquette County is the largest county in Michigan and is larger than the state of Rhode Island.
[RL]

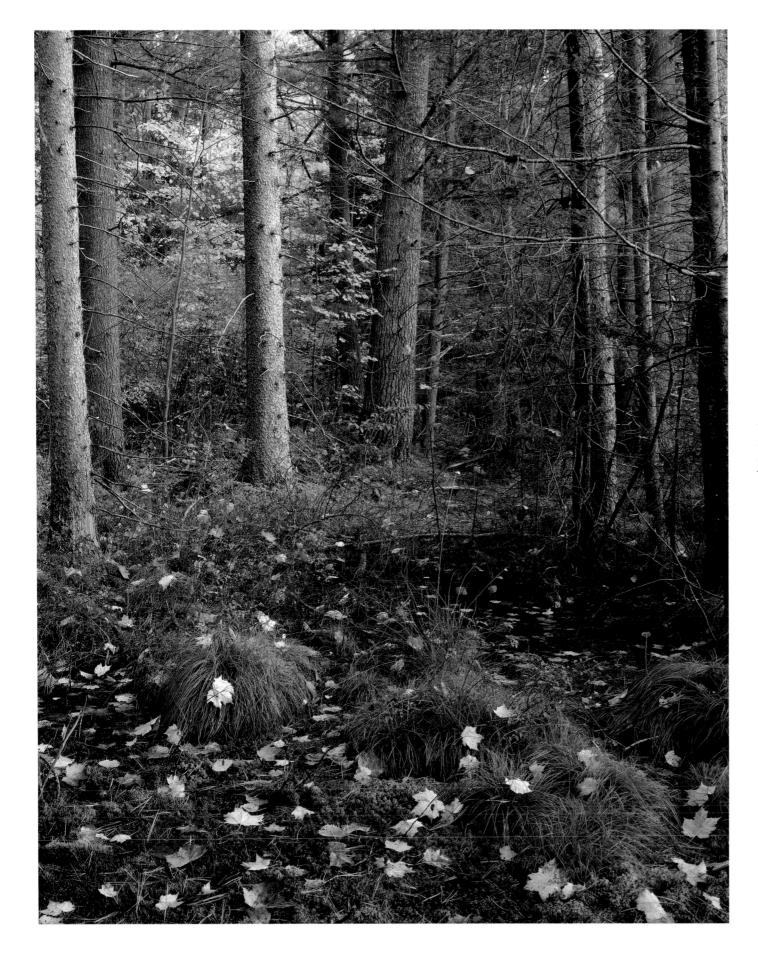

Leaves, grasses, and autumn color near the Lost Tamarack Pathway, part of the Mackinac State Forest [CJ]

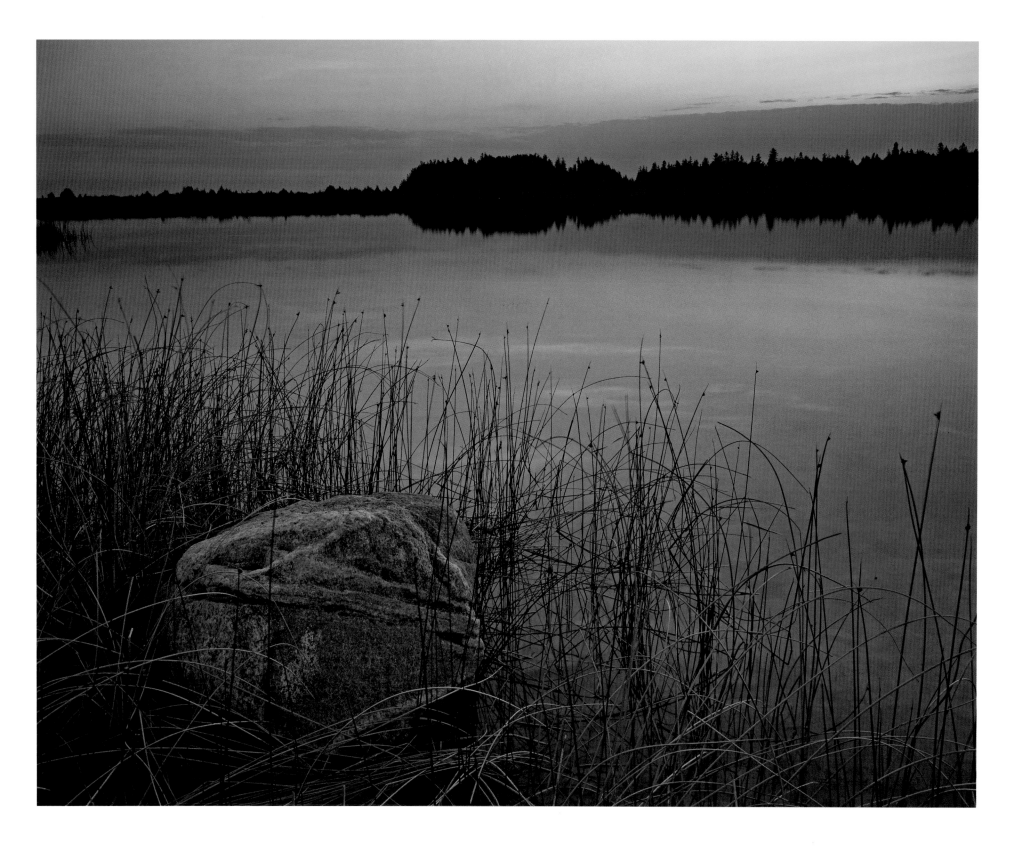

The rich hues of dawn color both earth and sky on one of the countless pools that dot Waugoshance Point in Wilderness State Park. [RL]

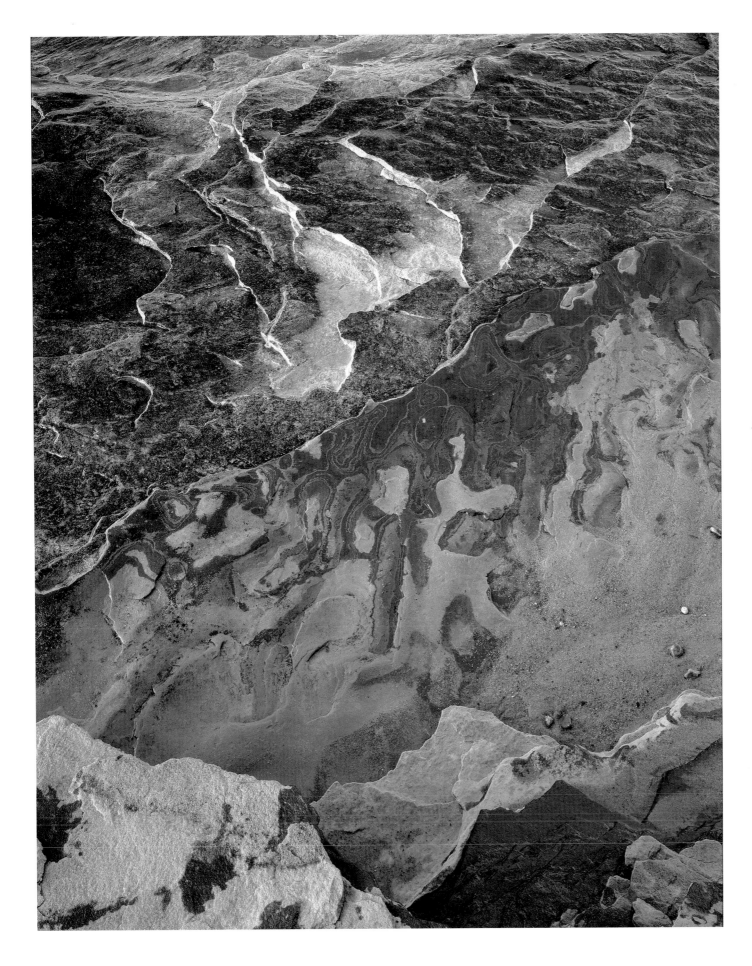

Multi-colored sandstone along the shore of Lake Superior, near Hurricane River [CJ]

Floating Autumn Leaves

The motivation behind the capture of any particular photograph is usually something that is fairly straightforward for me. I respond emotionally to the scenes and beauty of nature, and hope to capture some of that emotion and wonder for viewers. Occasionally, though, I will be surprised by my own hidden motives that may contribute to an image and the reasons why a particular scene will speak to me. . . .

In early October of 2006, I was headed to northern Michigan for a multi-day photo trip when I got a phone call from my wife. She had just received the news that a couple whom we love dearly had just had a miscarriage. As we talked about the situation, I felt my heart go out to these loved ones, both because I knew it was not the first time this unfortunate event had occurred for them, but also because my wife and I had the same experience prior to the eventual birth of our two children.

The second morning of the trip I was out looking for images and found a spot in the woods with standing water and a covering of autumn leaves of various colors. I thought it was a lovely, random pattern with some of the trees also reflected so I set up to take a photograph. After getting everything arranged, I was preparing to release the shutter when the thought flashed into my mind, "This image is for our friends who lost their baby." I froze and tried to understand why that thought had sprung so suddenly and completely into my head. I realized that the floating autumn leaves were a powerful metaphor for something that is dead or dying and yet still very alive and present. Even though the leaves had fallen, the fact that I was there observing and enjoying their beautiful colors and preparing to capture them forever on film left me with a strong sense that even though the reality of them would fade over time, the memory and joy of my experience with them would never go away. I immediately realized that I had the same feeling and hope about each of the little ones that have been lost to us before we ever had a chance to meet them. I share this story in the hope that the experience and the photograph will be a reminder of the love we will always have for those who are not here, and yet will never go away.

CJ

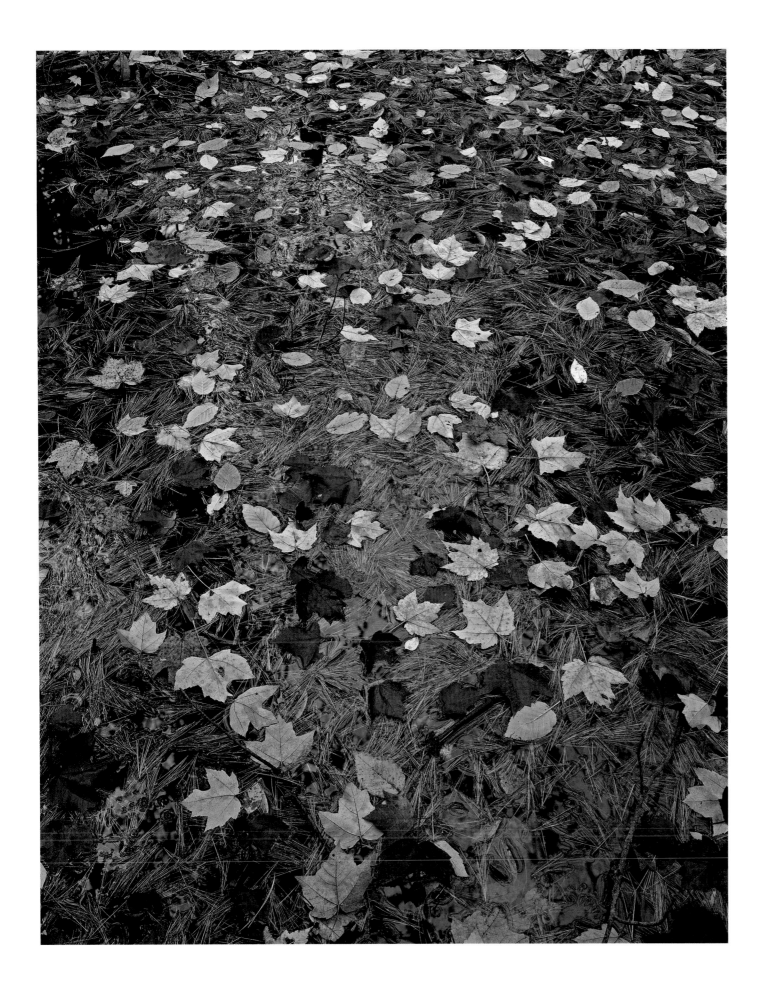

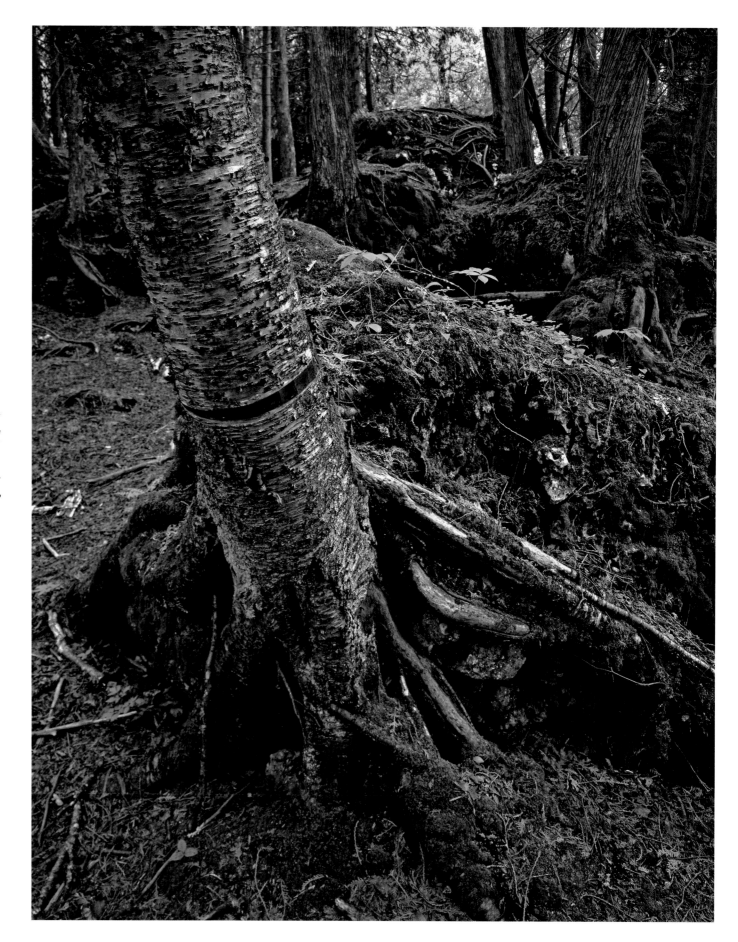

Huge birch and hemlock trees grow over, out of, and around moss-covered limestone boulders, creating a dense coastal forest that the locals call "Narnia," after the fictional kingdom of the same name. [RL]

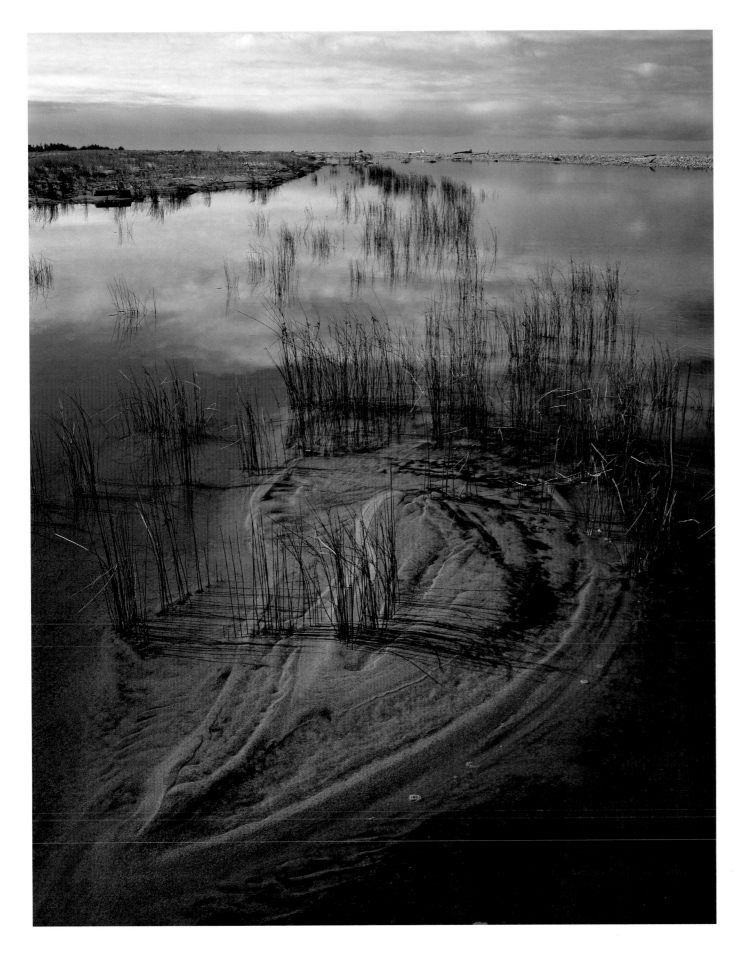

A small sand spit leaves its version of an exclamation point on a tidal pool along a stretch of eastern Lake Superior shoreline near Tower. This stretch of shoreline is critical nesting habitat for the piping plover. [RL]

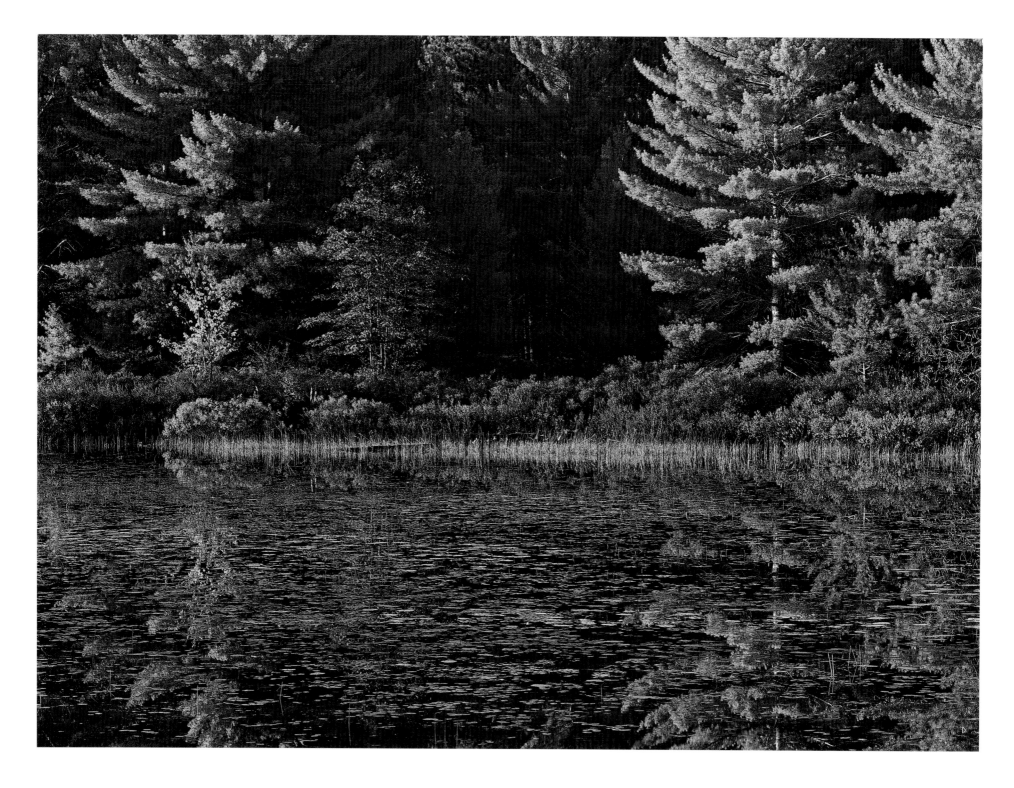

Morning sun rakes across a group of trees in early autumn, along the edge of one of the UP's many inland lakes. [CJ]

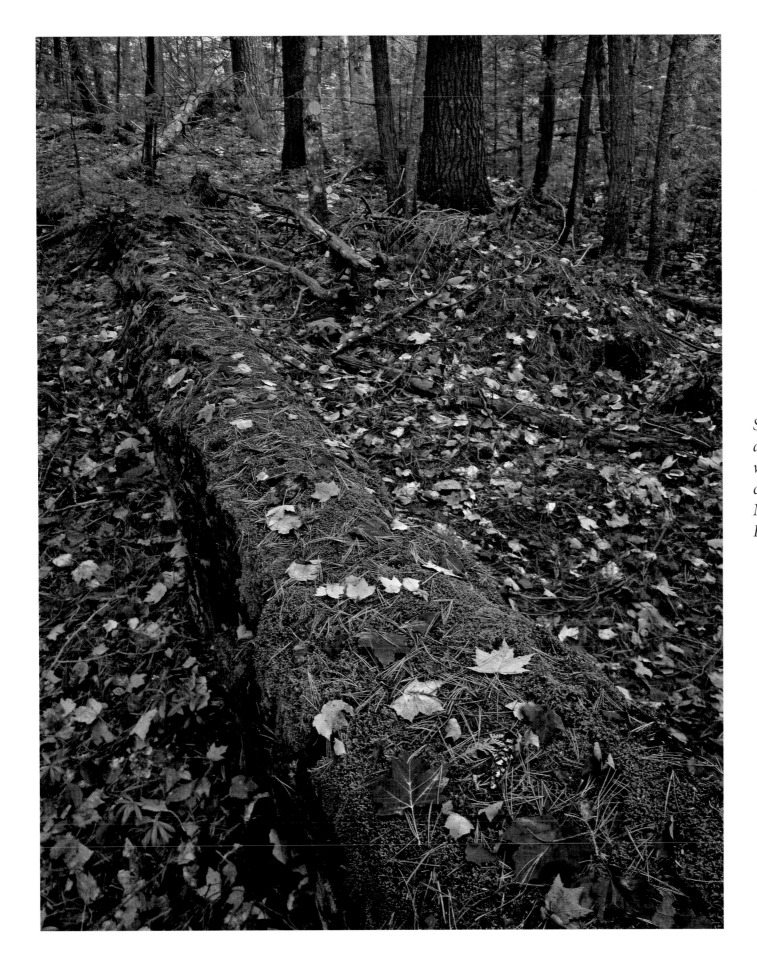

South of Pine Stump Junction, a decaying white pine is adorned with a coat of moss and the fallen color of autumn. This is in The Nature Conservancy's Two Hearted Forest Reserve. [RL]

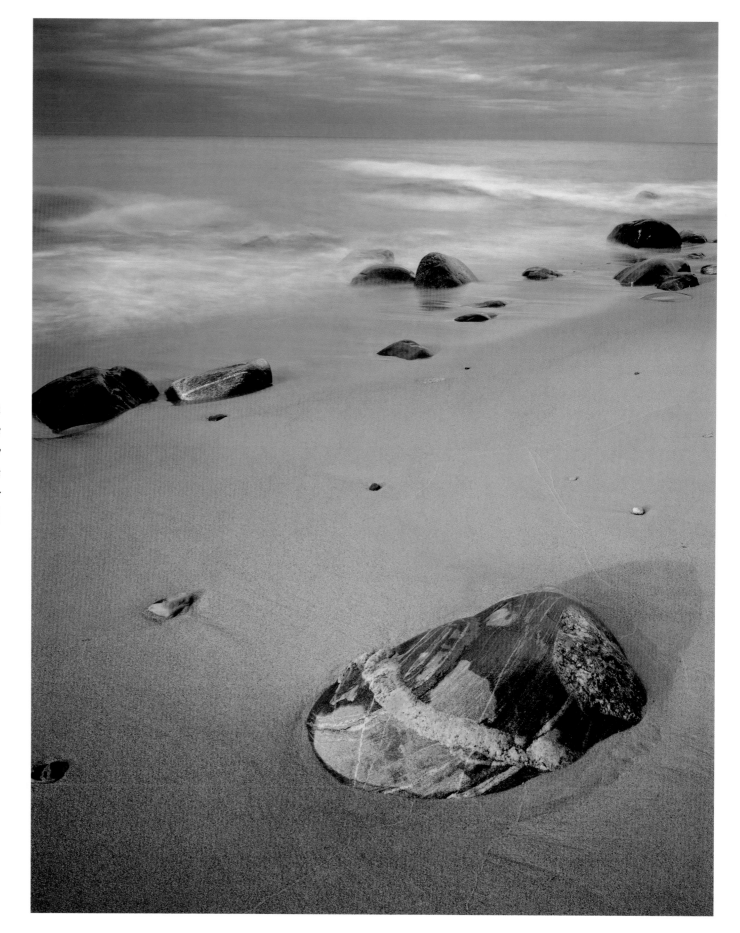

Near Hurricane River in Pictured Rocks National Lakeshore colorful boulders litter the sandy beach. Not far from this location is the deepest point in Lake Superior at 1,333 feet. [RL]

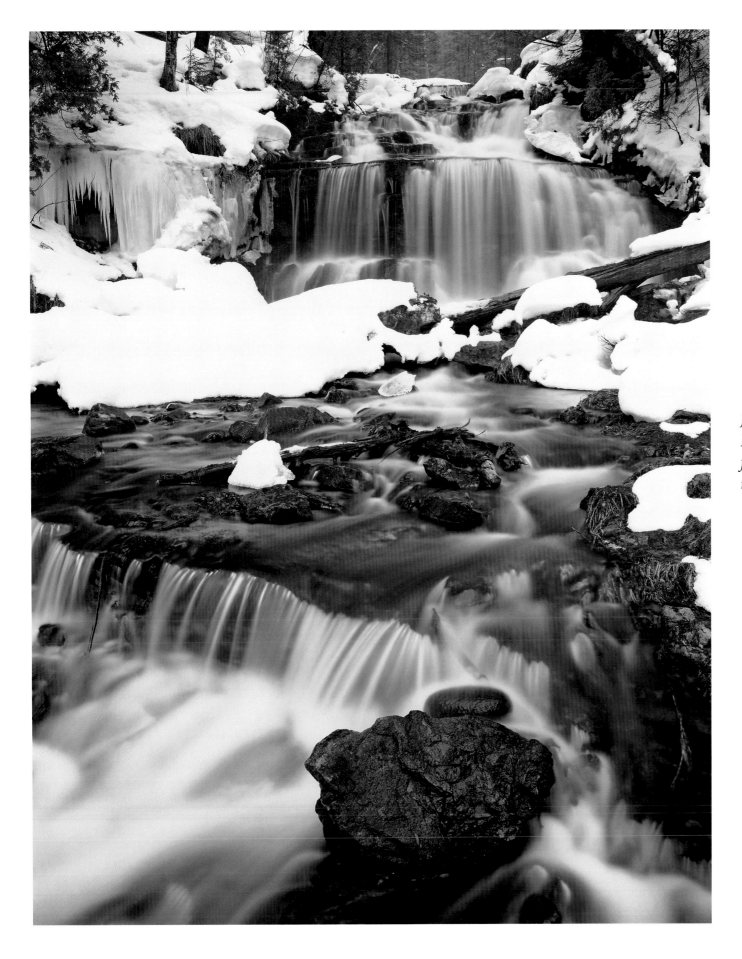

Just south of Munising is Wagner Falls Scenic Site. The picturesque falls are seen here flowing freely in early winter. [RL]

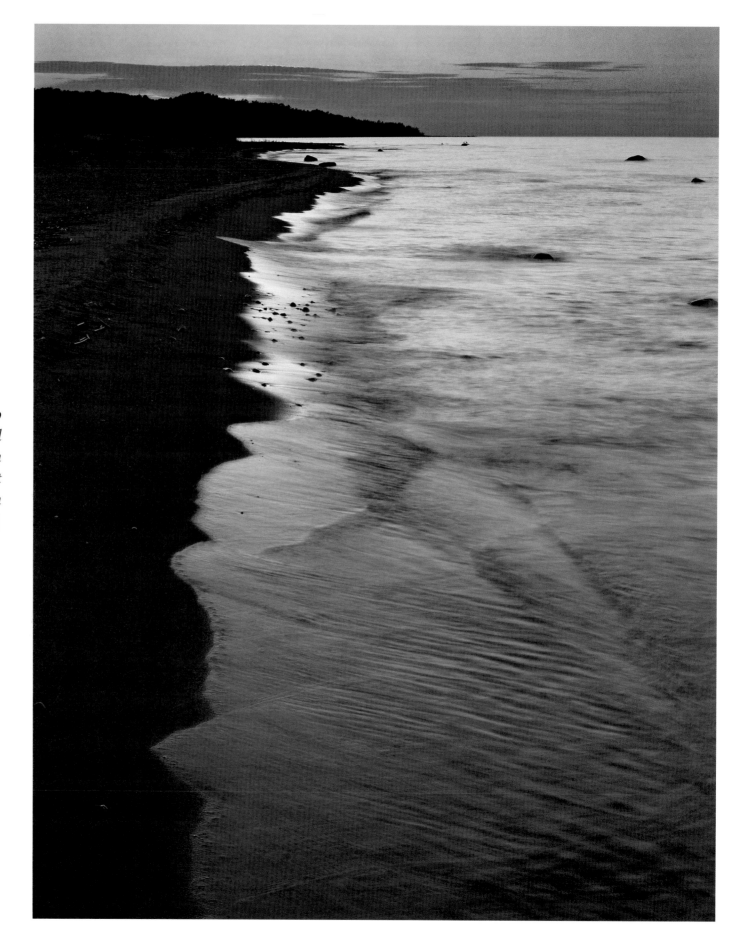

Though commonly referred to as the "Sunrise Coast," beautiful sunsets can also be witnessed on Lake Huron as seen here at P. H. Hoeft State Park north of Rogers City. [RL]

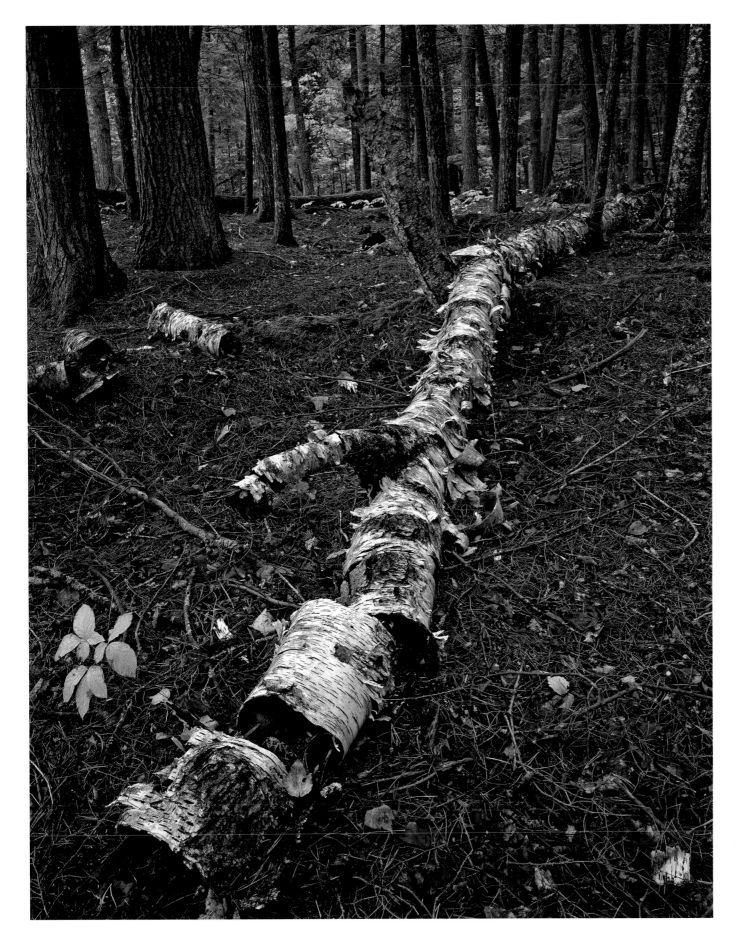

A fallen giant birch reverts back to the soil from which it derived its nutrition near Wetmore's Landing north of Marquette. [RL]

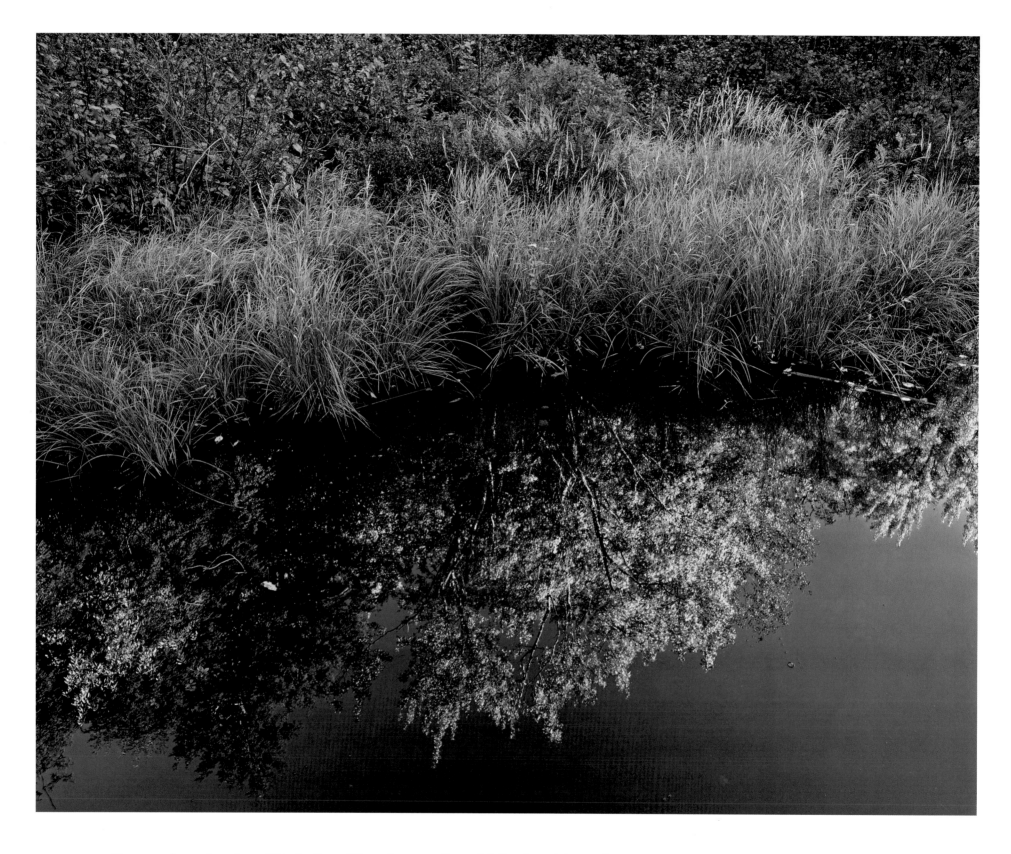

Grasses along the edge of Little Carp River frame reflected fall colors. The Little Carp River runs through the 60,000 acres of Porcupine Mountains Wilderness State Park. [CJ]

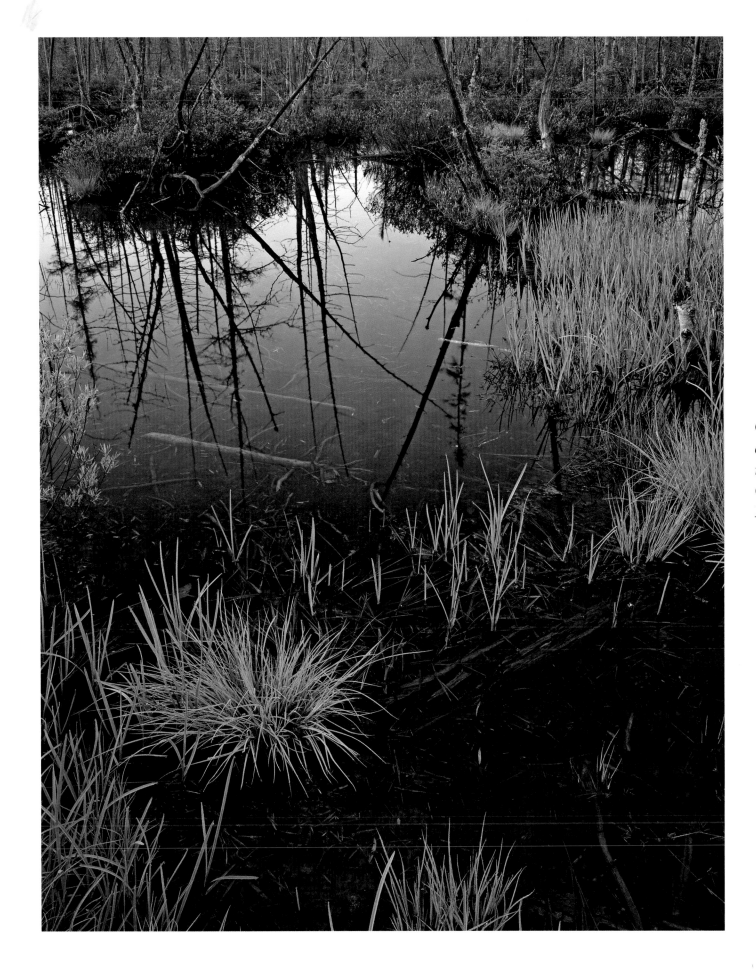

On a calm, foggy morning dead cedars cast eerie reflections on the mirror-like water of a bog in the Copper Country State Forest near Nestoria. [RL]

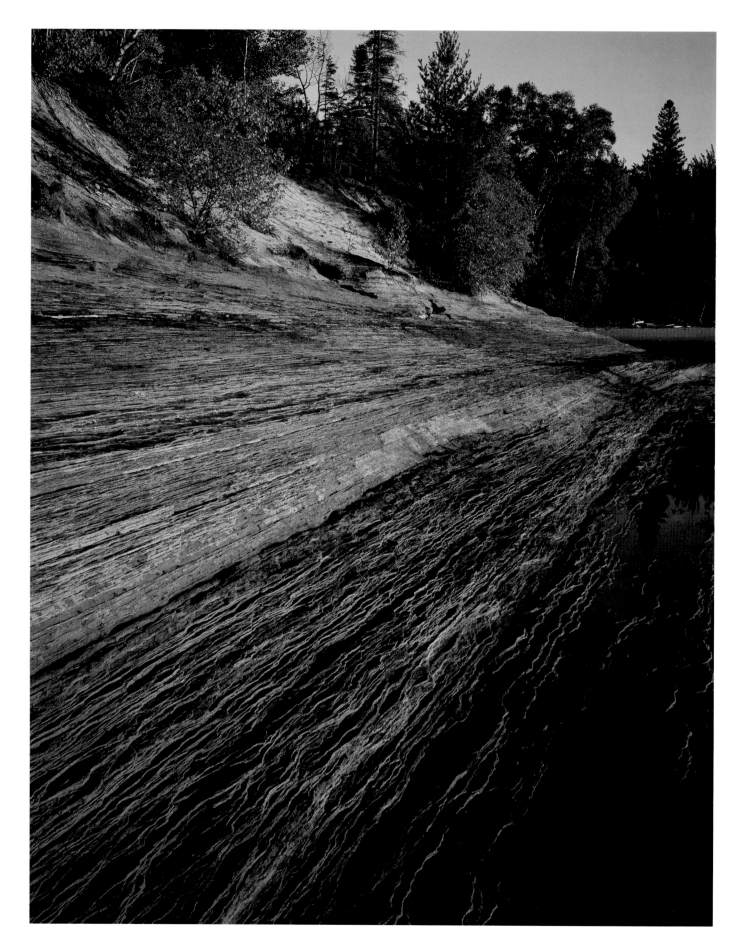

From the Chapel Road trailhead in Pictured Rocks it is a 1.8-mile hike to the Mosquito Beach area. There, the sandstone shoreline has been sculpted and shaped over eons by the wave action of Lake Superior.
[RL]

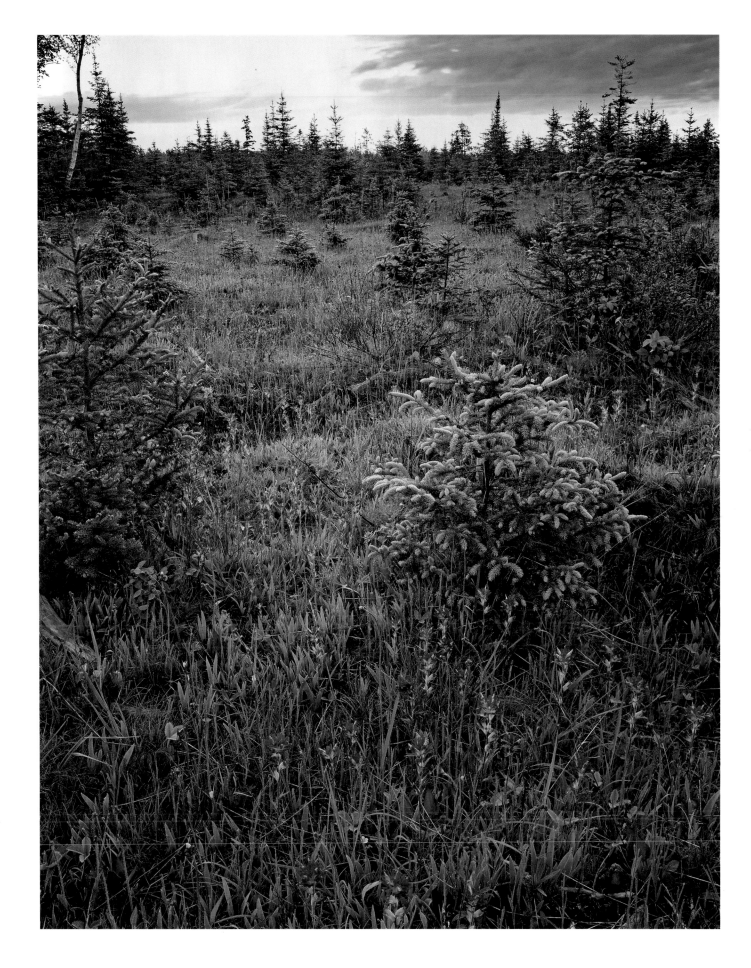

Indian paintbrush and young spruce share an open margin in the interior of the Garden Peninsula. [RL]

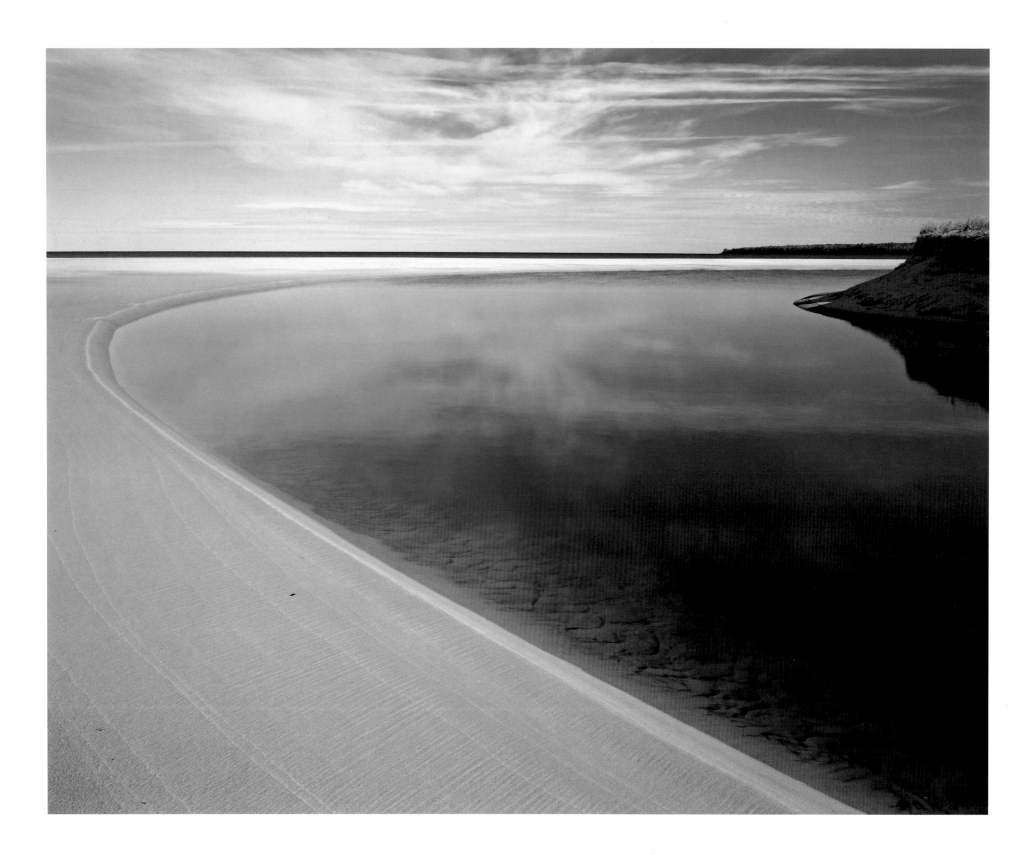

As the Au Train River widens and slows on its approach to Lake Superior, the mirror-like surface reflects an azure sky. [RL]

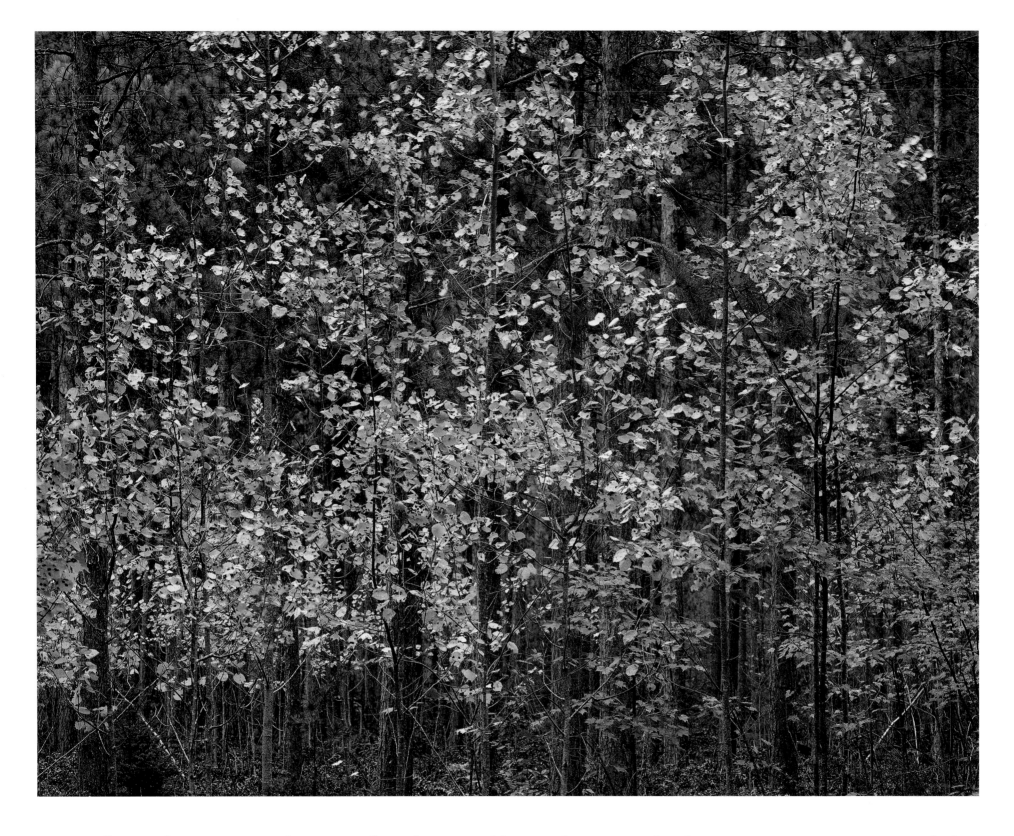

A small group of aspen trees provides intense yellow color in one of the many forest types within the Pigeon River Country State Forest. [CJ]

Acknowledgments

We would like to thank the many people who have contributed their time and energy to this project and to making this book possible. We are grateful to members of the Michigan Nature Association and the Michigan chapter of The Nature Conservancy for assistance and up-to-the-minute information on various locations around the state.

Special thanks to Nadine Cain for acting as tour guide, species expert, and especially innkeeper on short notice. She graciously allowed us to alter our lodging plans when weather turned unexpectedly bad, and the tasty French toast was a bonus!

Thanks again to Indiana University Press for joining with us to produce another book that showcases our love of the Great Lakes region. Janet Rabinowitch, Michael Lundell, and Linda Oblack have all worked to keep the project on track and supported our efforts to share the beauty of this wonderful state. Thanks also to Matt Williamson for the beautiful book design and layout.

As with *Unexpected Indiana,* we want to express our gratitude to all the organizations and employees who maintain, manage, protect, and preserve the natural landscapes still remaining in Michigan. This book would not be possible without your daily efforts.

Finally, we would be remiss if we did not posthumously recognize and thank Sharon Sklar for her friendship, support, and understanding of our work as seen in our previous two books. Sharon passed away unexpectedly not long after the completion of *The Nature Conservancy's Guide to Indiana Preserves* and we were (and are) saddened by the sudden loss of a truly unique person. Working with Sharon was one of the great joys of our first two projects. We miss you, Sharon.

RL & CJ

I would like to express my sincere appreciation to all the people who helped me with this project. I hope that you will take some satisfaction in this book—you definitely deserve it. First and foremost my gratitude to the folks at Indiana University Press for their continued confidence and support. It has been nothing but a pleasure working with everyone there.

A number of my images were made possible due to the dedicated efforts of organizations like The Nature Conservancy. In particular I want to thank Melissa Soule and her team. The Nature Conservancy in Michigan's offices in Lansing and Marquette were invaluable in my efforts to find and photograph the most beautiful and environmentally unique places in the state. I am most grateful and humbled by your support and friendship.

About twenty years ago I was fortunate to have worked with Bertha Daubendiek of the Michigan Nature Association. Bertha has passed away but her legacy is perpetuated in the many preserves and sanctuaries with the MNA name on them. My thanks to Paul Steiner and Natalie Kent for their time and help. A heartfelt thanks to all the other people that I met in my travels who helped me pull this body of work together. Your kindness and guidance is greatly appreciated.

Special thanks to Christopher Jordan for being such a great partner on this project. Every book we have worked on together has been fun and this was no exception. I thoroughly enjoyed our camping trip at Wilderness State Park and, by the way, thanks for making the coffee every morning at 4:00 AM. As you would say: "That's what I'm talkin' about."

Then there is my lovely wife and partner, Tammy. Of all the preserves, sanctuaries, and special places I have been to, none compare to the sanctuary I find in your love. I thank you for this most wonderful gift.

RL

Any project of this type is impossible in isolation, and once again I'm grateful to many people for their support of this book in ways both large and small. First of all, thanks to my wonderful and loving family. My wife, Carrie-Ann, is truly my best friend and strongest supporter. Thank you for your love and understanding during this project. Thanks also to my children, Iris and Solomon, for patience while I was away and for your love when I'm home. I also would like to thank Carrie-Ann's family, especially Mary Beth, for providing companionship and support to my family on multiple occasions while I traveled.

Thanks to Randy Jordan for being crazy enough to join me on a winter camping trip to Ludington Dunes, and enjoying the cold and snow and ice (and wind) as much as I did. Thanks to Patrick Matthiessen for photographic and camping adventures at Pictured Rocks and Sleeping Bear Dunes. Thanks to Toni Lankerd for willingly providing on-the-spot information about conditions in Michigan to that pesky photographer from Indiana. And thanks to Pamela Mougin for quietly and continuously encouraging and challenging a fellow photographer.

Finally, I'm again grateful for the continued collaboration and friendship of Ron Leonetti. Thank you for making these projects fun and challenging, and for sharing your vision of nature with me. I am proud of all we have accomplished together.

CJ

Technical Details

All of the photographs in this book were recorded using either medium or large format camera equipment. The Pentax 645N or NII medium format camera systems were used for all medium format images, utilizing Pentax lenses ranging in focal length from 35mm wide angle to 200mm telephoto. Large format cameras used included an Arca-Swiss F-Line Field Camera, a Walker Titan, and a Zone VI wood field camera, all in 4" × 5" format. Large format lenses used were made by all the major manufacturers (Fuji, Nikon, Rodenstock, and Schneider) and covered focal lengths from 80mm wide angle to 400mm telephoto. Some of the panoramic photographs in the portfolio were taken using a Horseman 612 roll film back on the large format cameras.

Fujichrome Velvia (50 and 100F) and Provia 100F were the main film types used to capture these images. Other Fuji and Kodak films were also used in certain situations.

Our use of filters was limited to those necessary to most accurately translate a scene onto film. The most commonly used filter was a polarizing filter to eliminate glare and help saturate colors. Color correcting filters were also sometimes used to counteract the effects of reflected sky or reciprocity failure–related color shifts due to long exposures. Graduated neutral density filters were occasionally used to minimize the contrast range of a scene.

All photographs were taken with the camera mounted on a sturdy tripod (either Gitzo or Ries brands). Lens aperture/shutter speed combinations were usually chosen to maximize depth of field in a given situation. Shutter speeds ranged from $\frac{1}{60}$ second to as long as 3½ minutes. Lens apertures ranged from f11 to f32 for medium format images, and f16 to f64 for large format images.

Ultimately the use of specific equipment, including camera, lens, film, or filter, is not an end unto itself but simply the process followed to capture all of the unique yet fleeting moments in time contained herein. Our goal and hope is that you will enjoy this collection of images and gain an increased appreciation of the beauty of these areas, regardless of the technical details involved in the image capture.

Resources

The areas photographed for this book are administered by a variety of organizations dedicated to the preservation and protection of the natural landscapes of Michigan. Without their tireless efforts to identify, acquire, and protect the sites that we visited and photographed, this book and the opportunities for recreation, relaxation, and solitude that these sites provide would not have been possible. We encourage you to visit the parks, nature preserves, forests, and recreation areas of the state to appreciate these natural treasures first-hand. We hope that you will support these organizations with your time and/or money so that the work they do can continue.

Michigan Department of Natural Resources
Parks and Recreation
Mason Building, Third Floor
P.O. Box 30031
Lansing, MI 48909
http://www.michigan.gov/dnr

Michigan Nature Conservancy
Michigan Field Office
101 East Grand River
Lansing, MI 48906
http://www.nature.org/michigan

Michigan Nature Association
326 E. Grand River Ave.
Williamston, MI 48895
http://www.michigannature.org

National Park Service
Links to multiple parks located in Michigan
http://www.nps.gov/

National Forest Service
Links to various national forest lands in Michigan
http://www.fs.fed.us/

In Memoriam

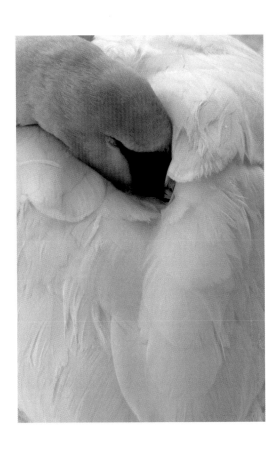

IN MEMORY OF SHARON SKLAR

"They are not dead who live in the hearts they leave behind."

(*Tuscarora proverb*)

We respected you as an artist
We admired your work as a designer
We will always remember you as a friend

Ron and Christopher

About the Photographers

PHOTO BY NICOLE BLASING

Ron Leonetti began capturing provocative images of Michigan's diverse and beautiful landscape with a camera more than twenty years ago. His first published photo was of a whitetail doe in a winter storm near his home in Brighton back in 1985. Today, his critically acclaimed large-format photography is featured in many types of publication including three coffeetable books, periodicals, field guides, textbooks, and mass marketing campaigns. Ron promotes the visual output of his passion to the public in an effort to instill greater awareness for and involvement in the preservation of our threatened natural communities. He is active in conservation issues around the Midwest, volunteering his time and imagery to The Nature Conservancy on a regular basis.

Born and raised in Michigan, Ron now bases his photographic art and design business out of the Minneapolis area where he lives with his wife, Tammy, and their dog, Booker. To view more of Ron's work, visit his website at http://www.ronleonettiphotography.com.

PHOTO BY CHRIS BUCHER

Christopher Jordan has been sharing his passion for the natural world through photography for more than ten years. Born and raised in Indiana, he specializes in finding intimate and unexpected beauty in the natural landscapes of the Midwest, Southeast, and Eastern United States. His work has been published in a wide variety of publications and forums, including *SIERRA Magazine, Forest Magazine,* and promotional materials for the Indianapolis Museum of Art and the Indiana chapter of The Nature Conservancy. His award-winning images are showcased in public and private collections throughout the United States. For more information on Christopher's work, please visit http://www.christopherjordanphotography.com.